ROME 360°

ROME
360°

Photographs by Attilio Boccazzi-Varotto
Research by Giovanna Tavazzi
Sketches by Marco Filaferro

RANDOM HOUSE

NEW YORK

Library of Congress Cataloging-in-Publication Data
Boccazzi-Varotto, Attilio.
[Roma 360˚. English]
Rome 360˚/photographs by Attilio Boccazzi-Varotto;
research by Giovanna Tavazzi; sketches by Marco Filaferro.
p. cm.
ISBN 0-679-44286-3
1. Rome (Italy)–Pictorial works.
I. Filaferro, Marco. II. Title.
DG806.8.B63 1998 97-3971
937'.6–dc21

Random House website address: www.randomhouse.com

Manufactured in Italy by Mariogros
2 4 6 8 9 7 5 3
First Edition

1.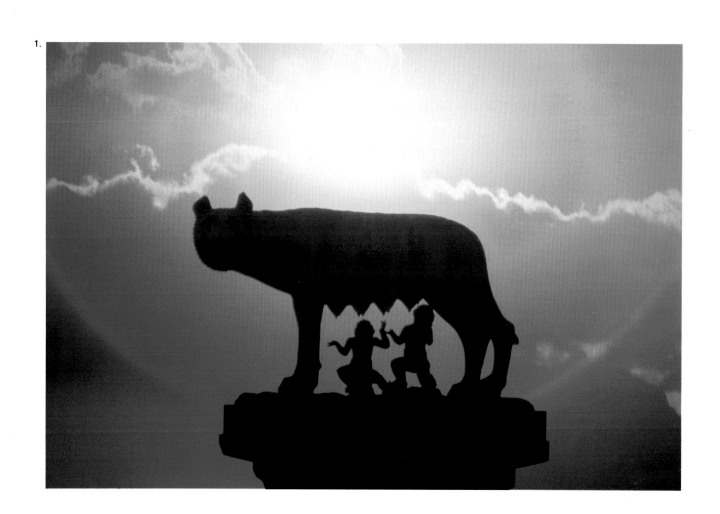

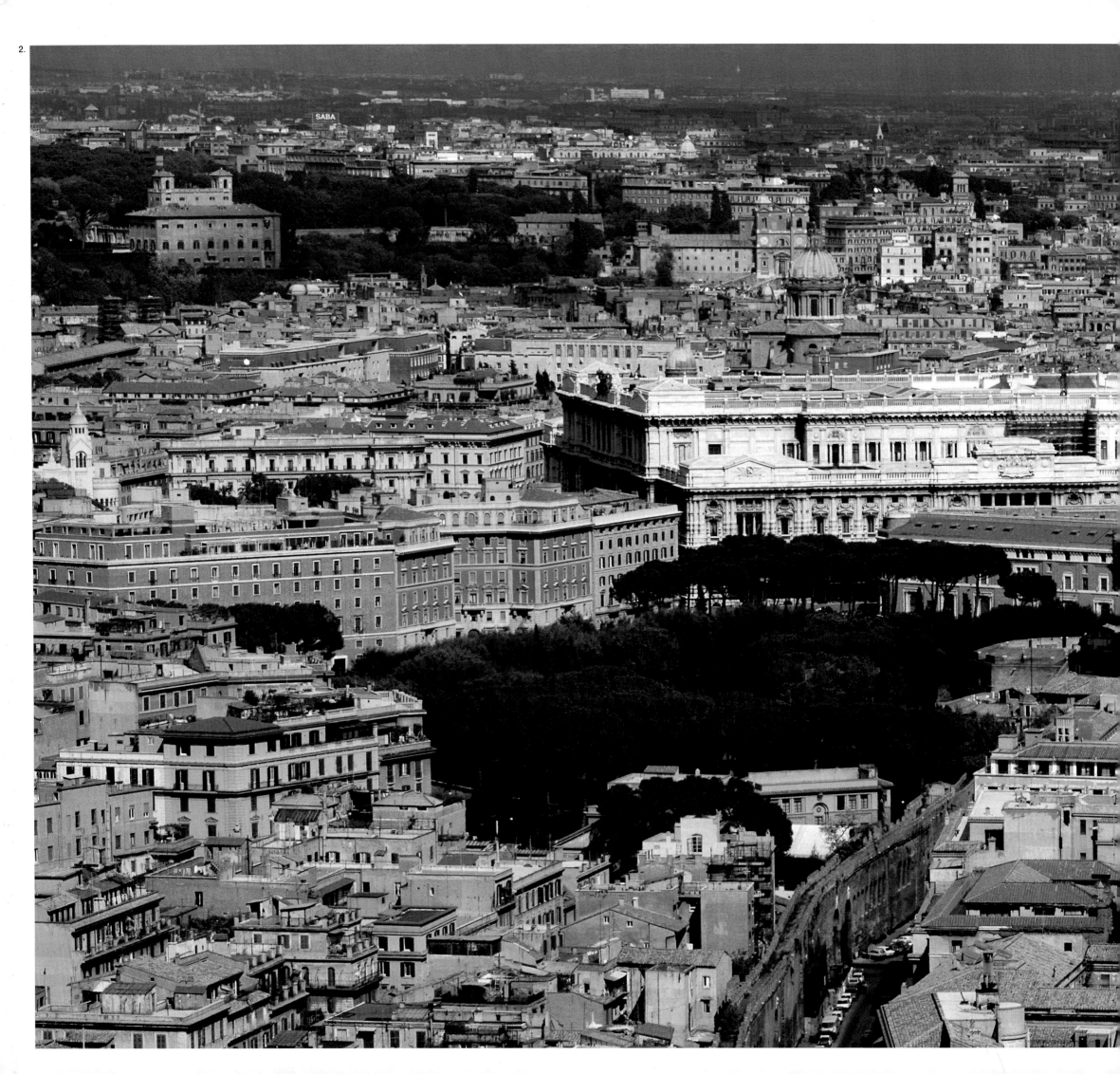

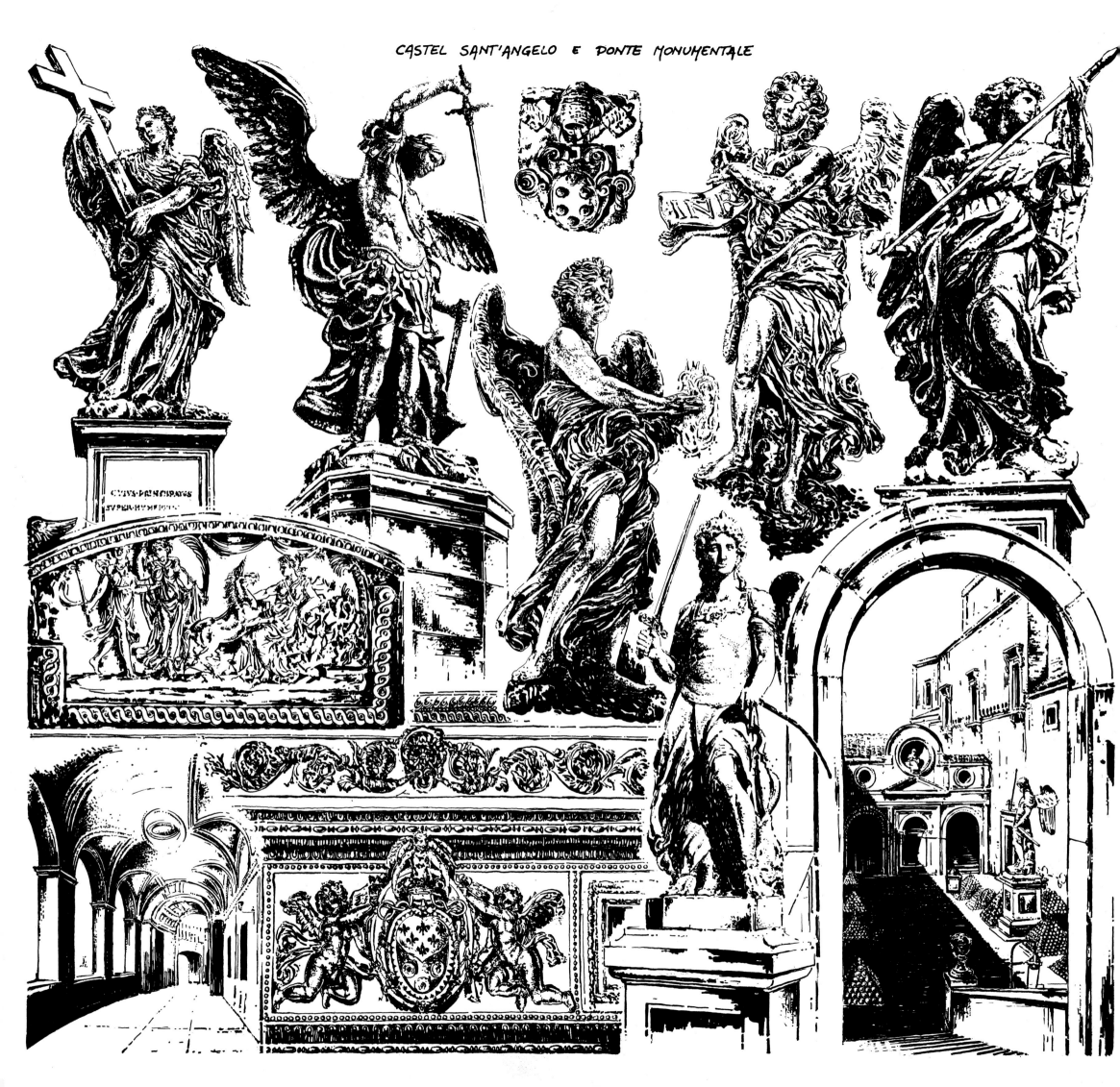

CASTEL SANT'ANGELO E PONTE MONUMENTALE

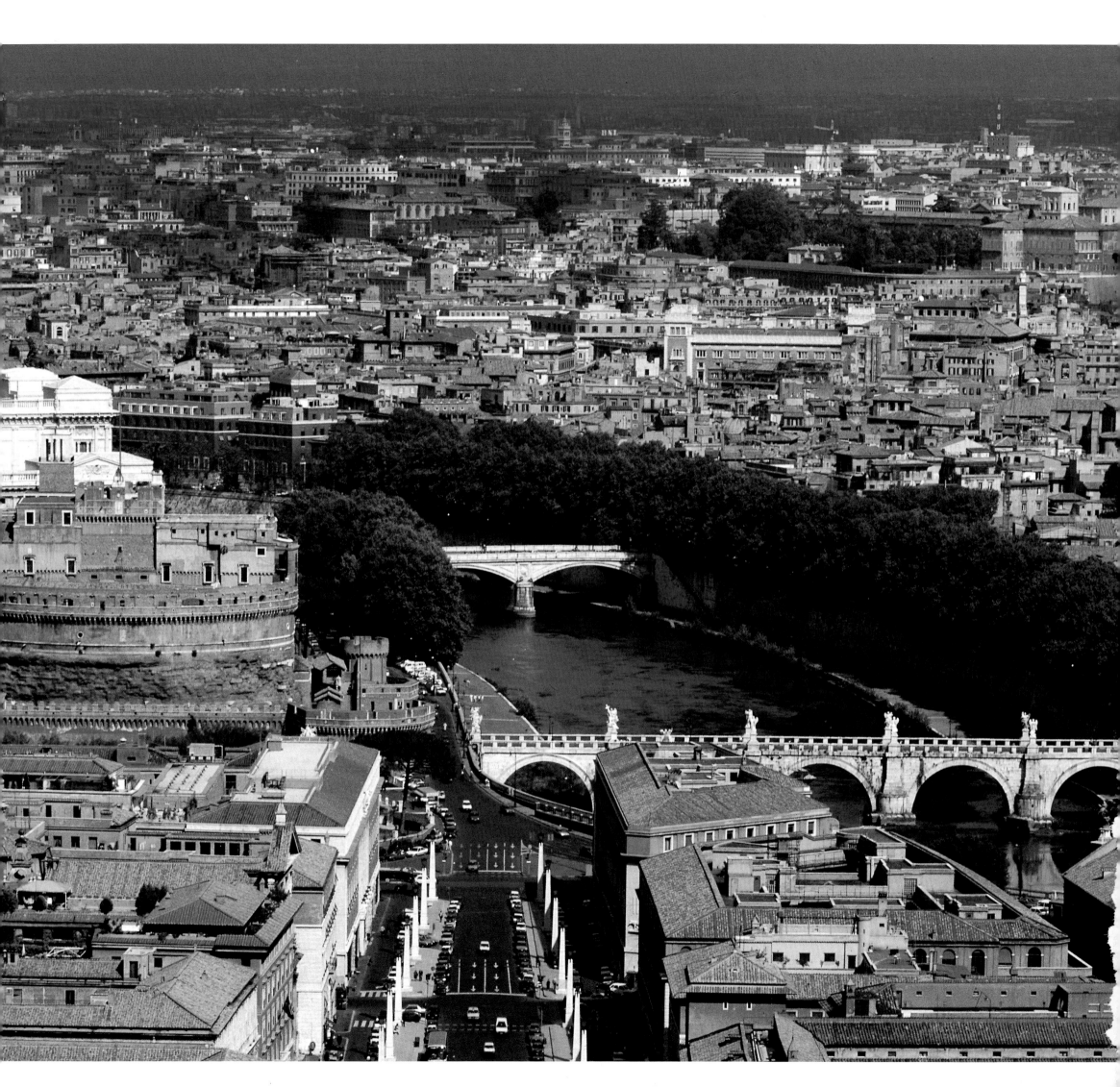

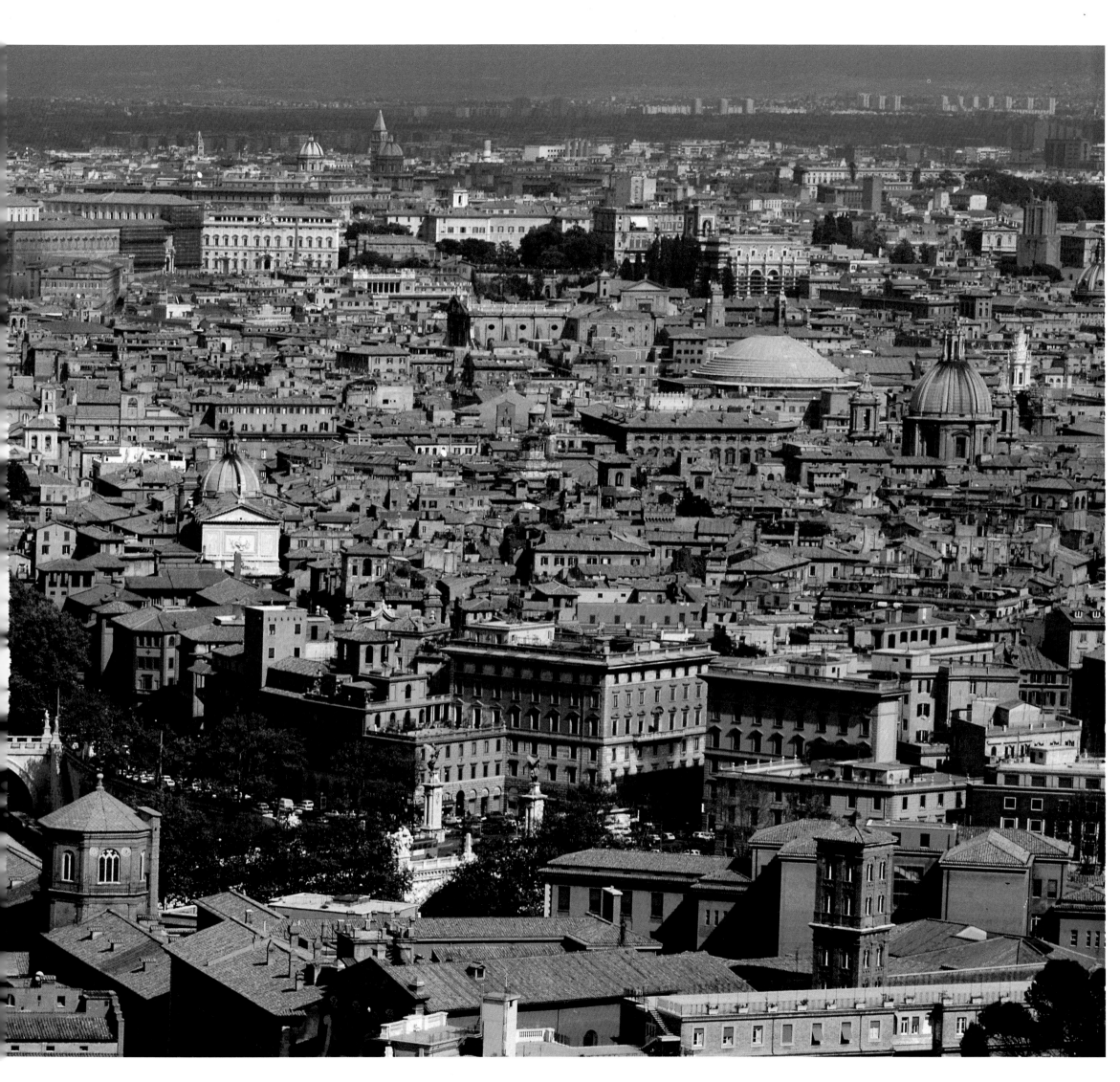

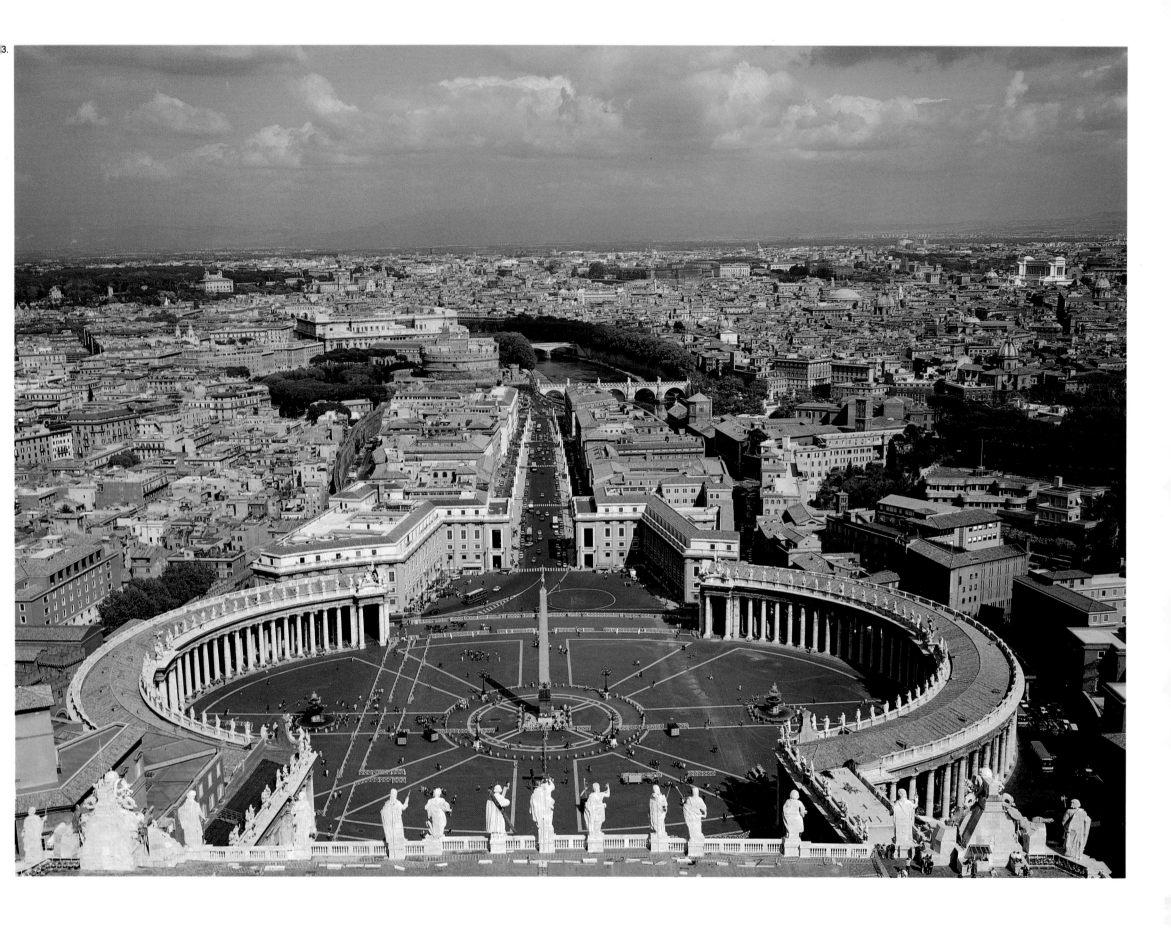

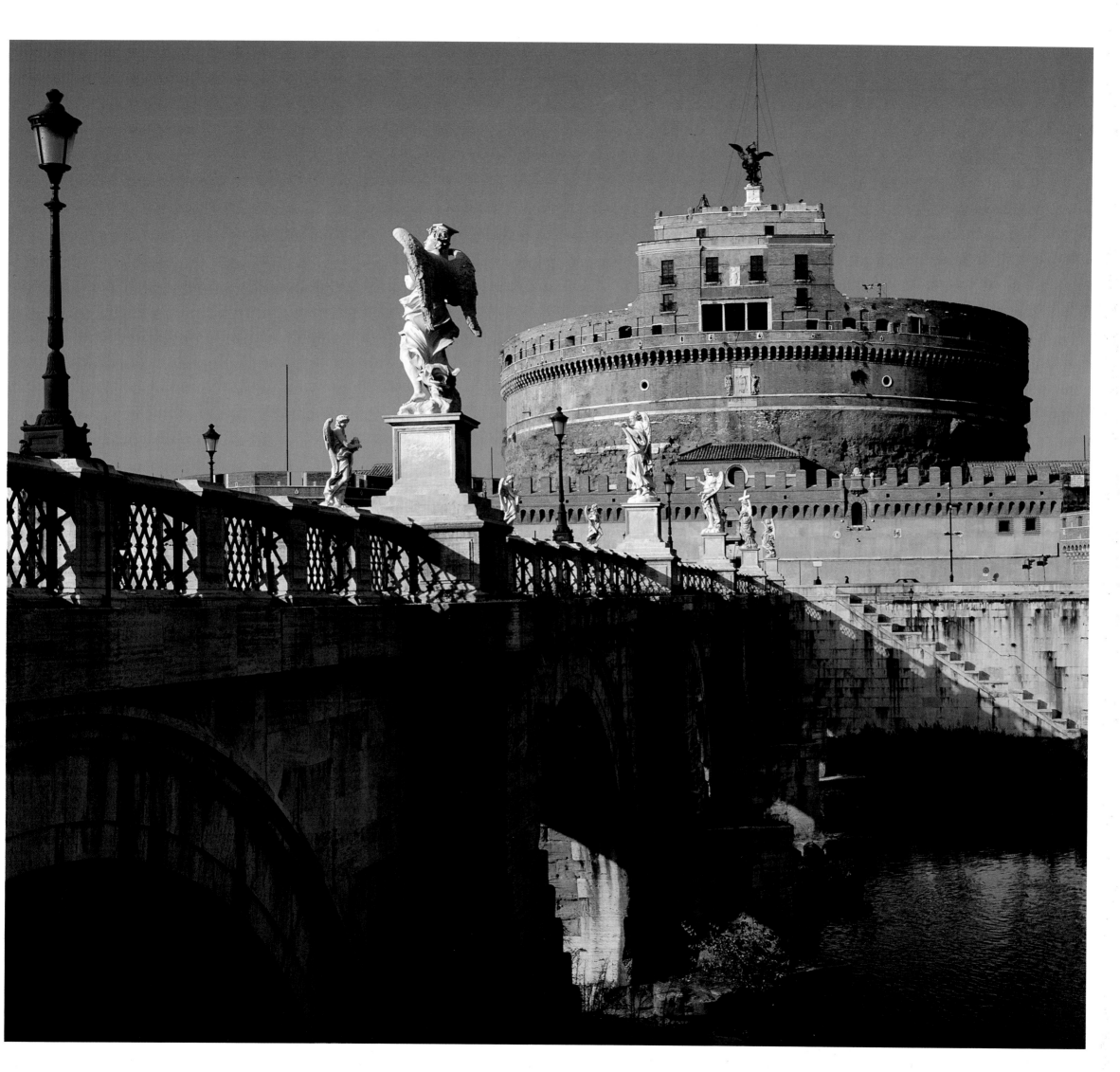

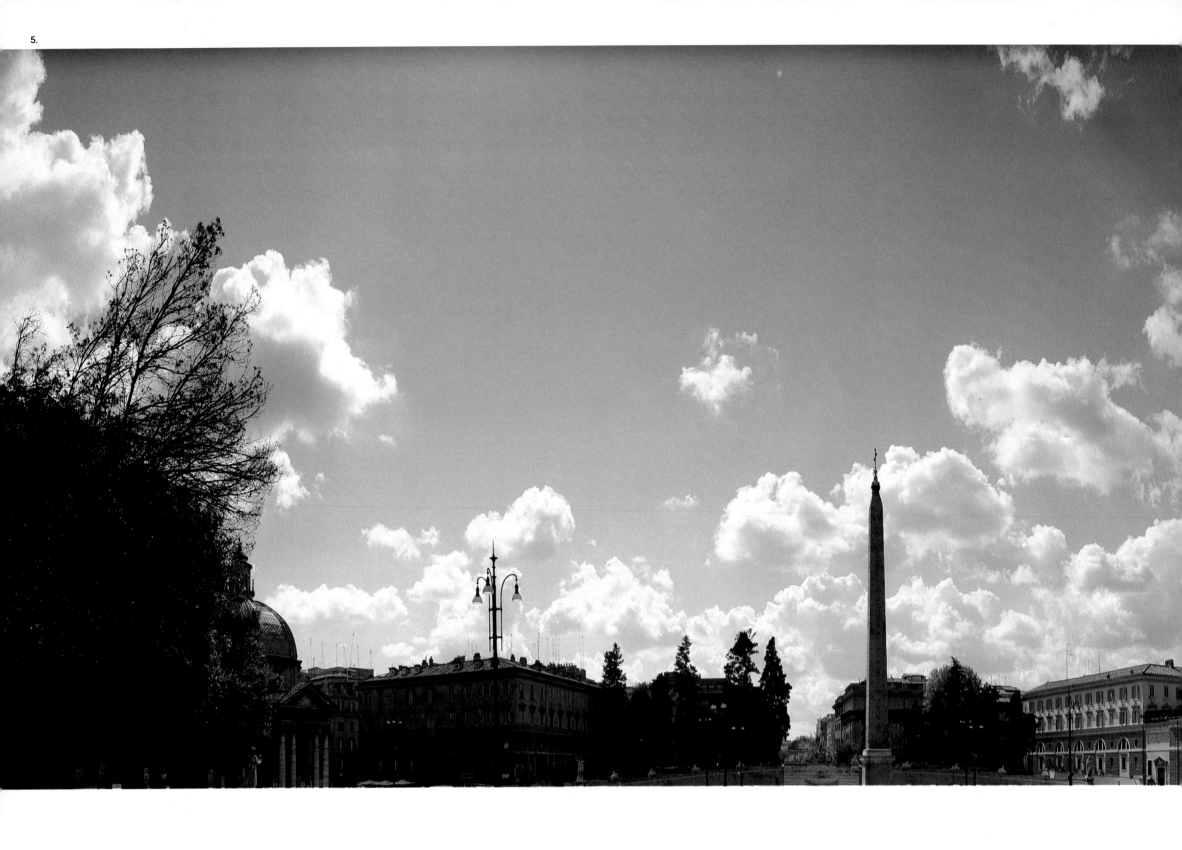

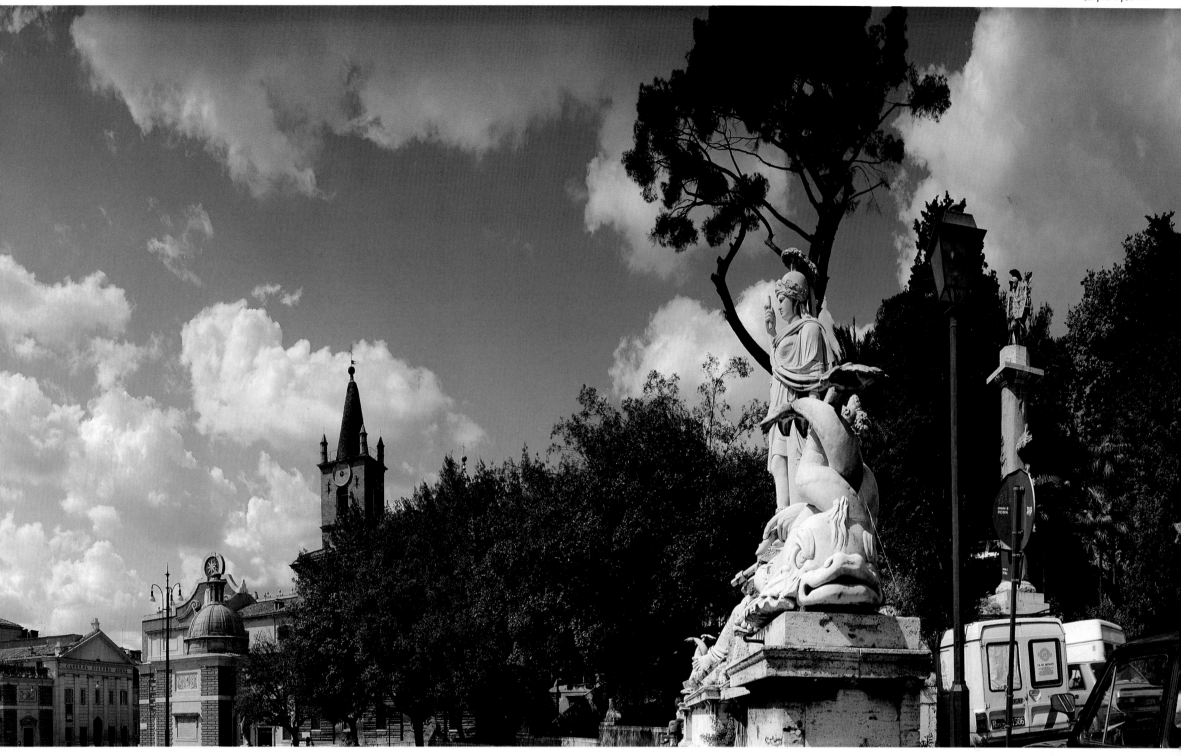

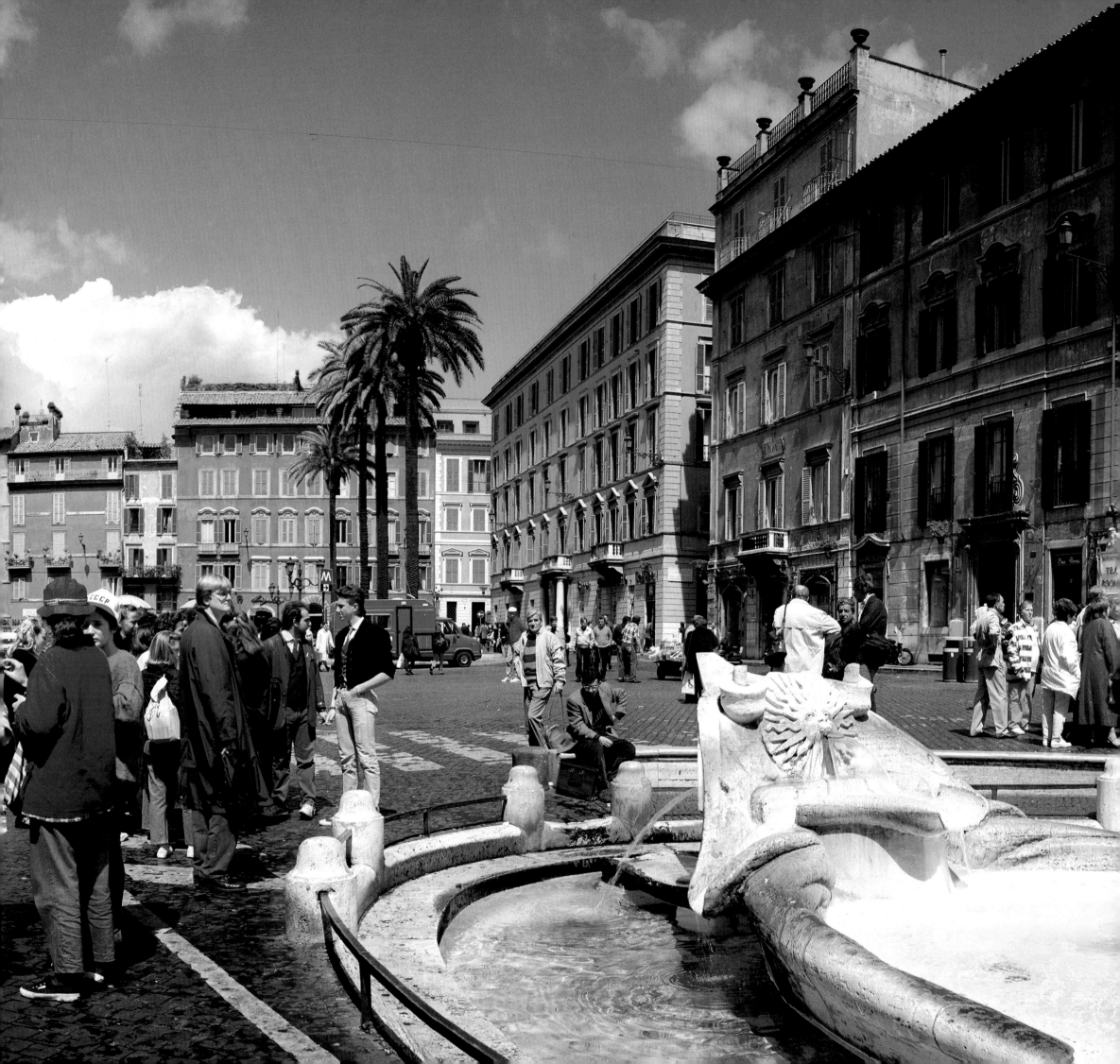

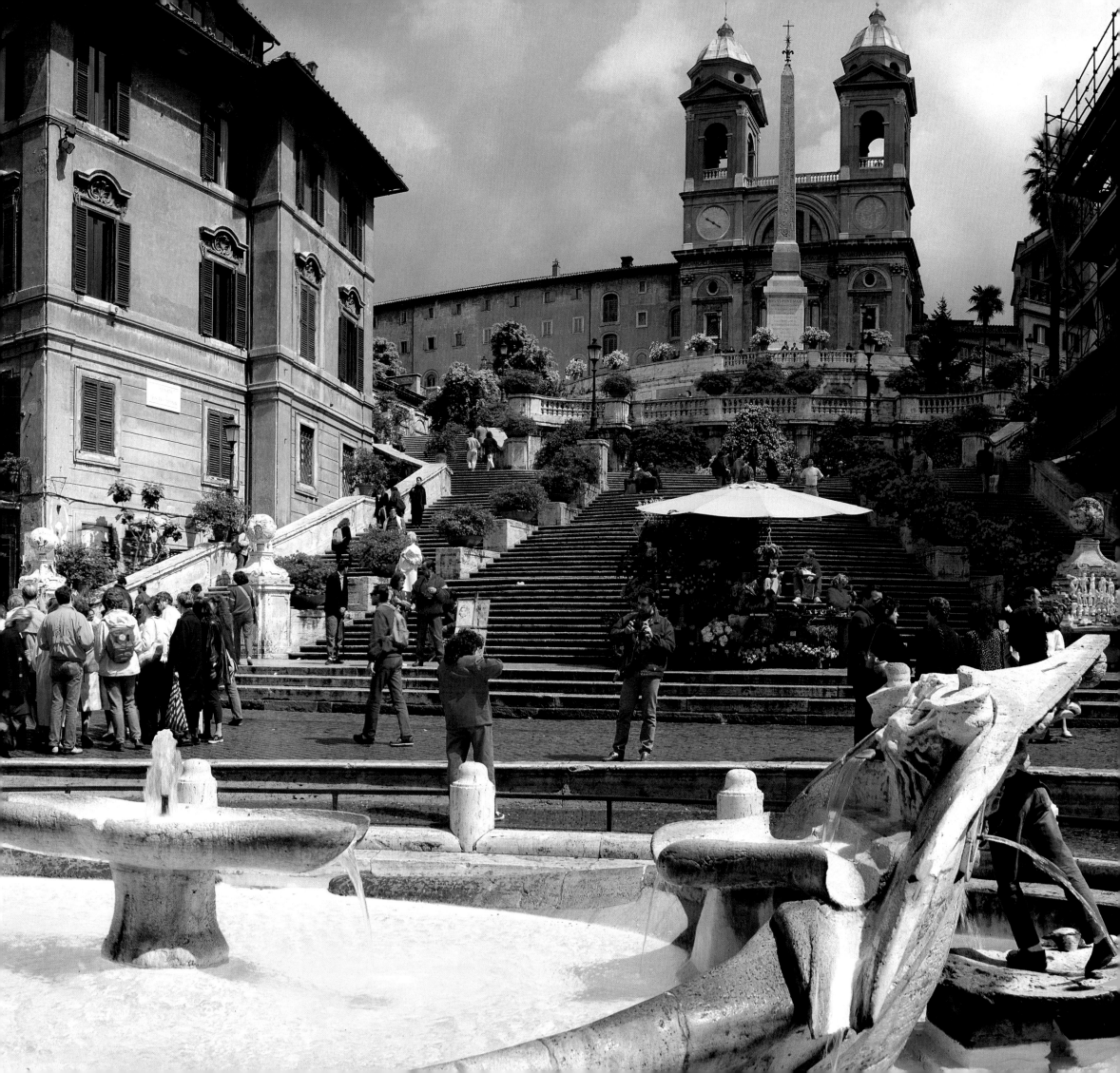

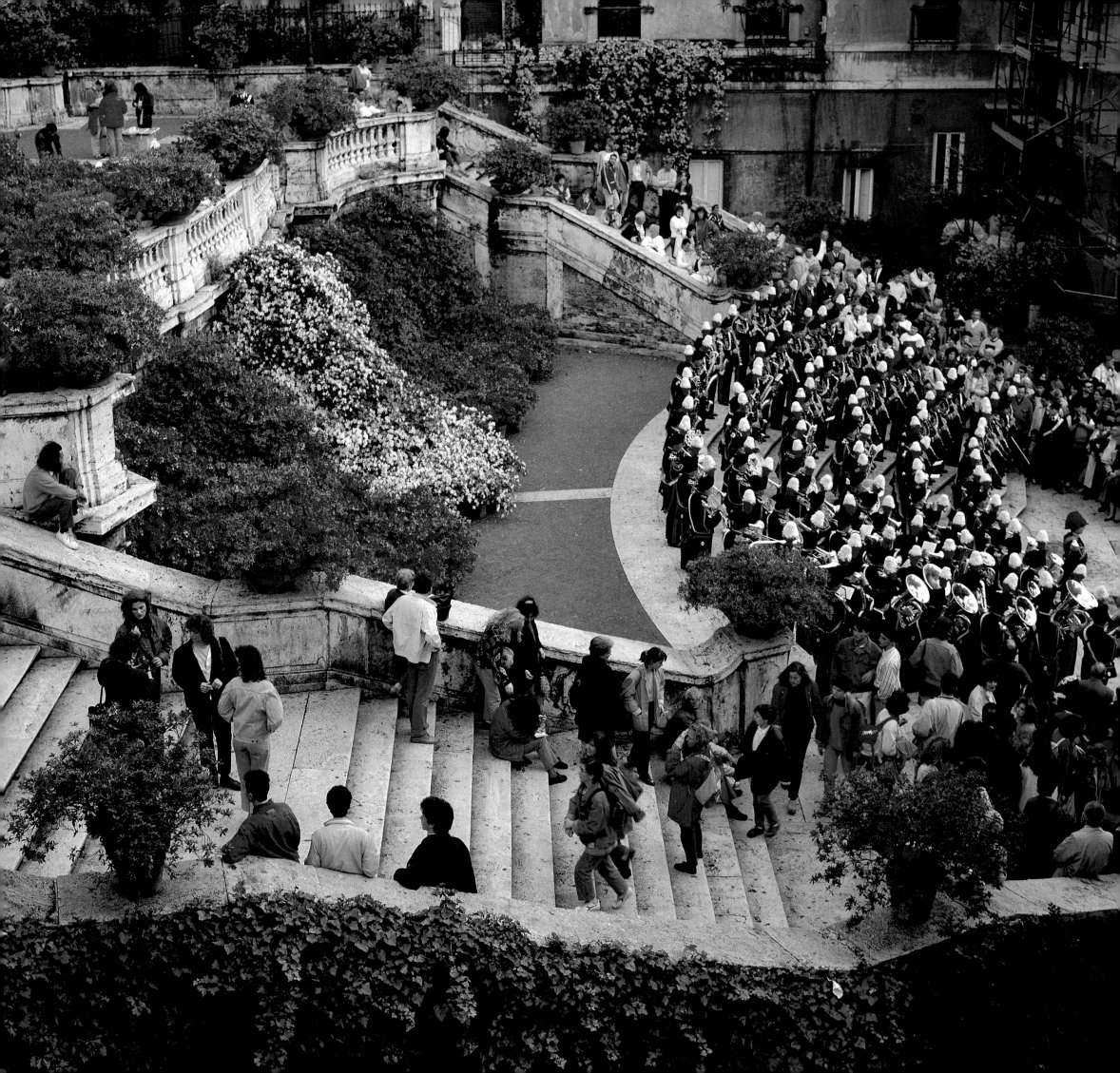

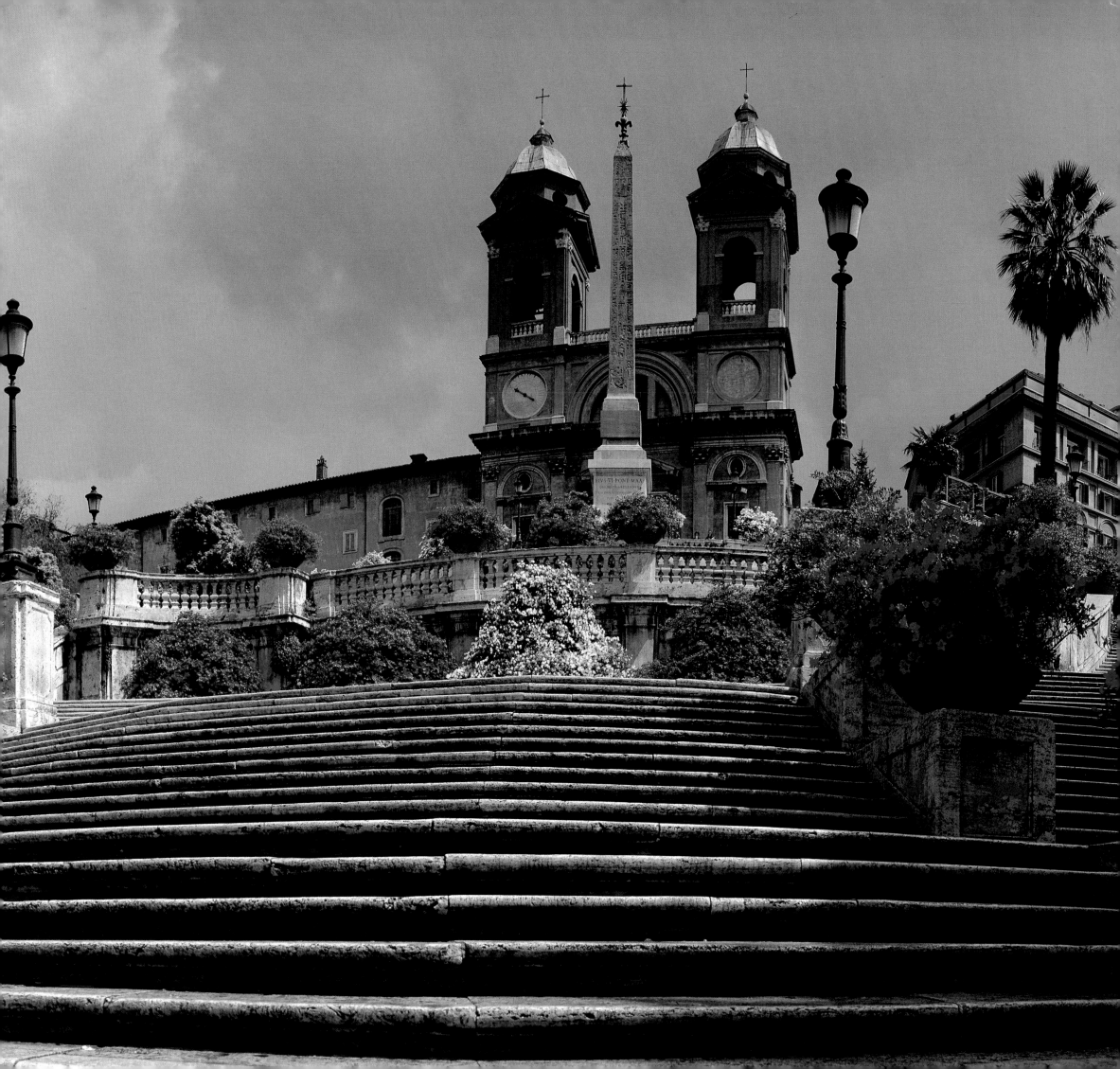

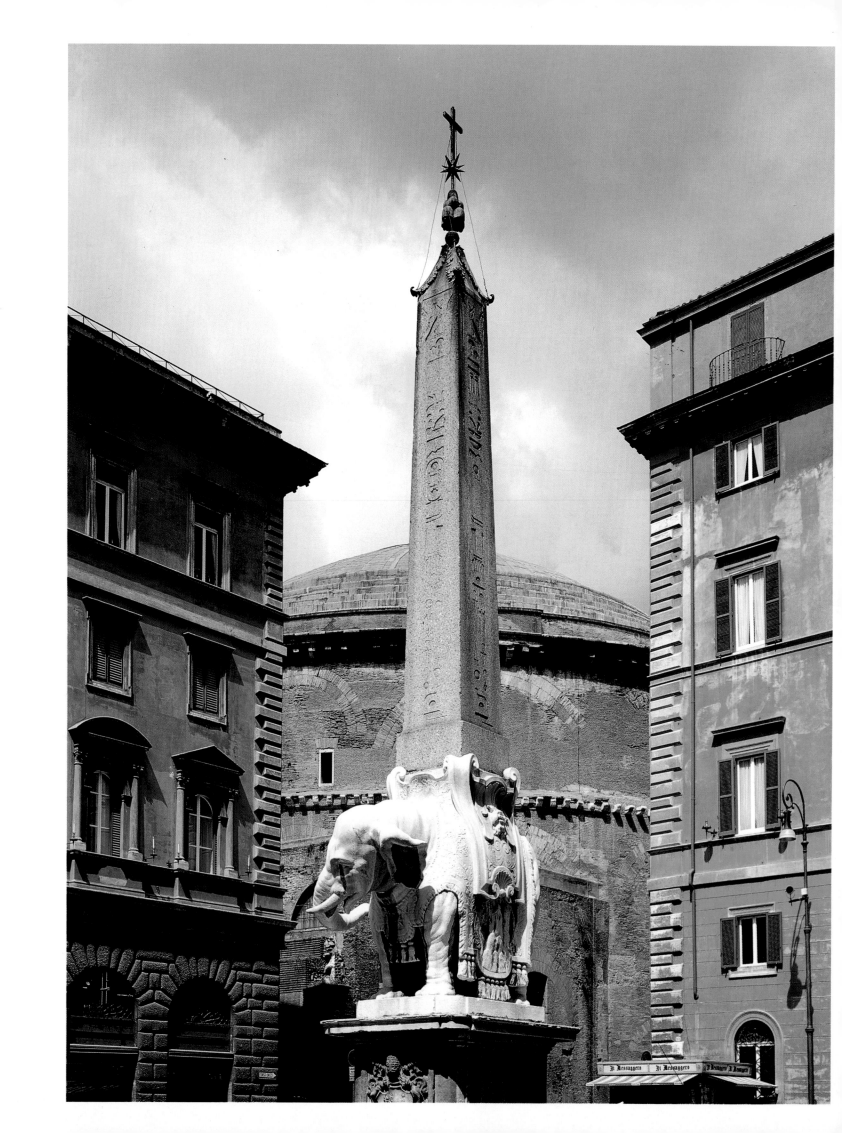

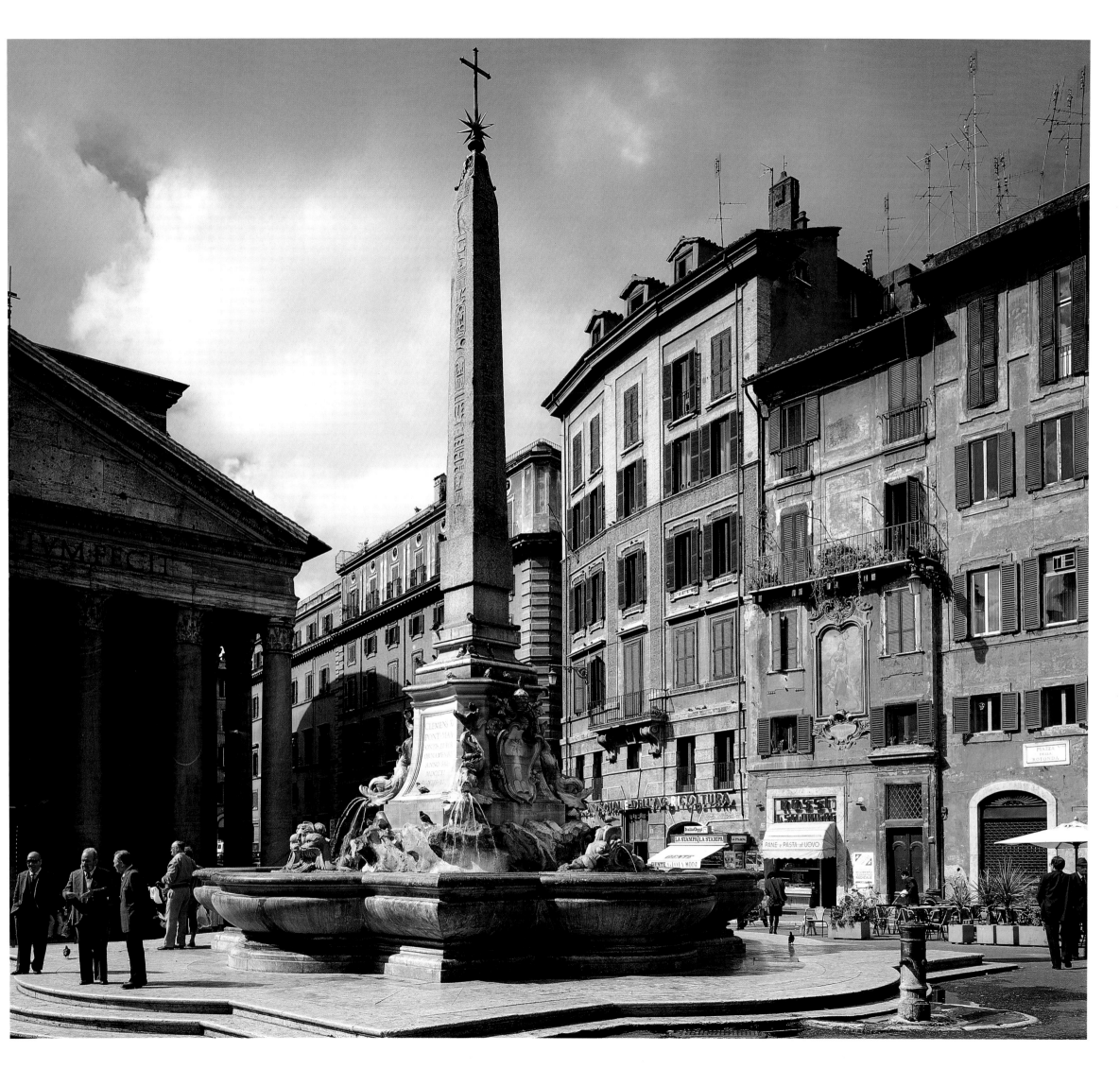

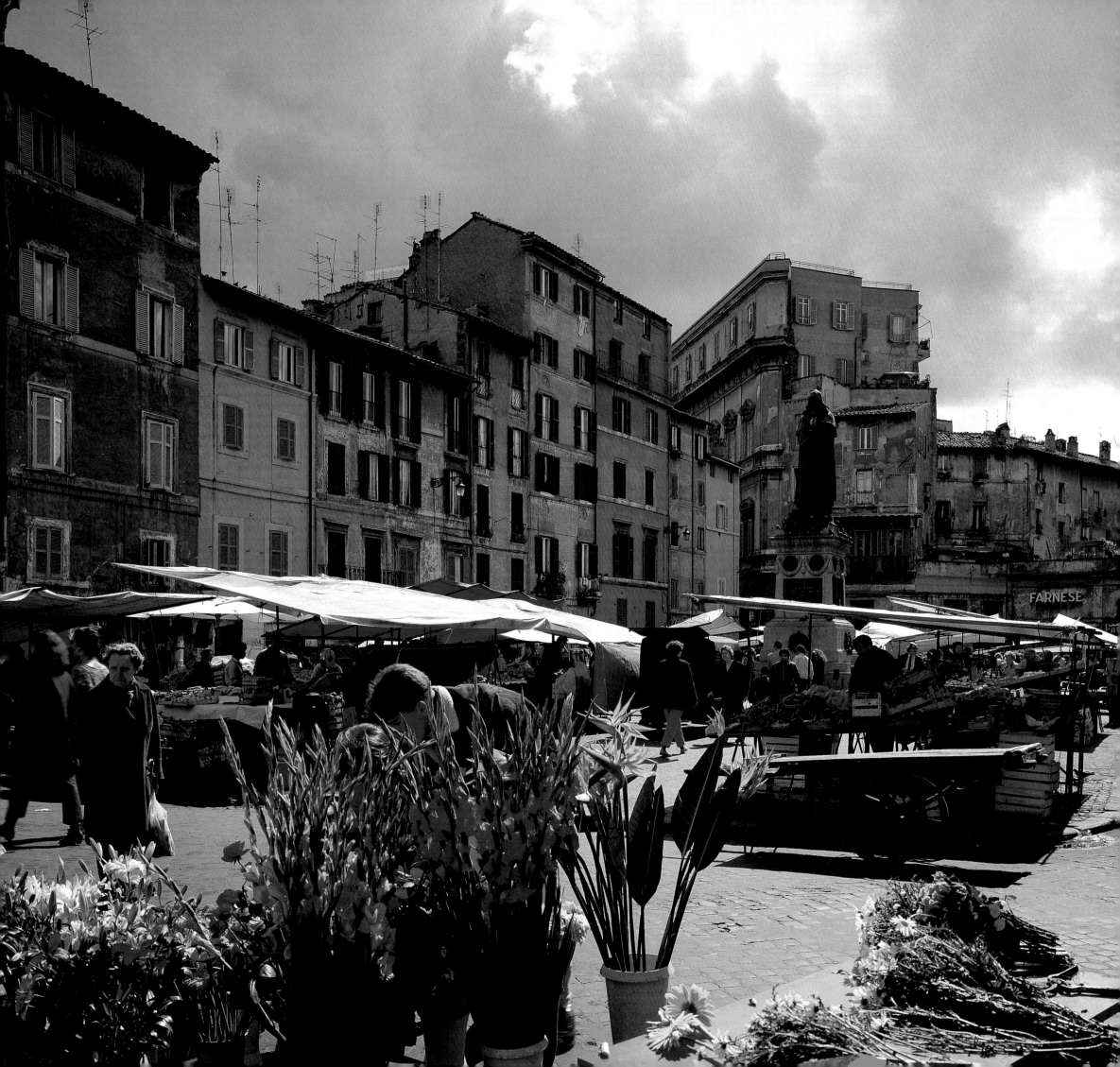

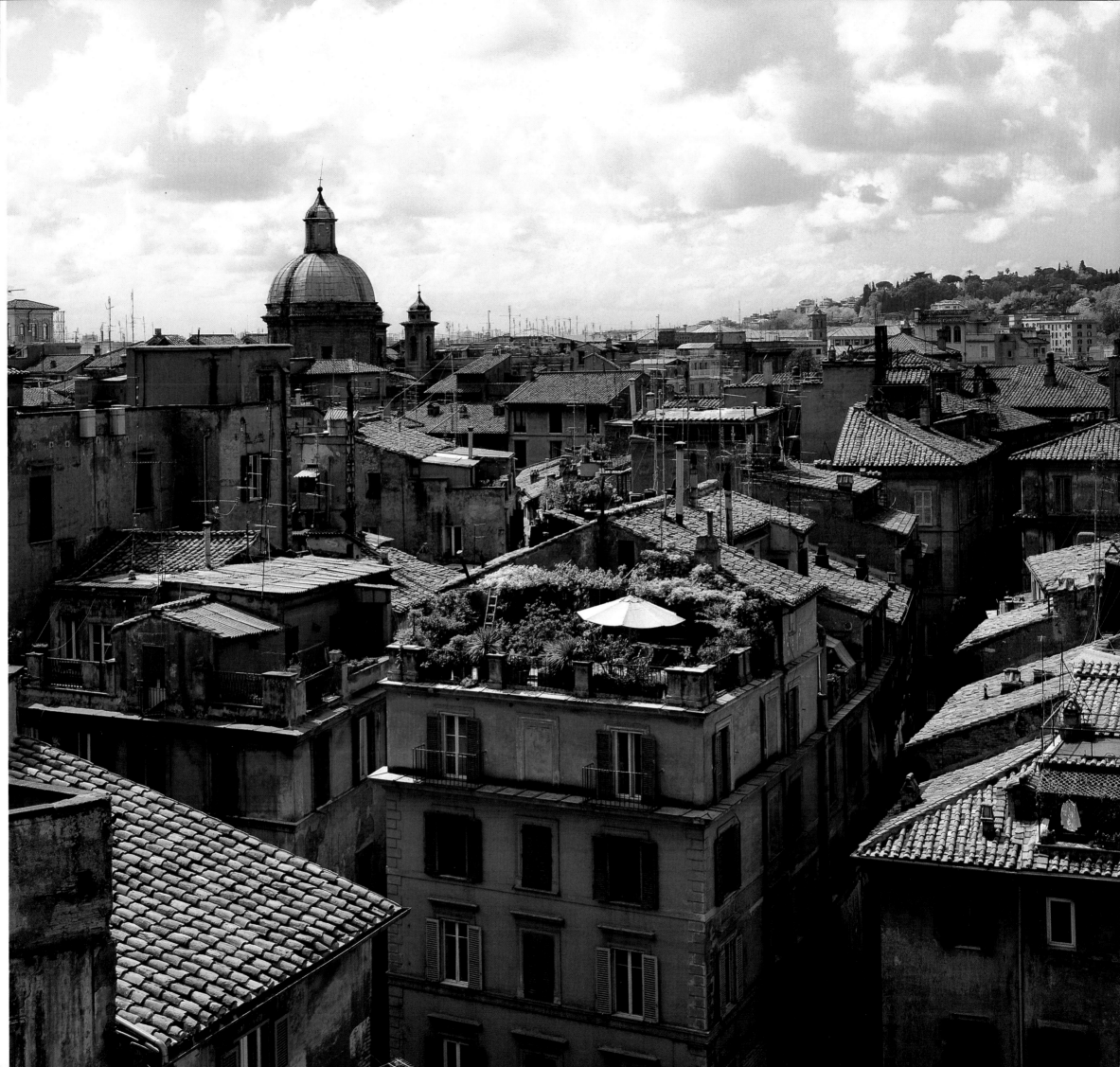

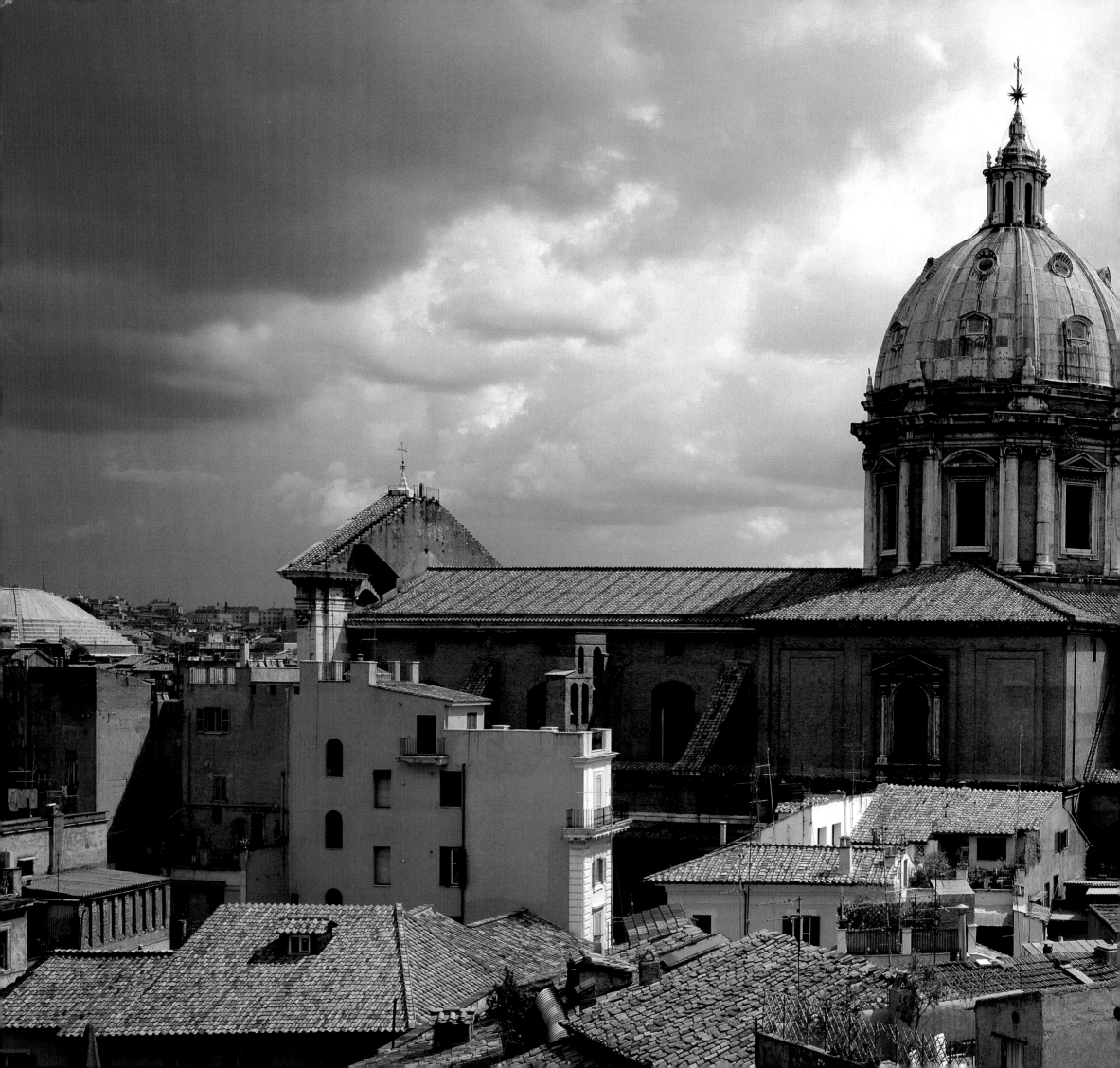

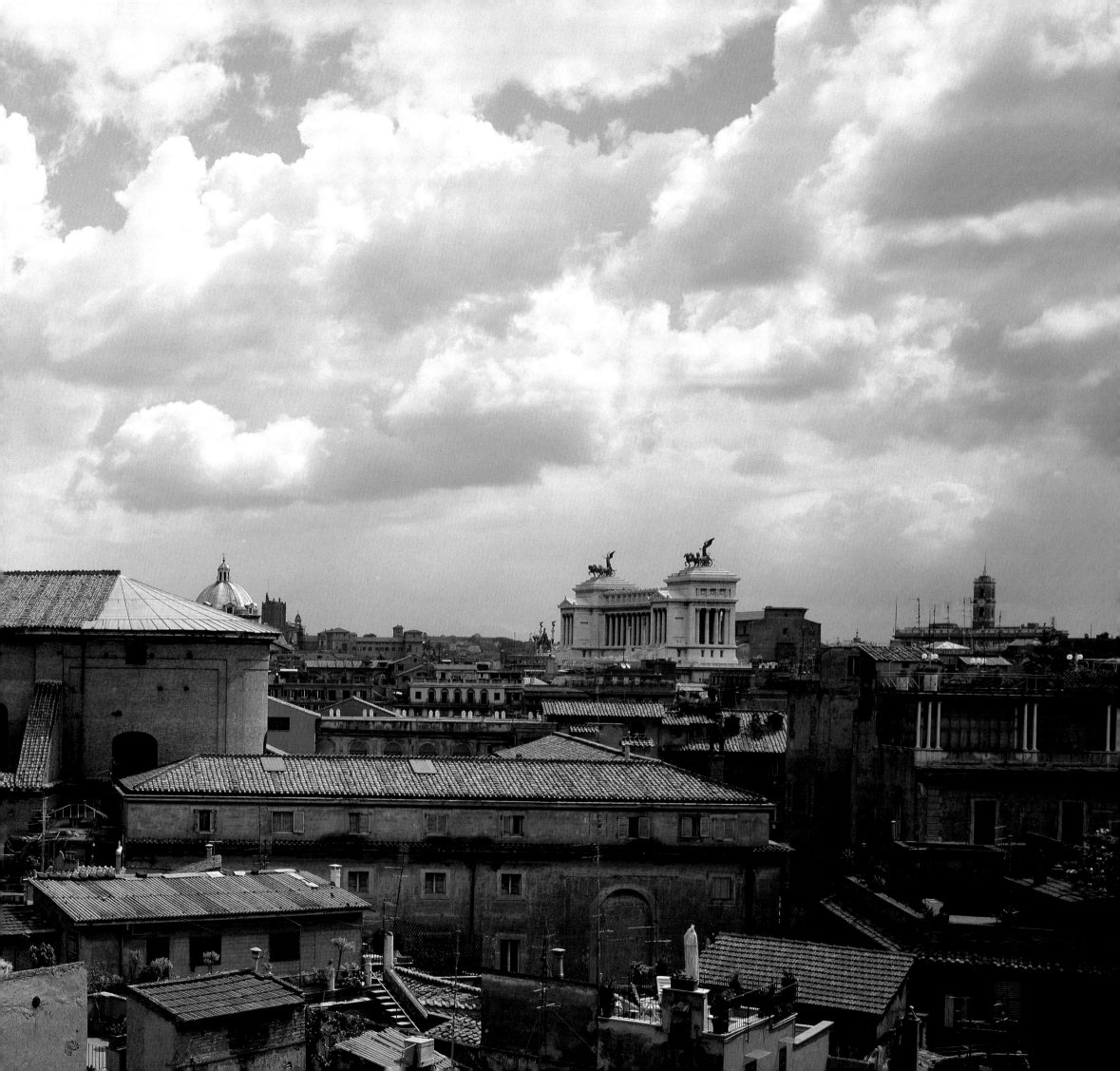

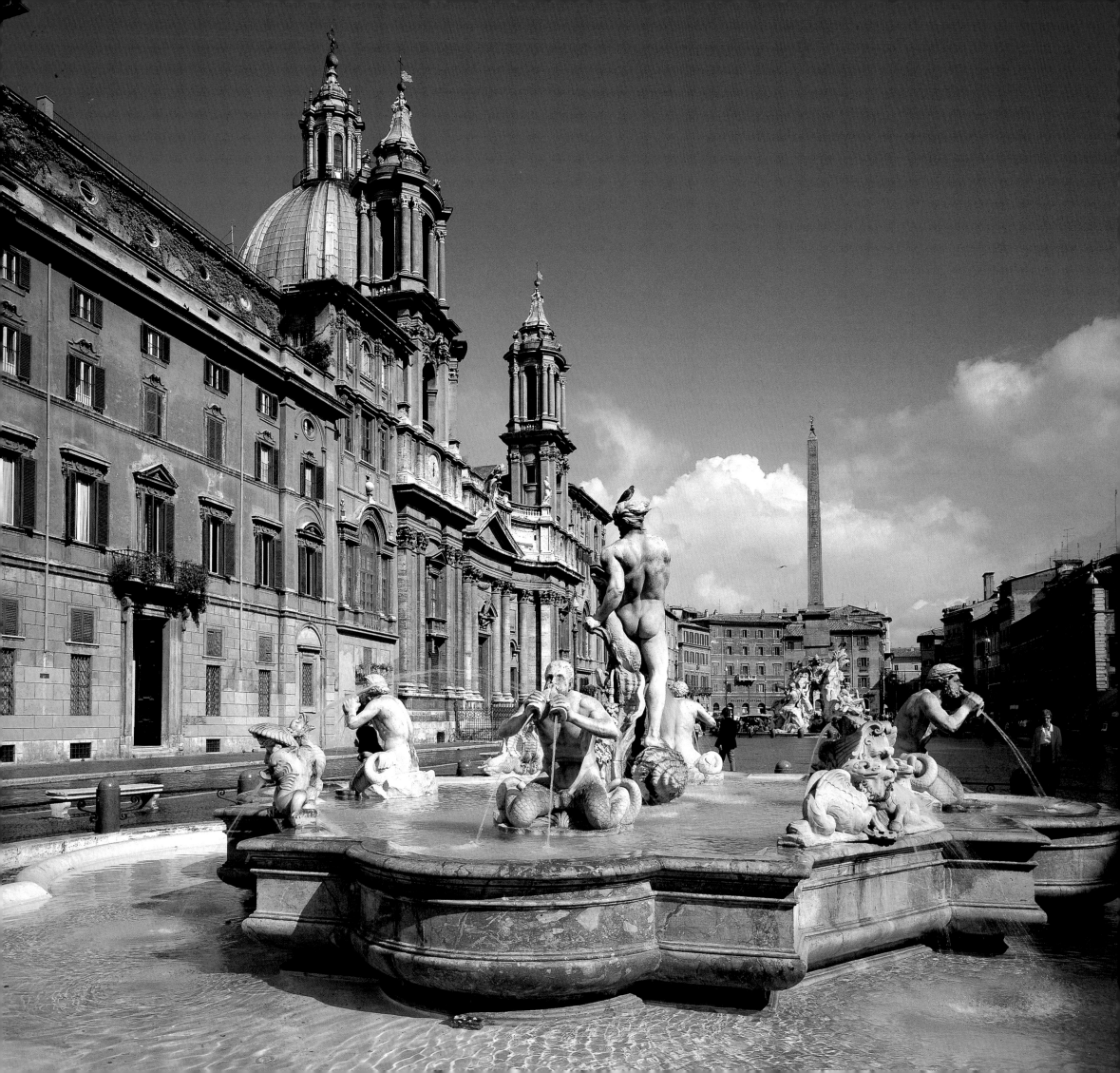

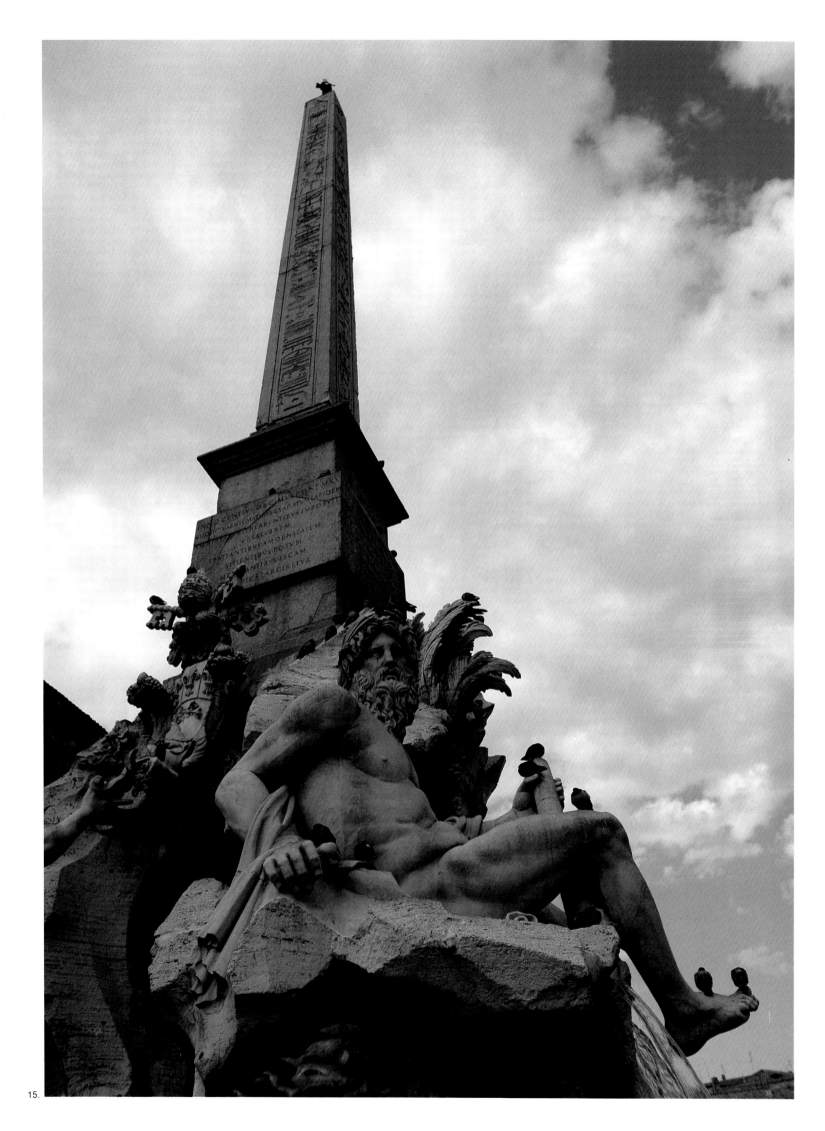

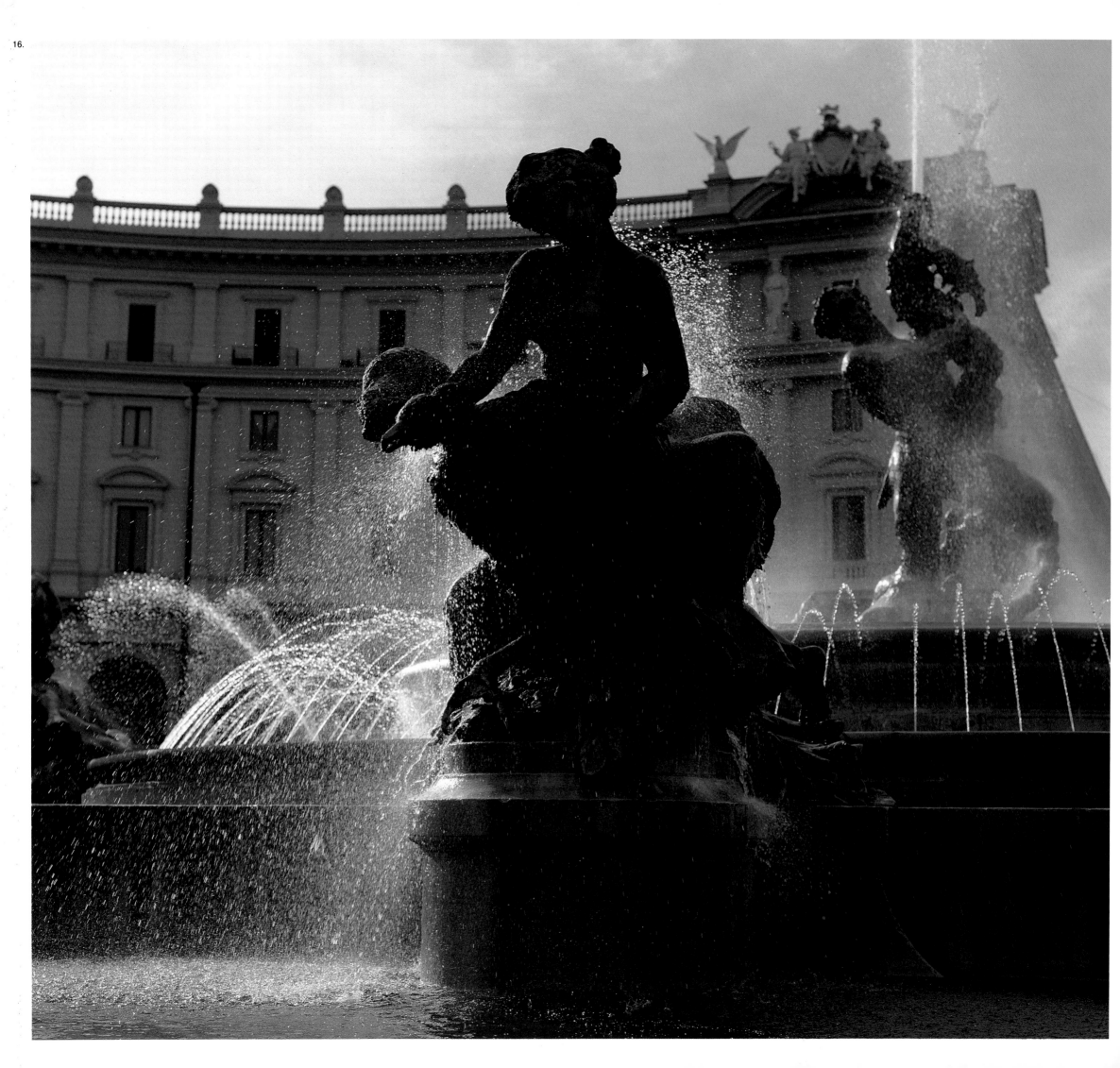

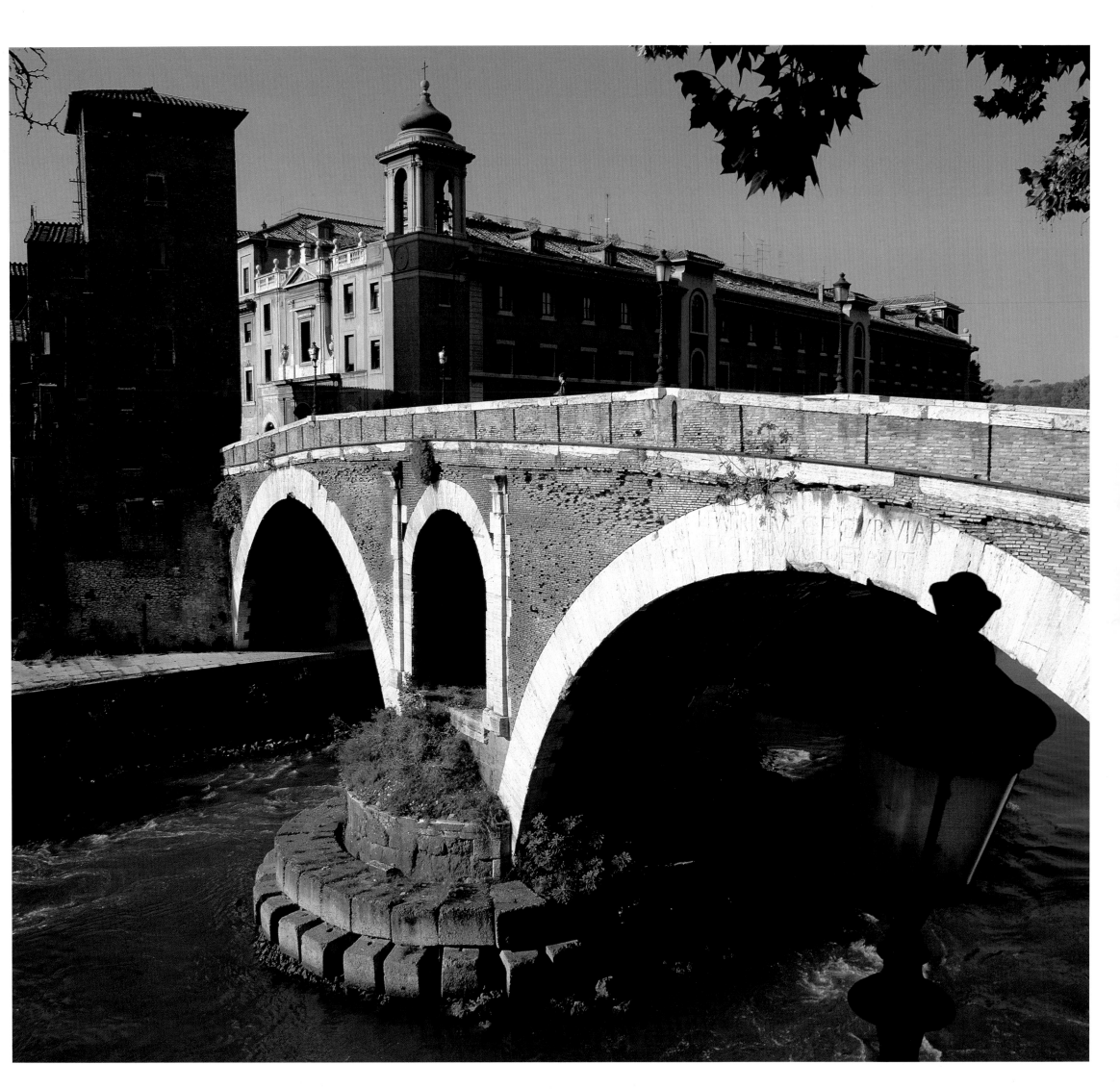

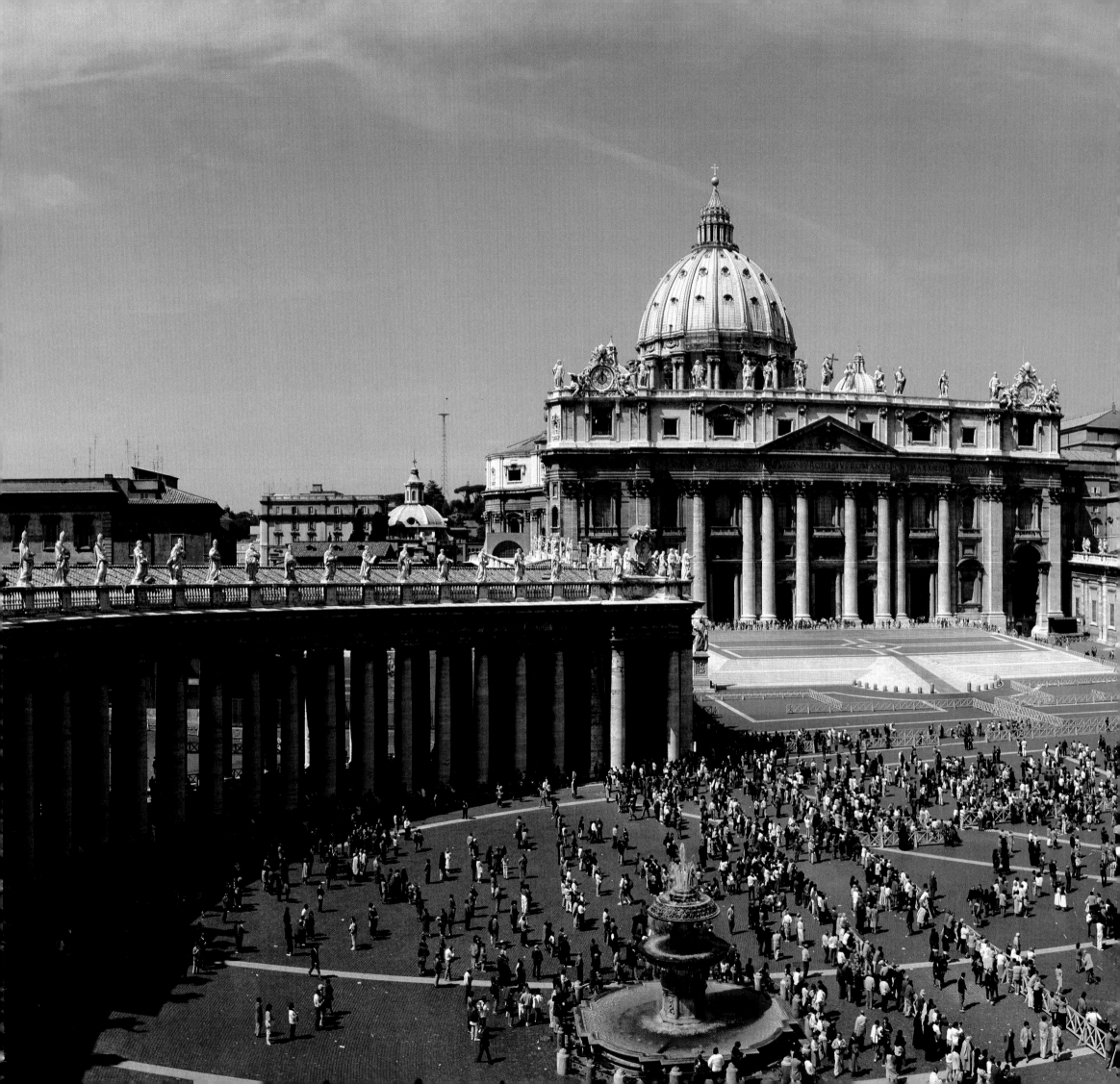

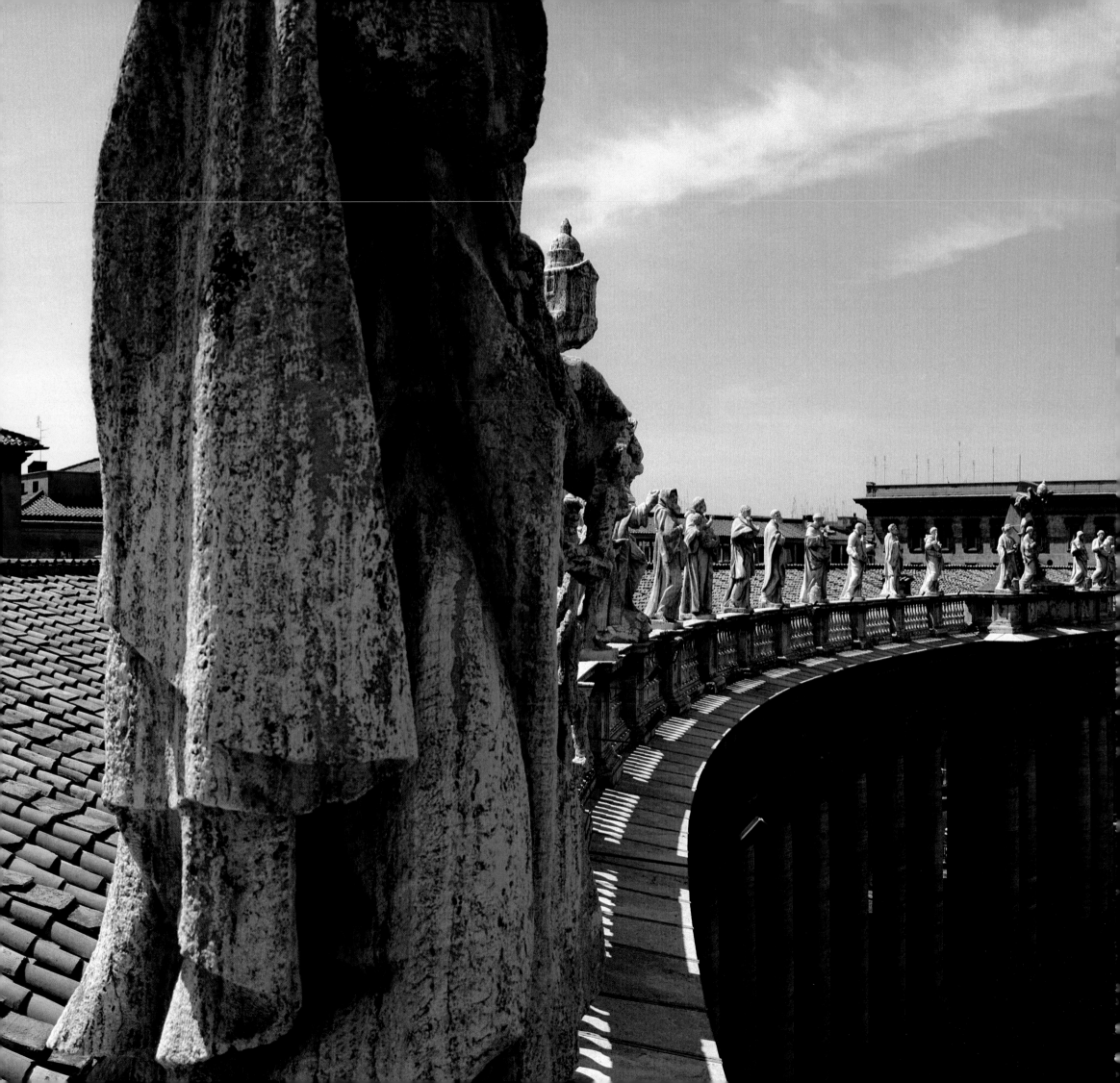

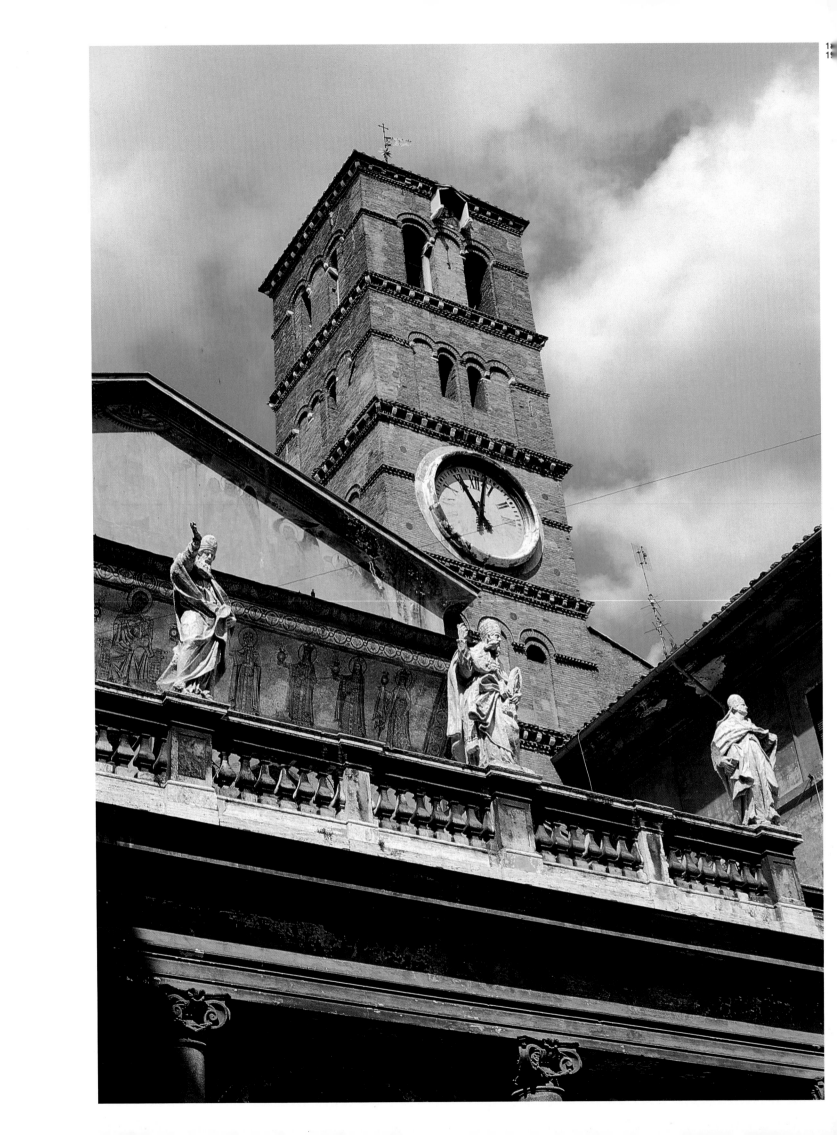

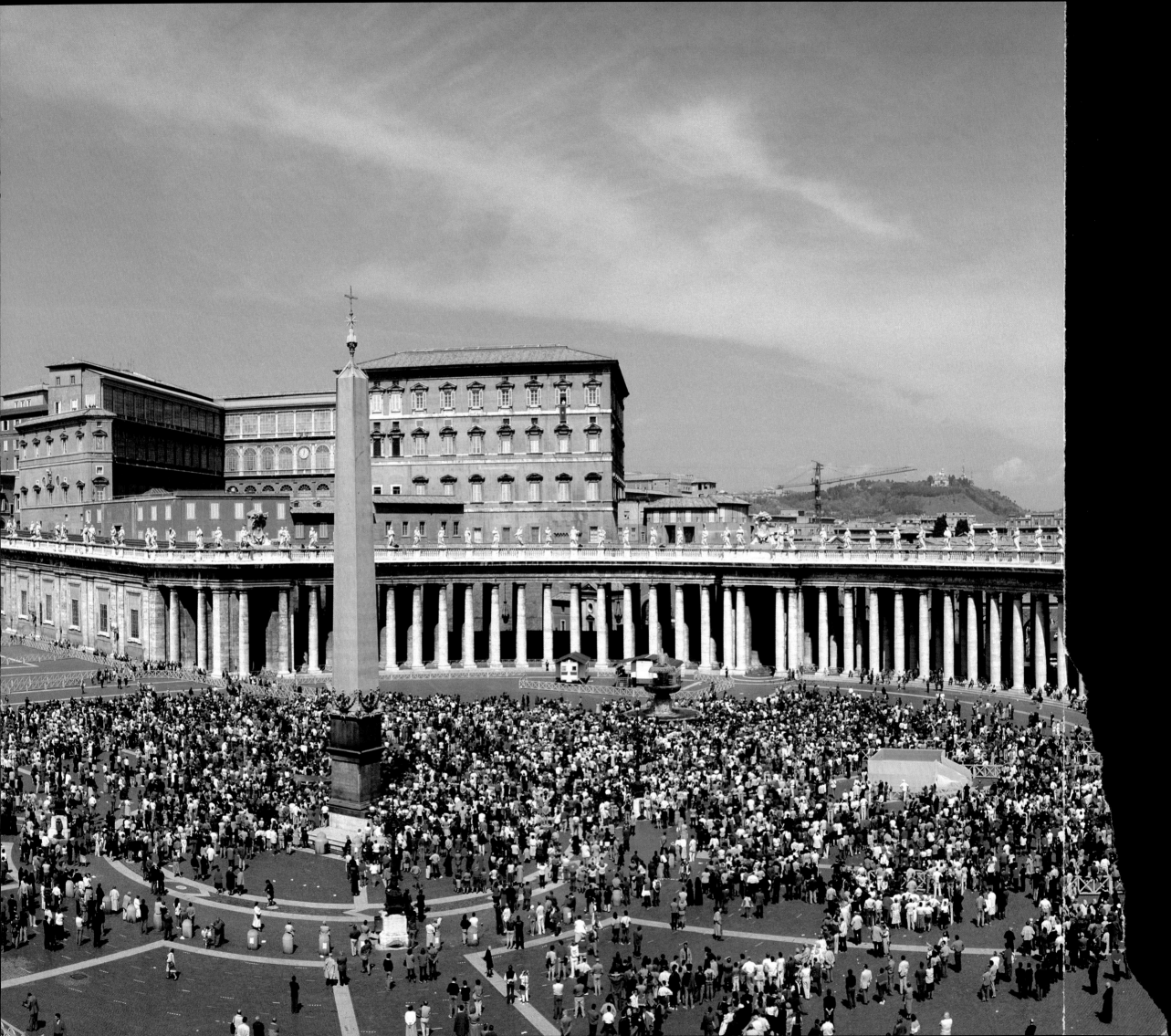

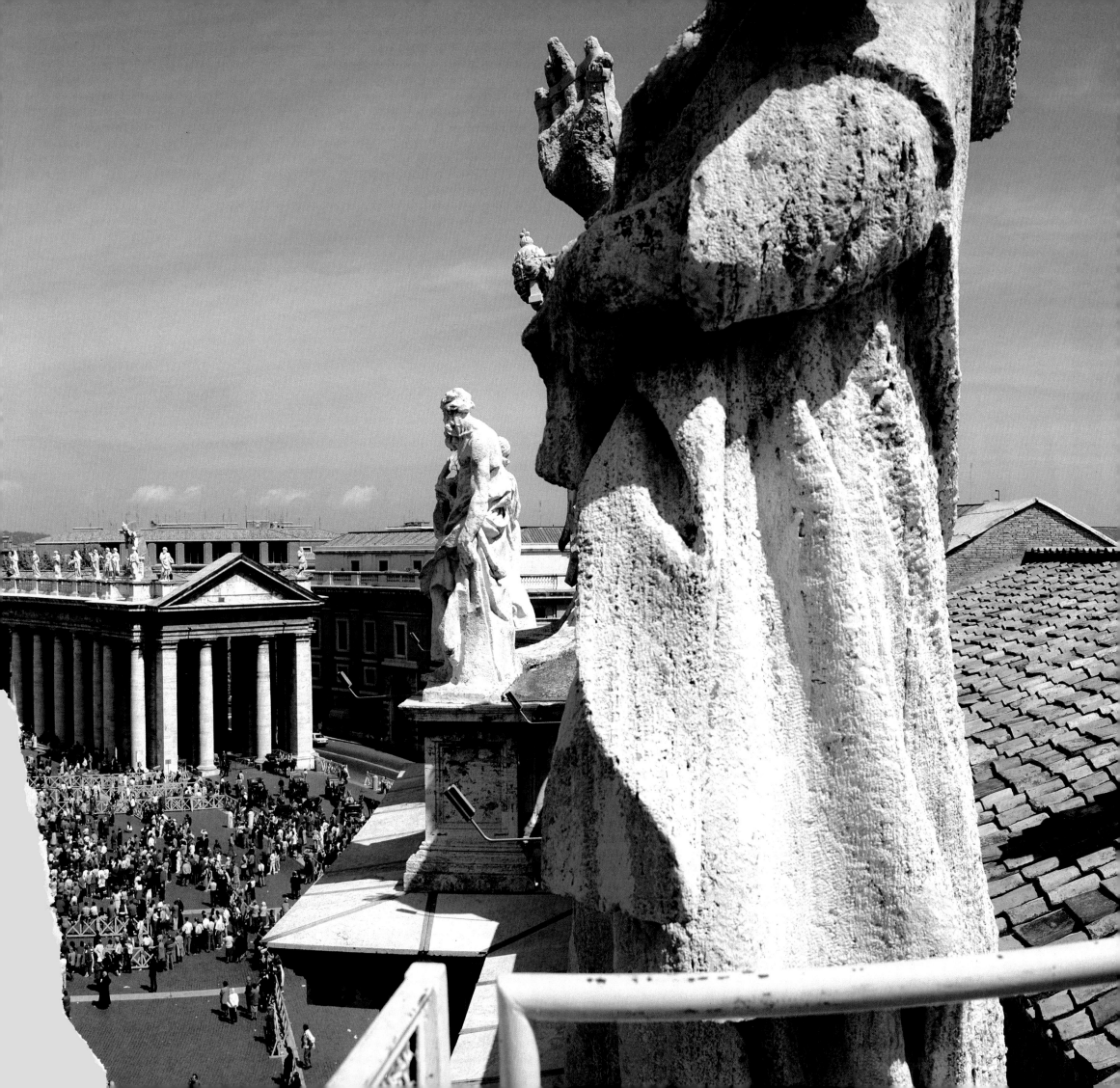

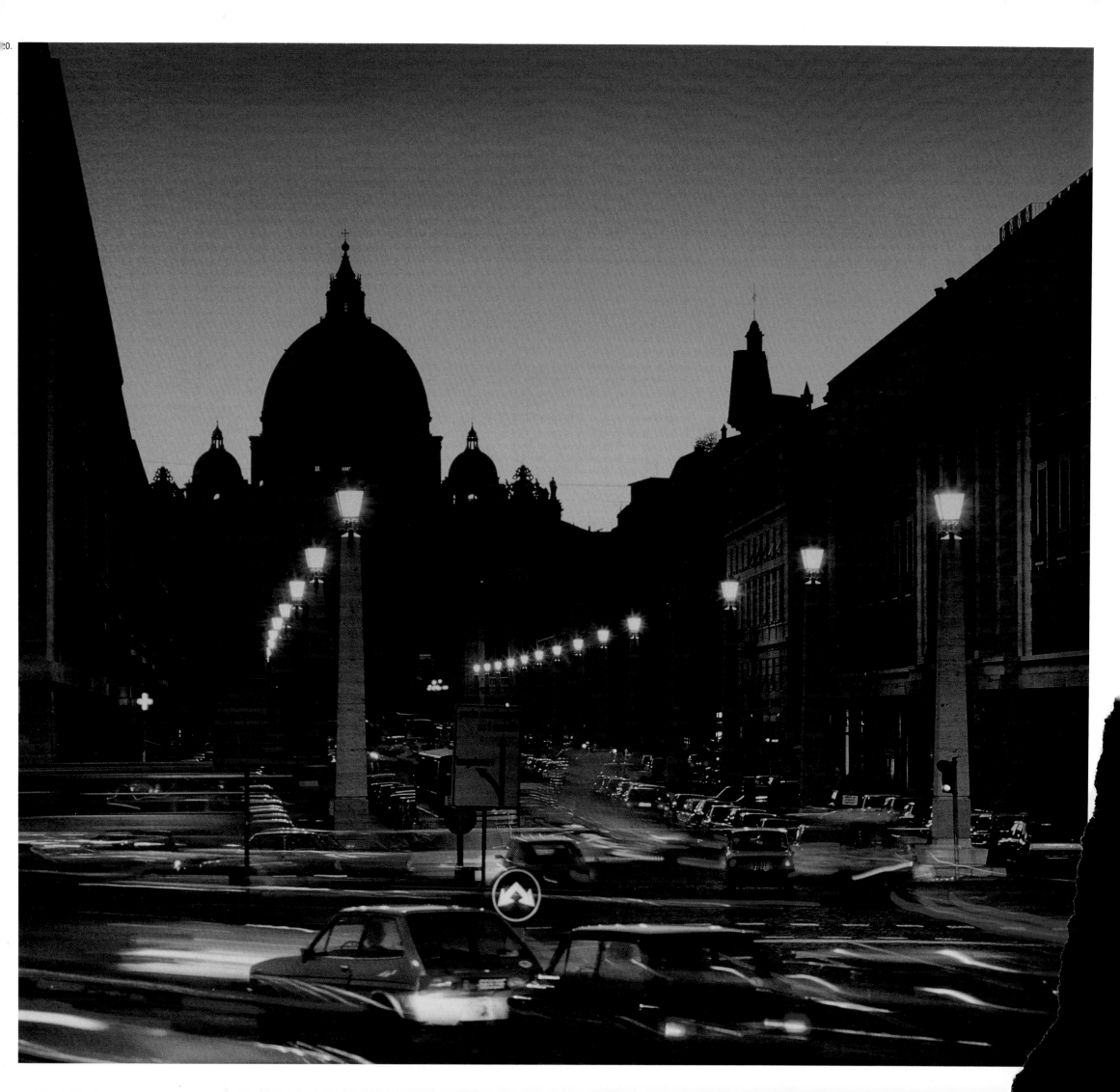

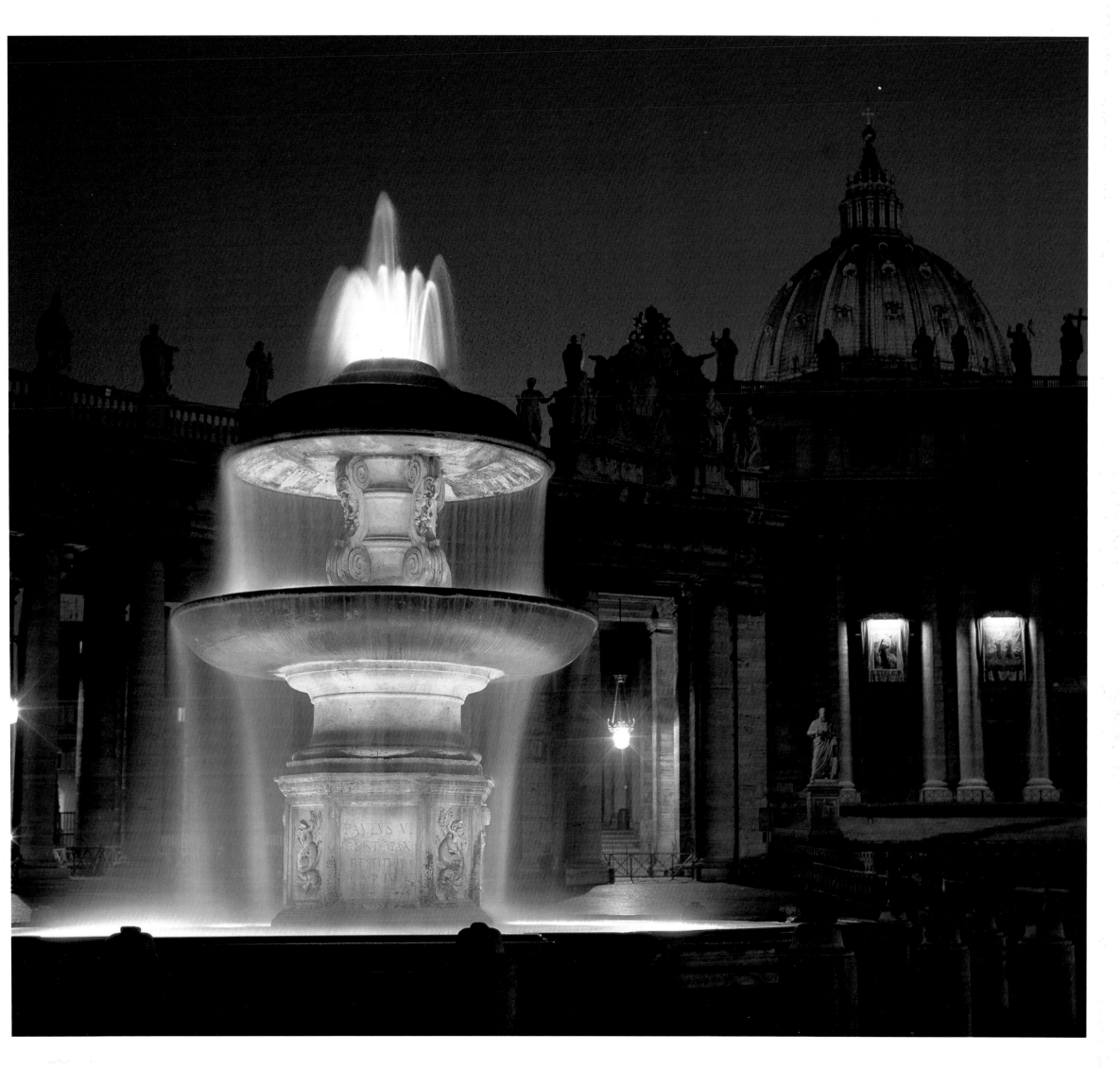

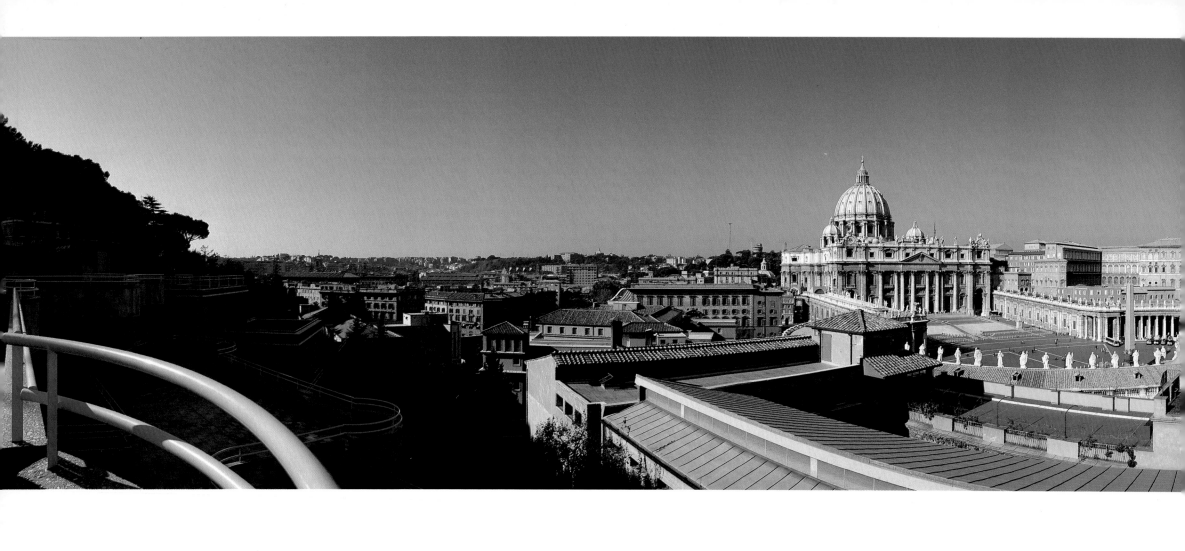

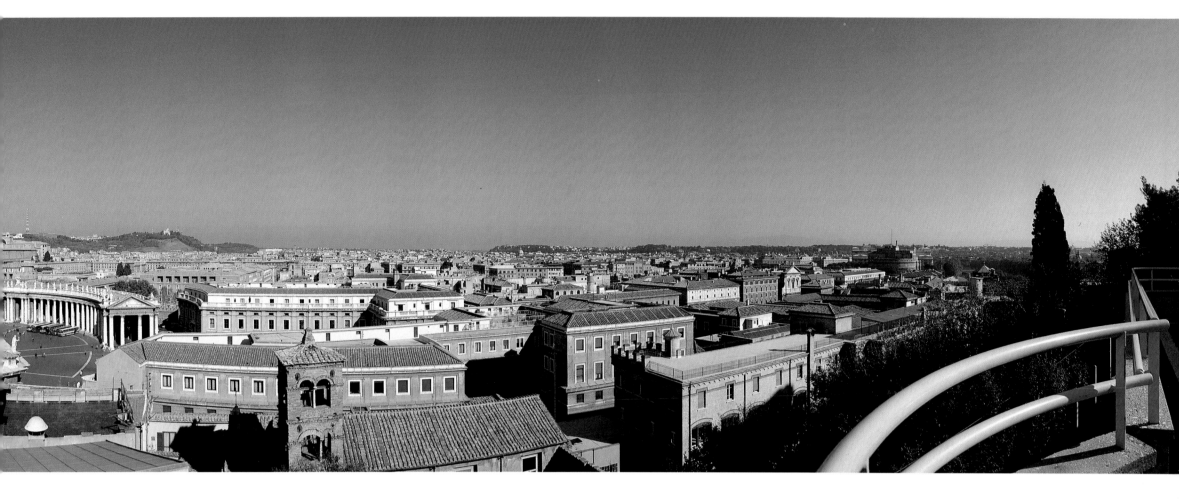

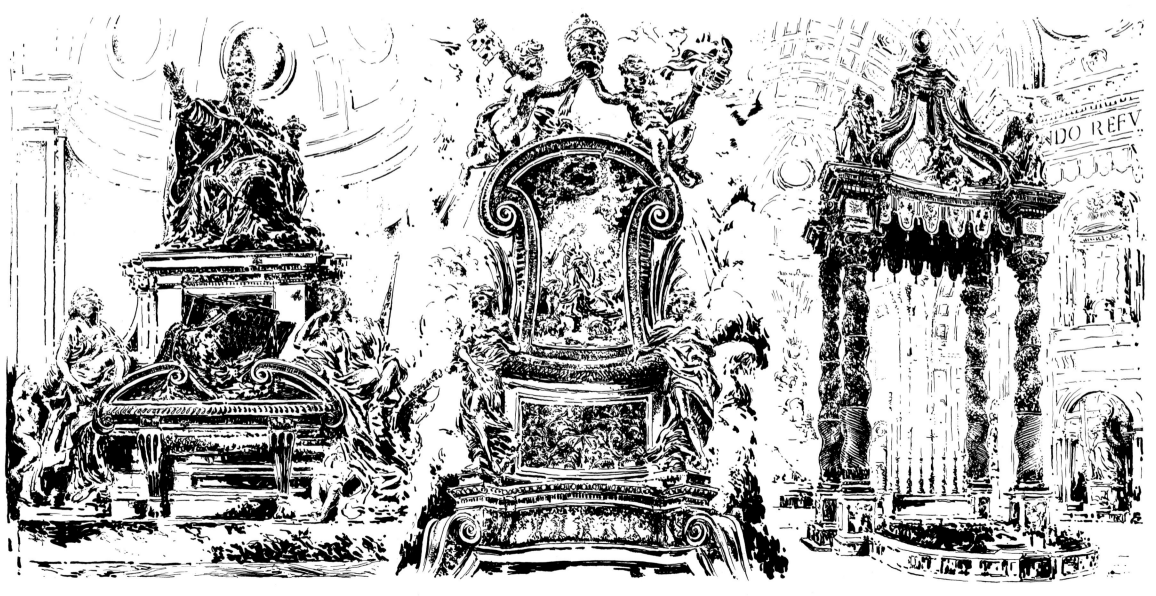

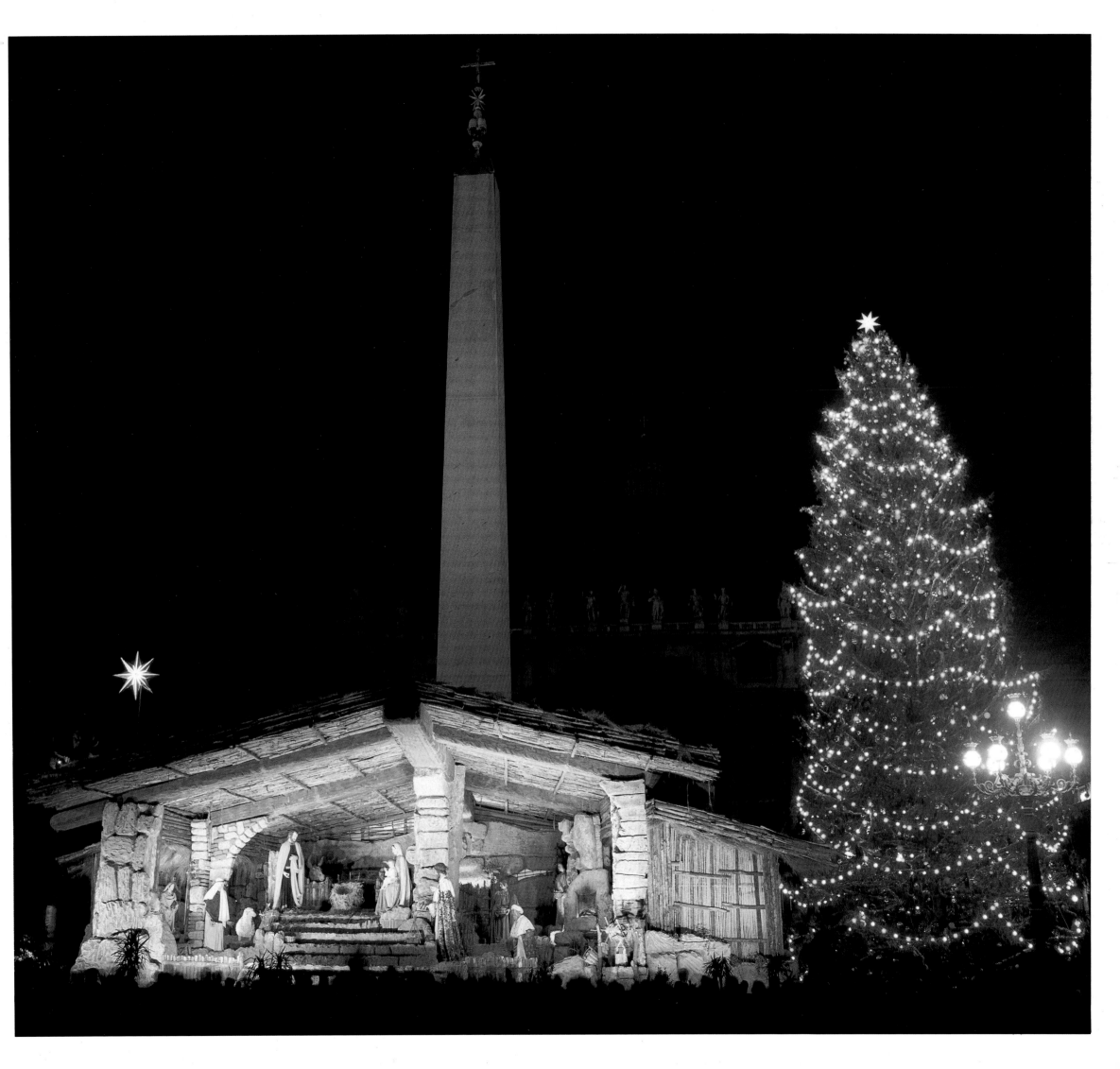

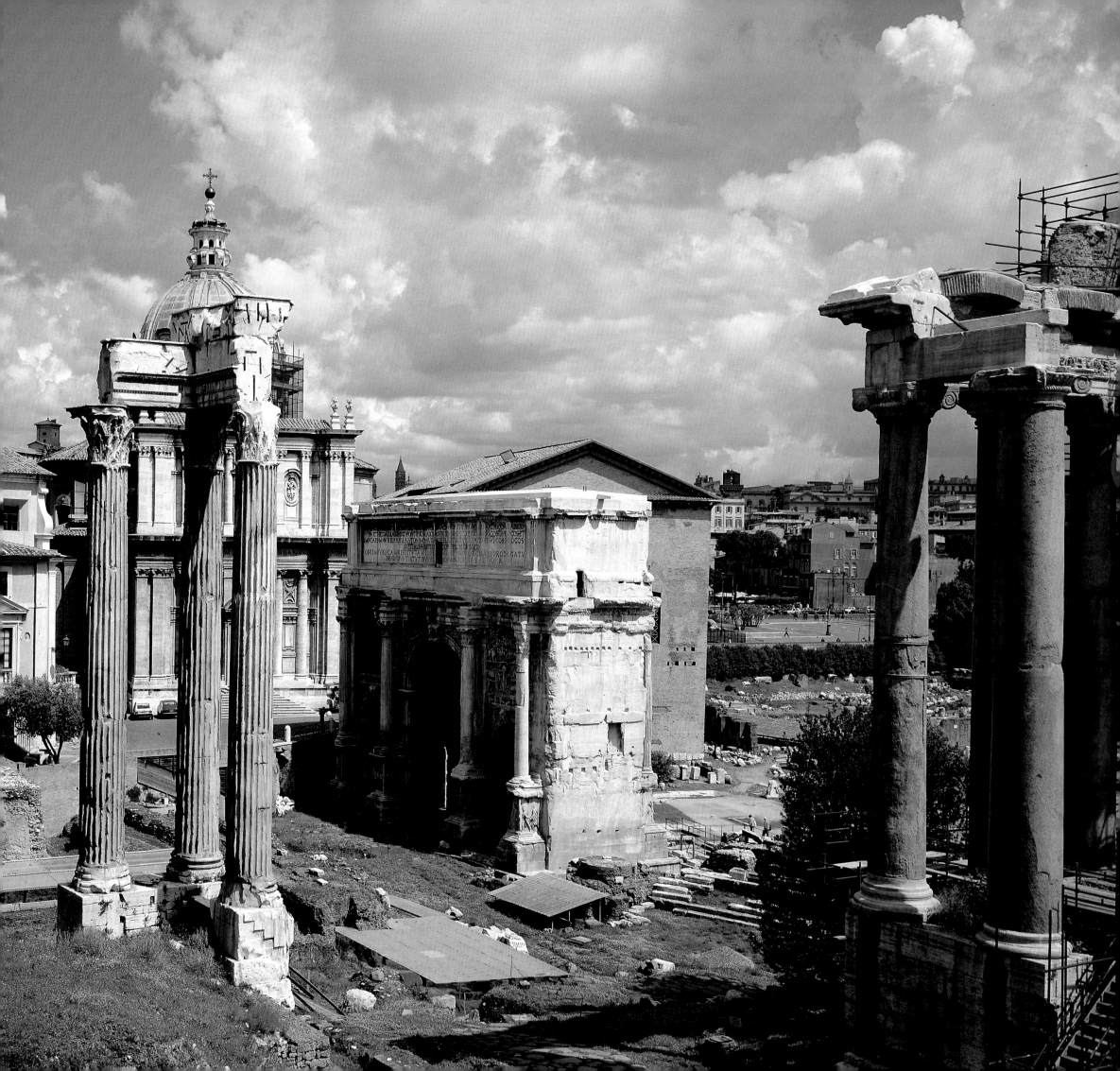

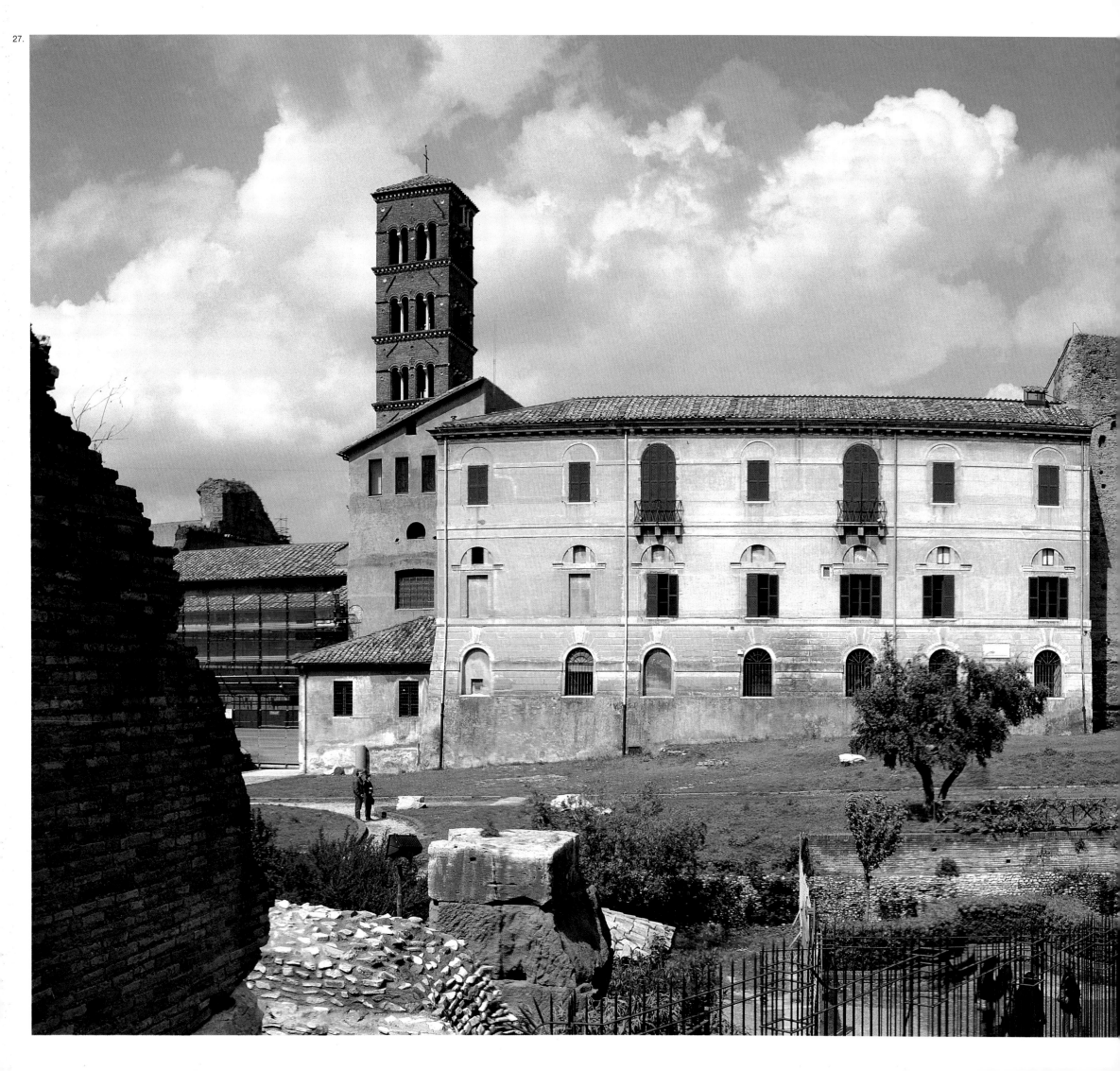

ARCO DI COSTANTINO

COLOSSEO

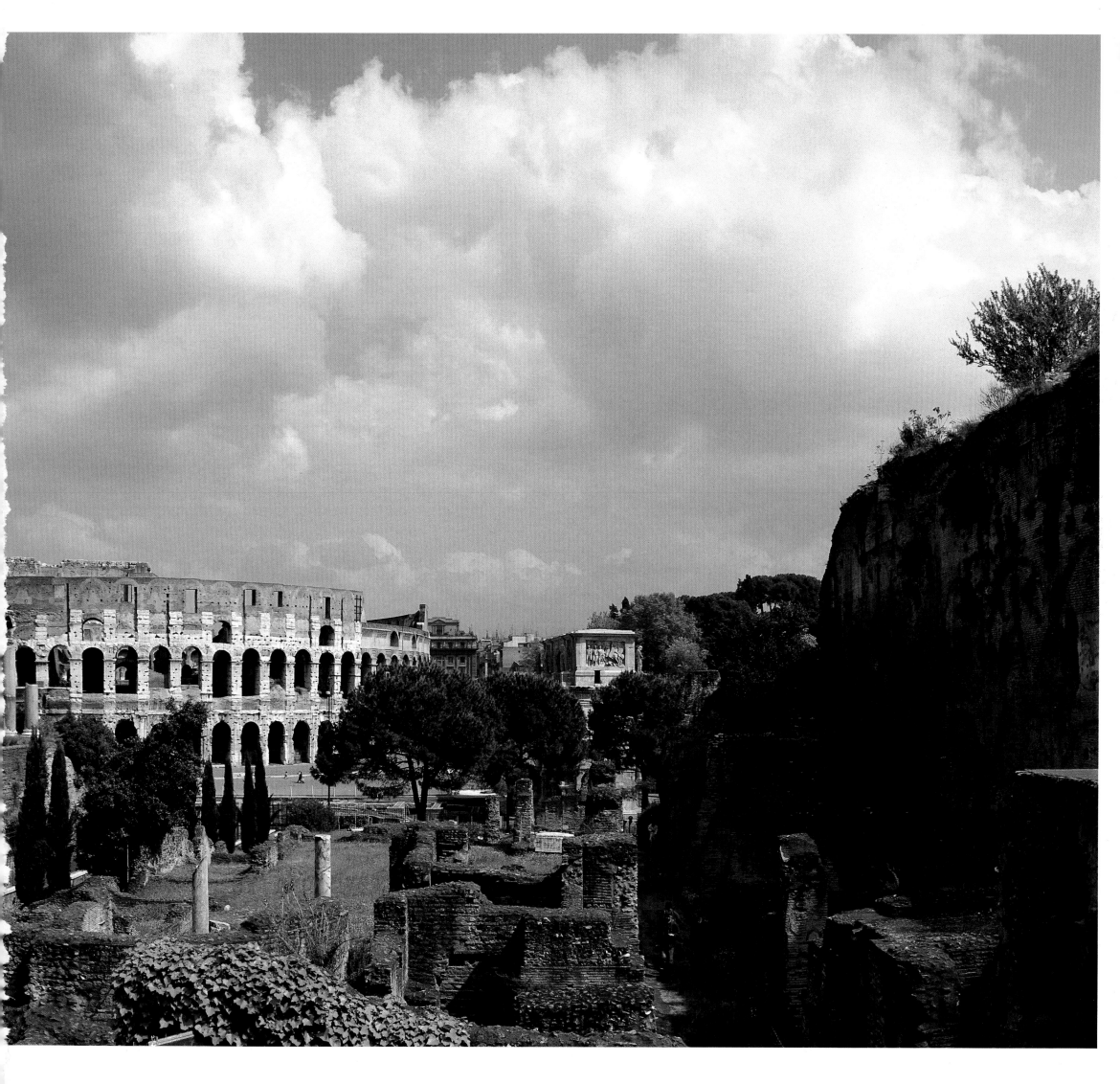

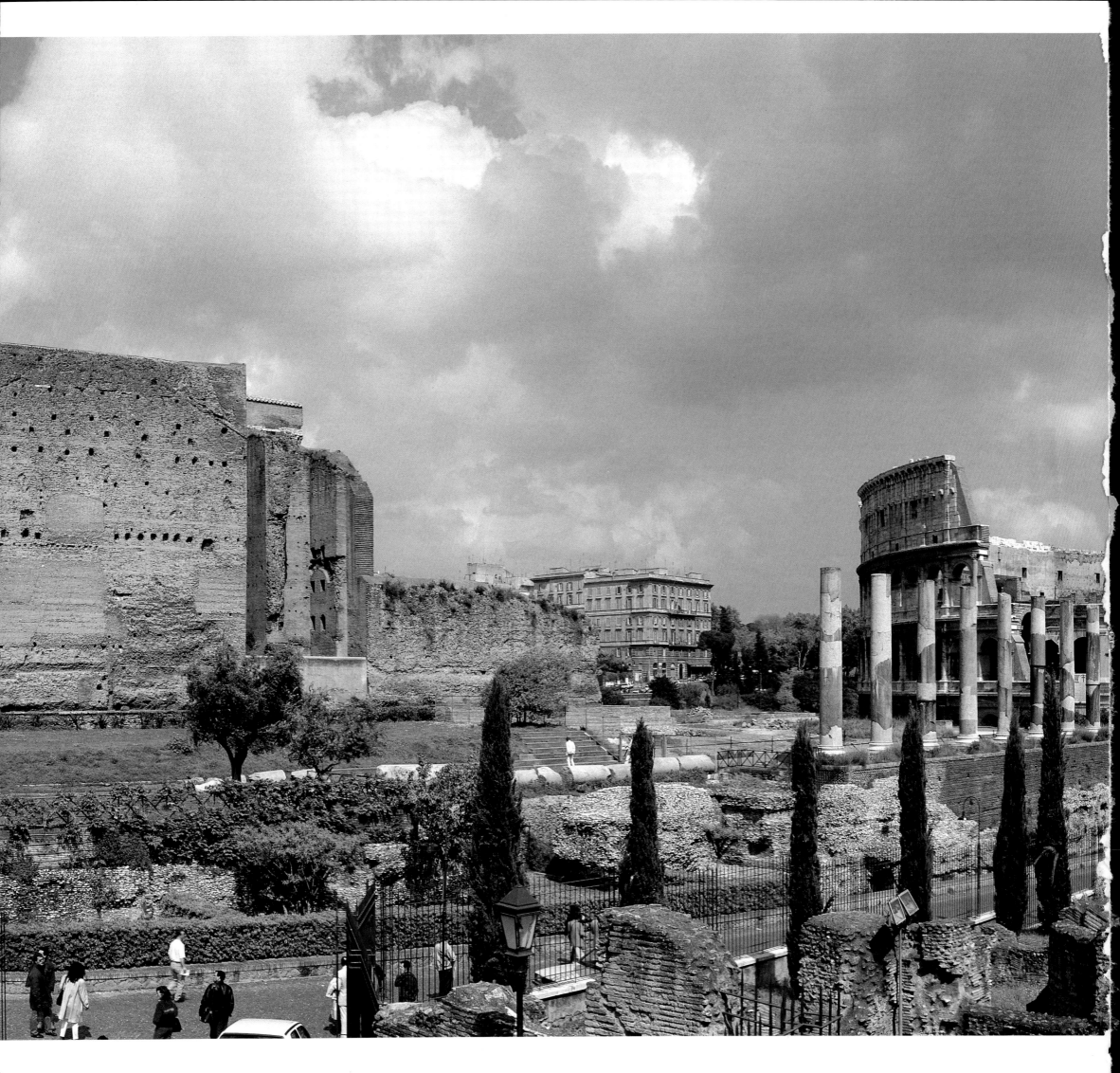

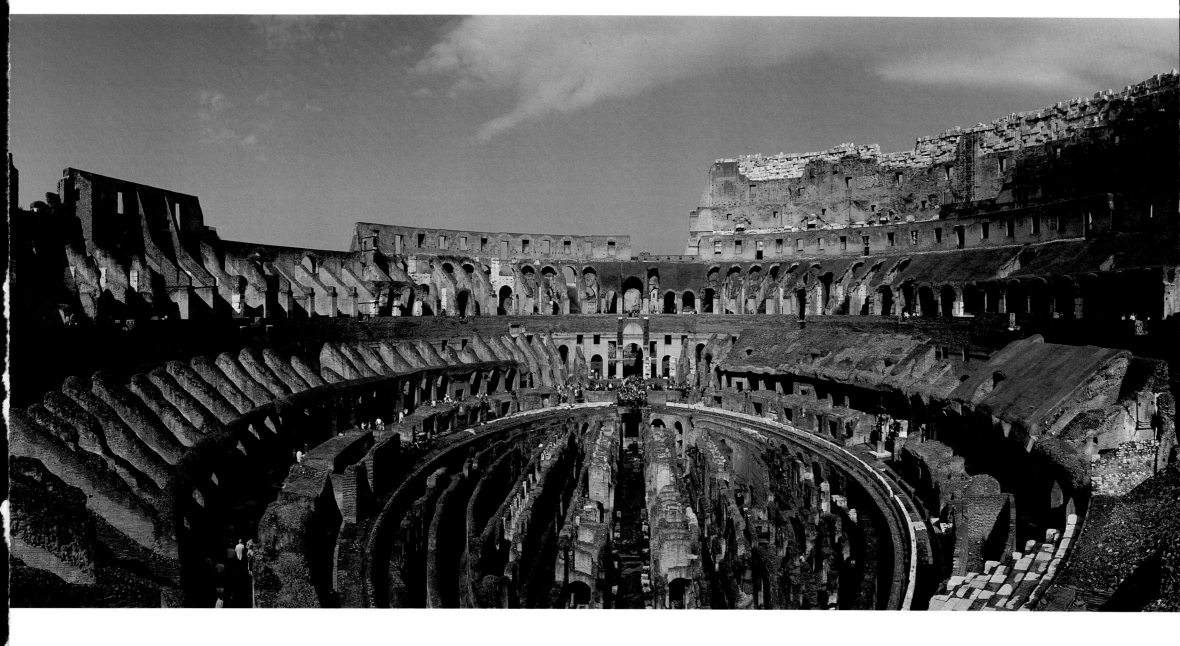

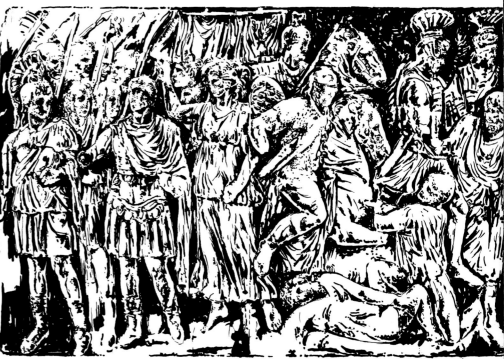

 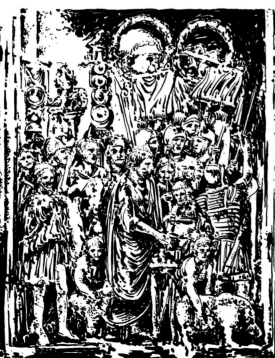

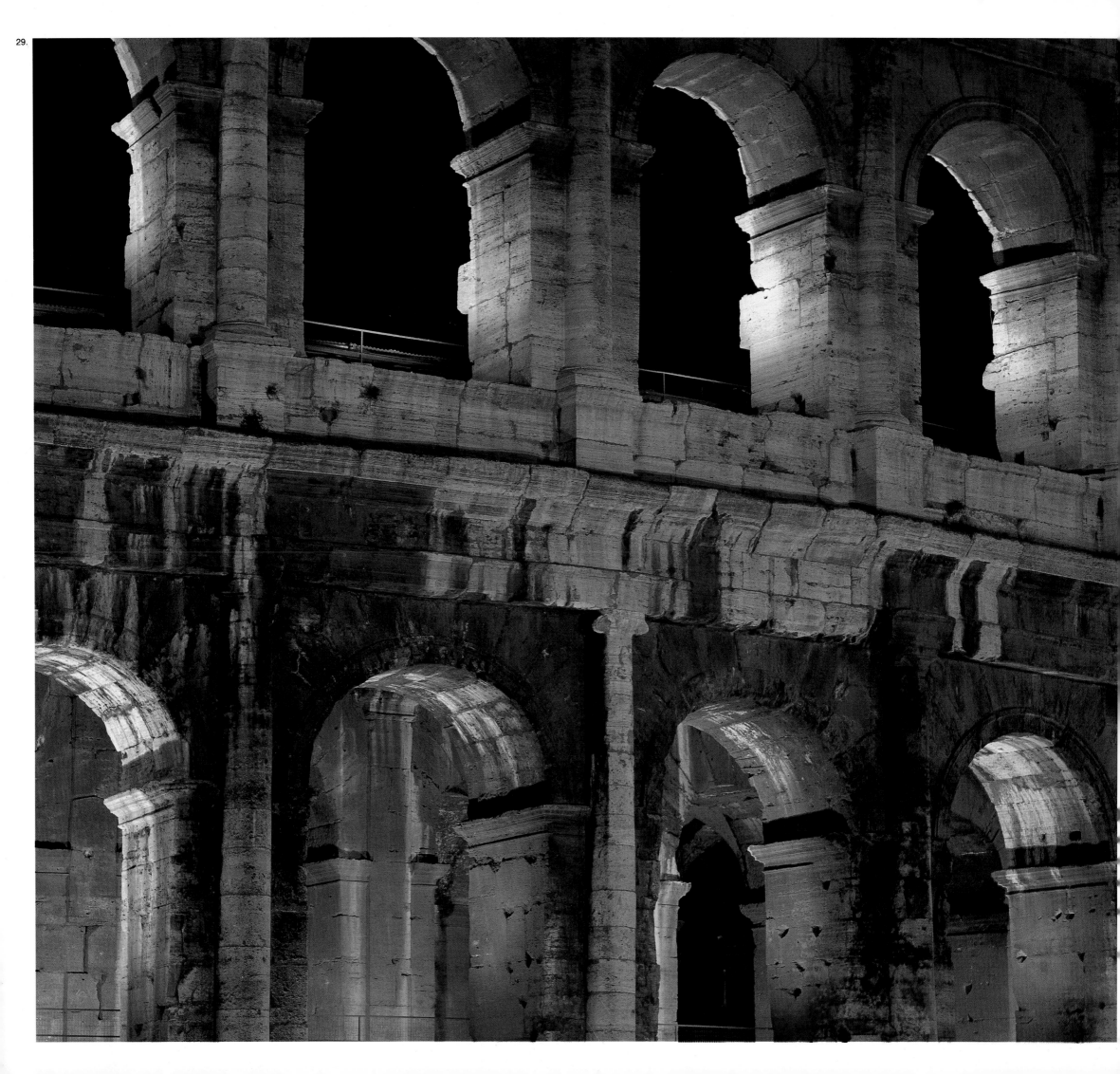

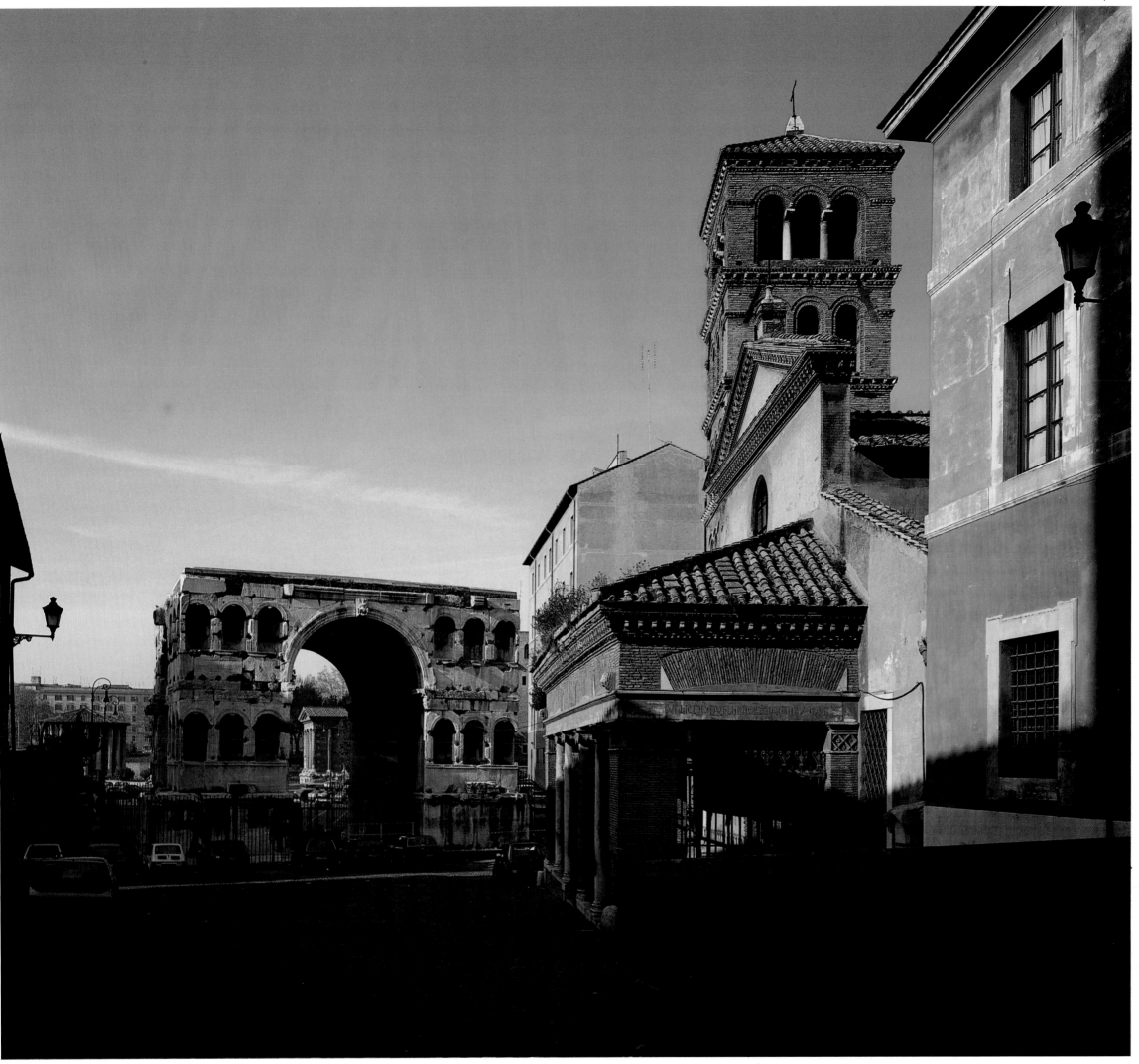

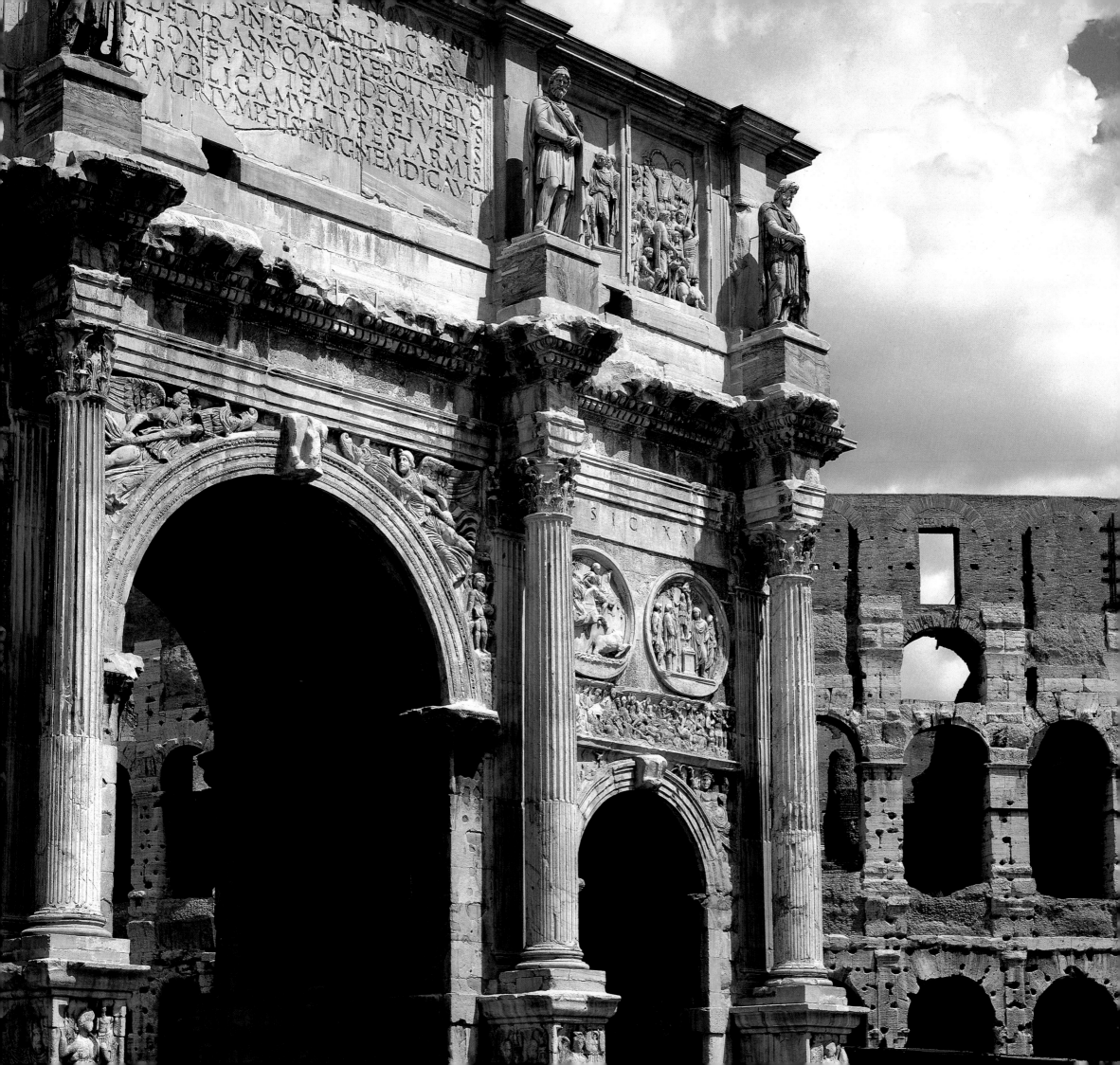

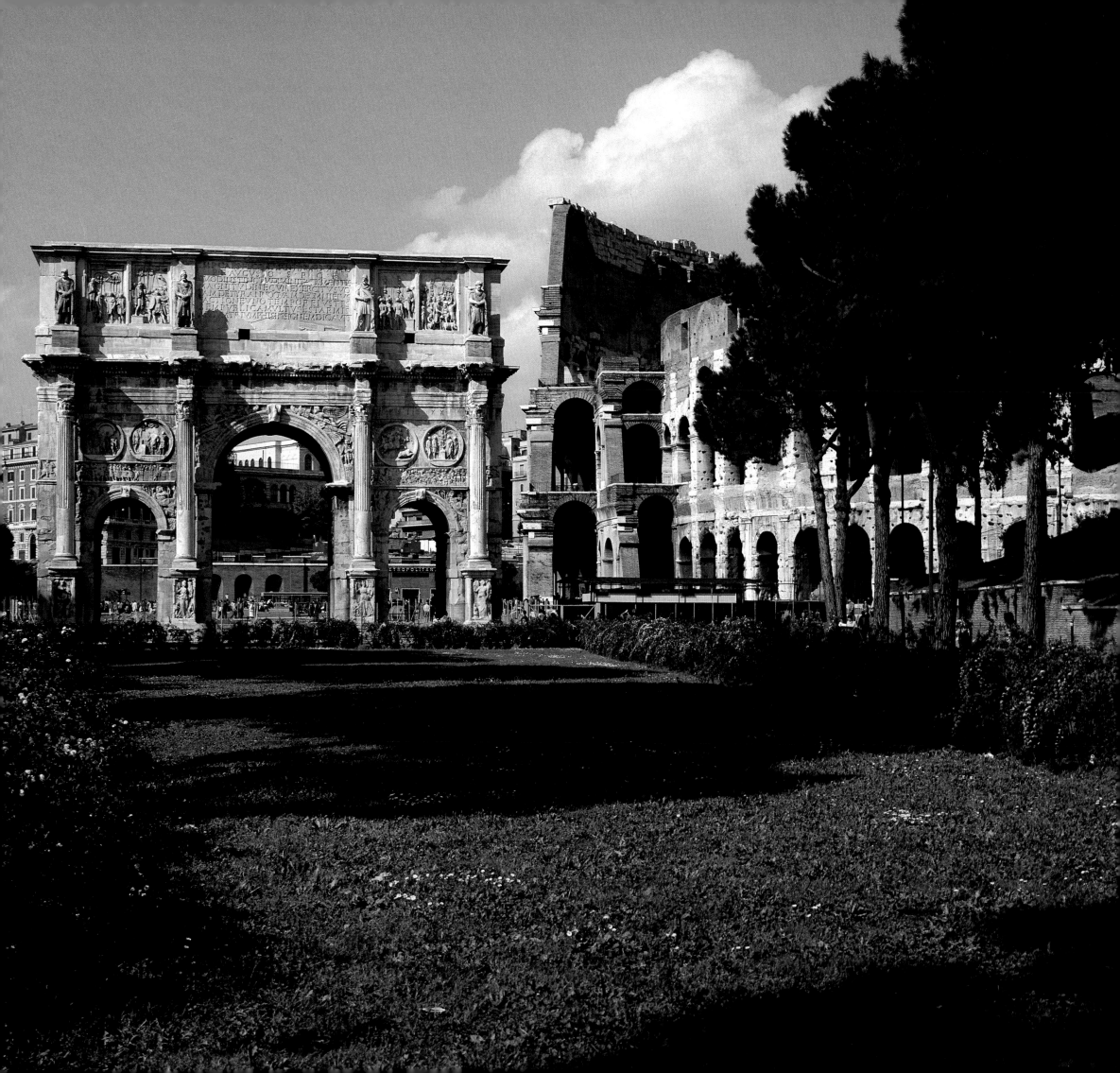

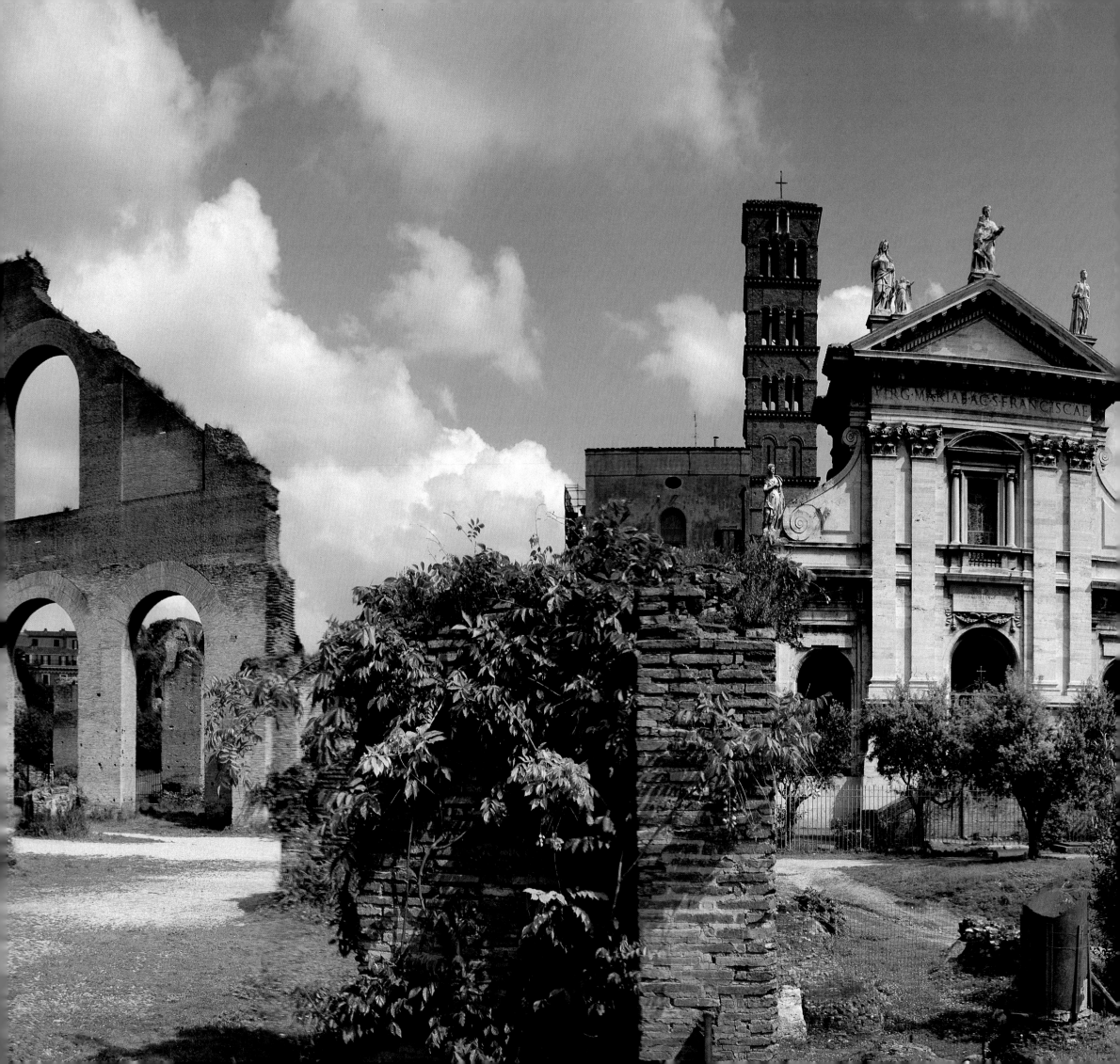

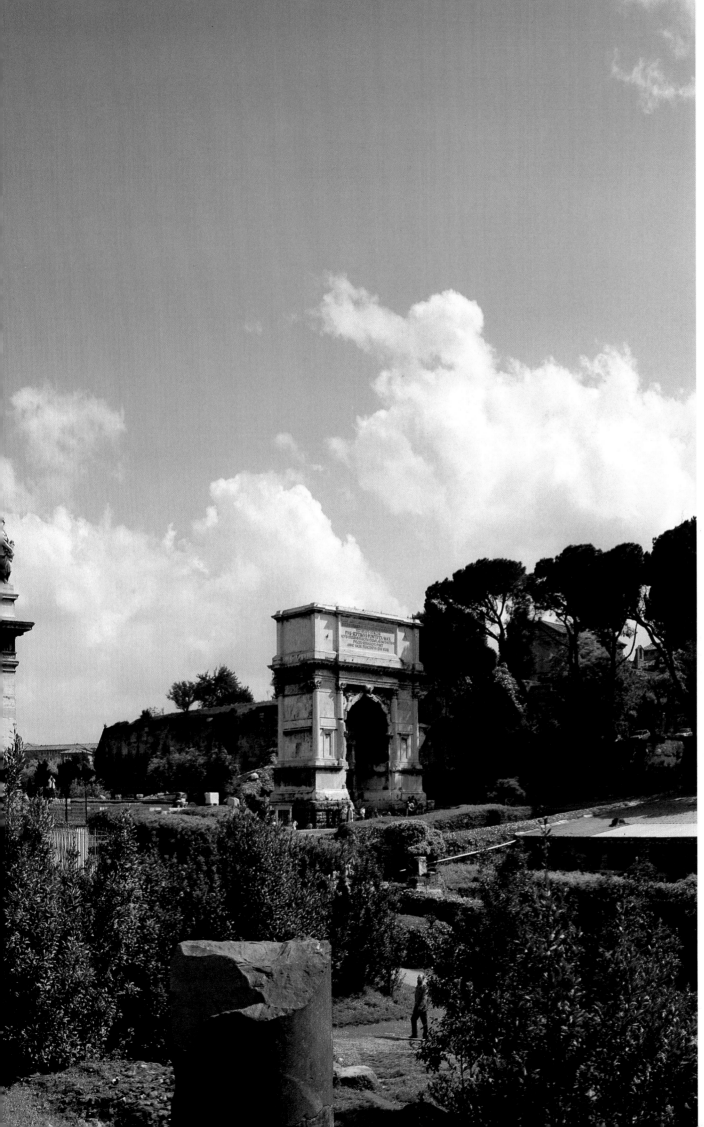

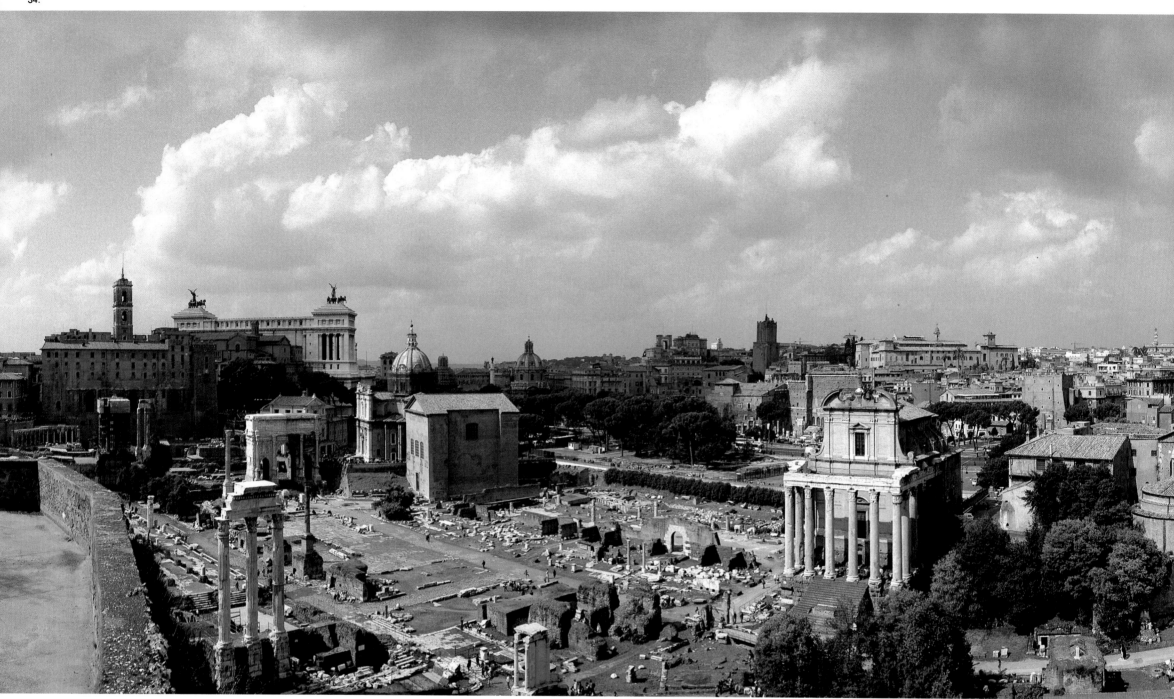

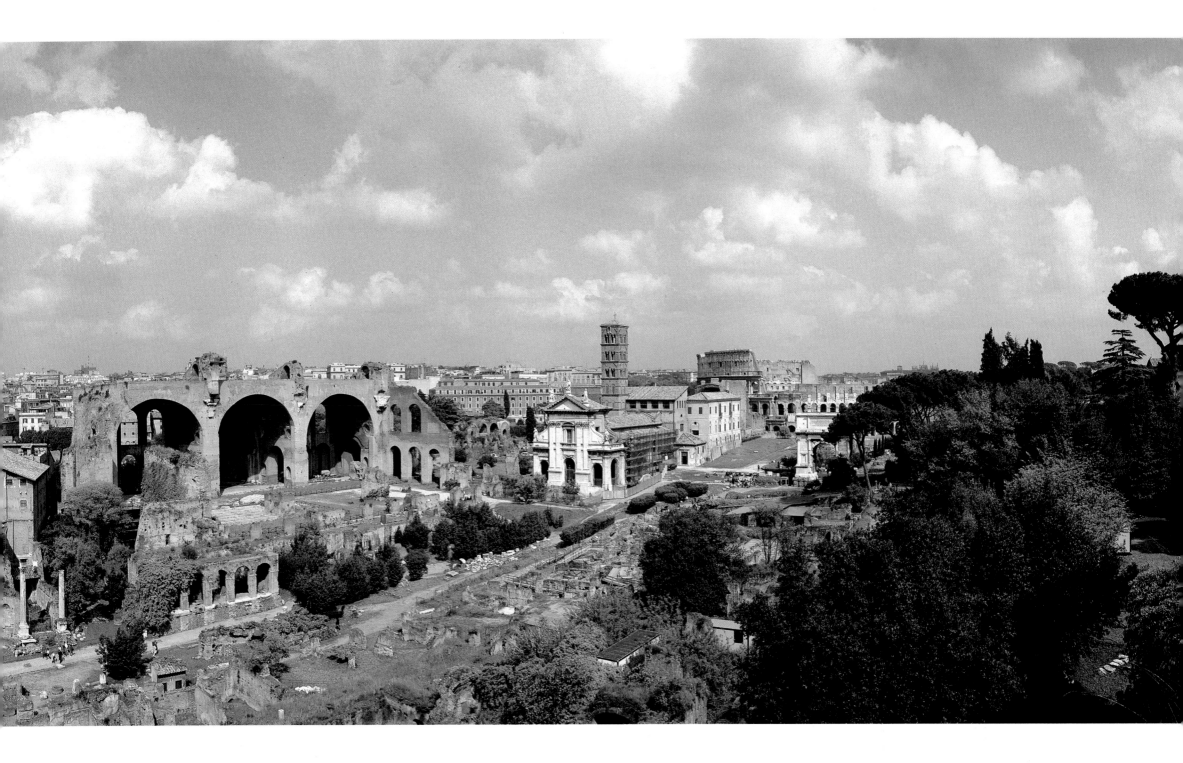

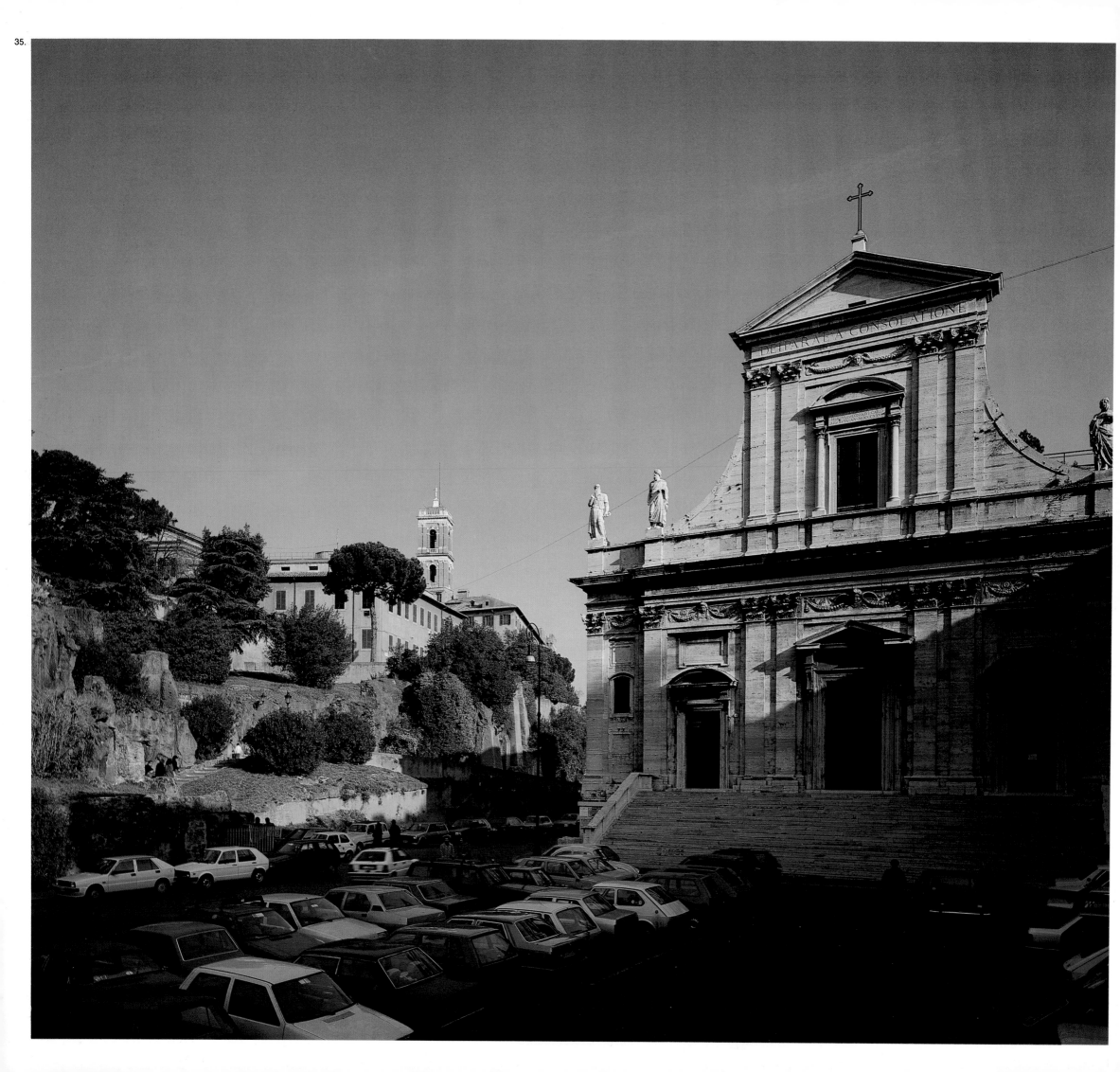

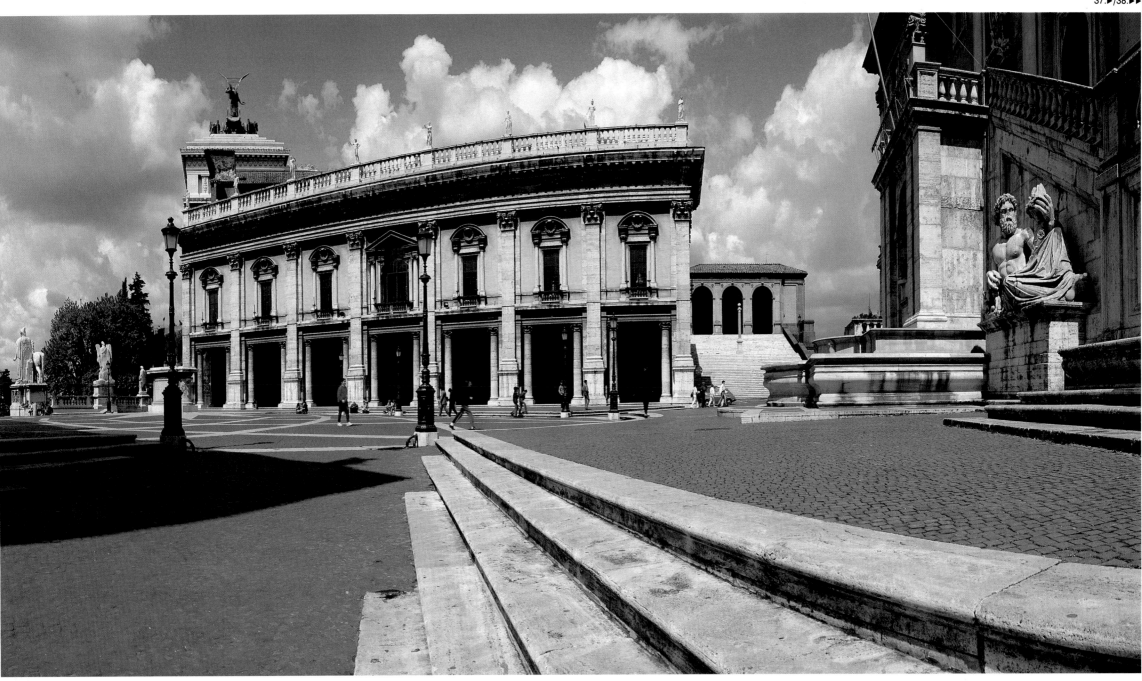

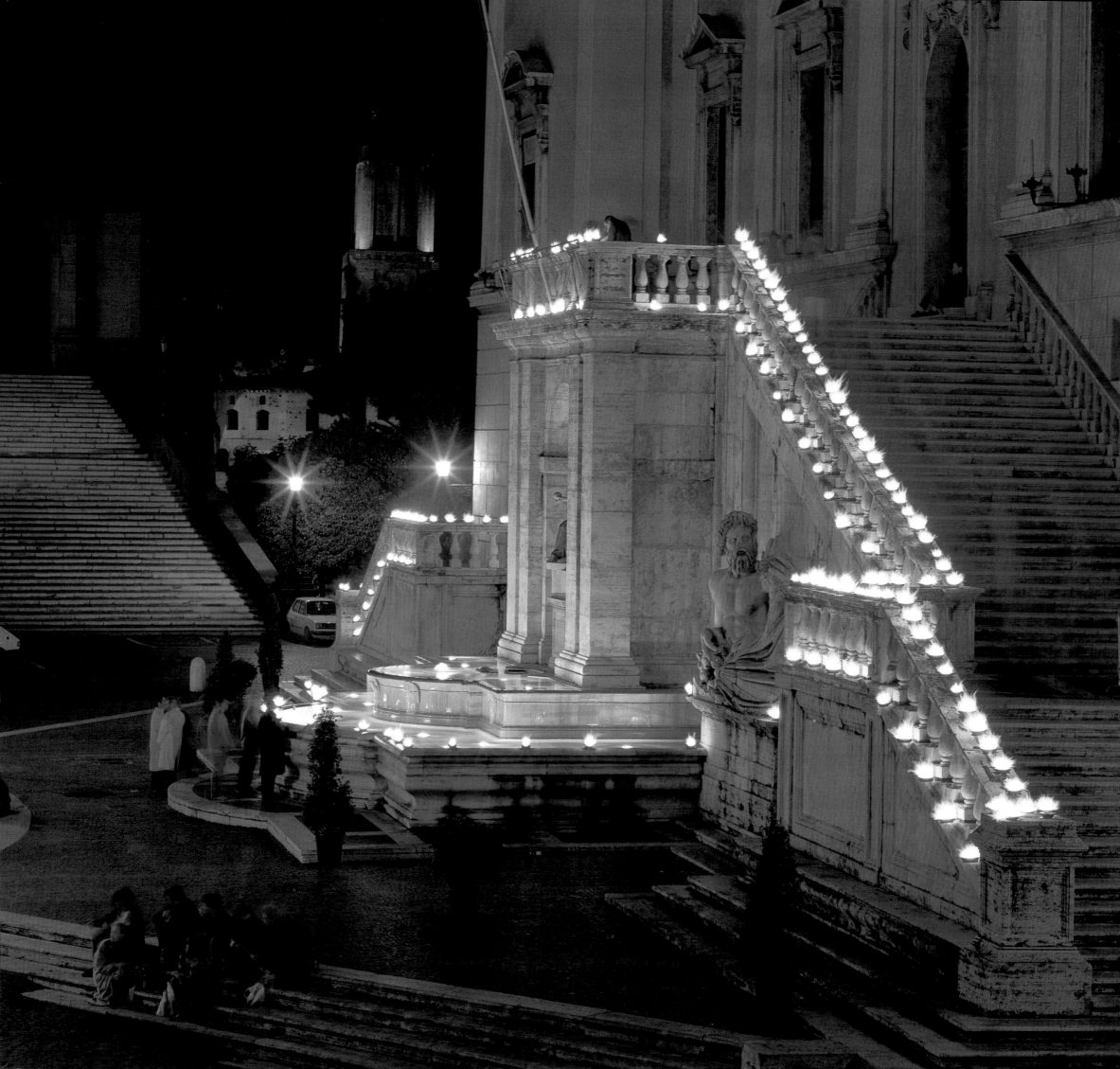

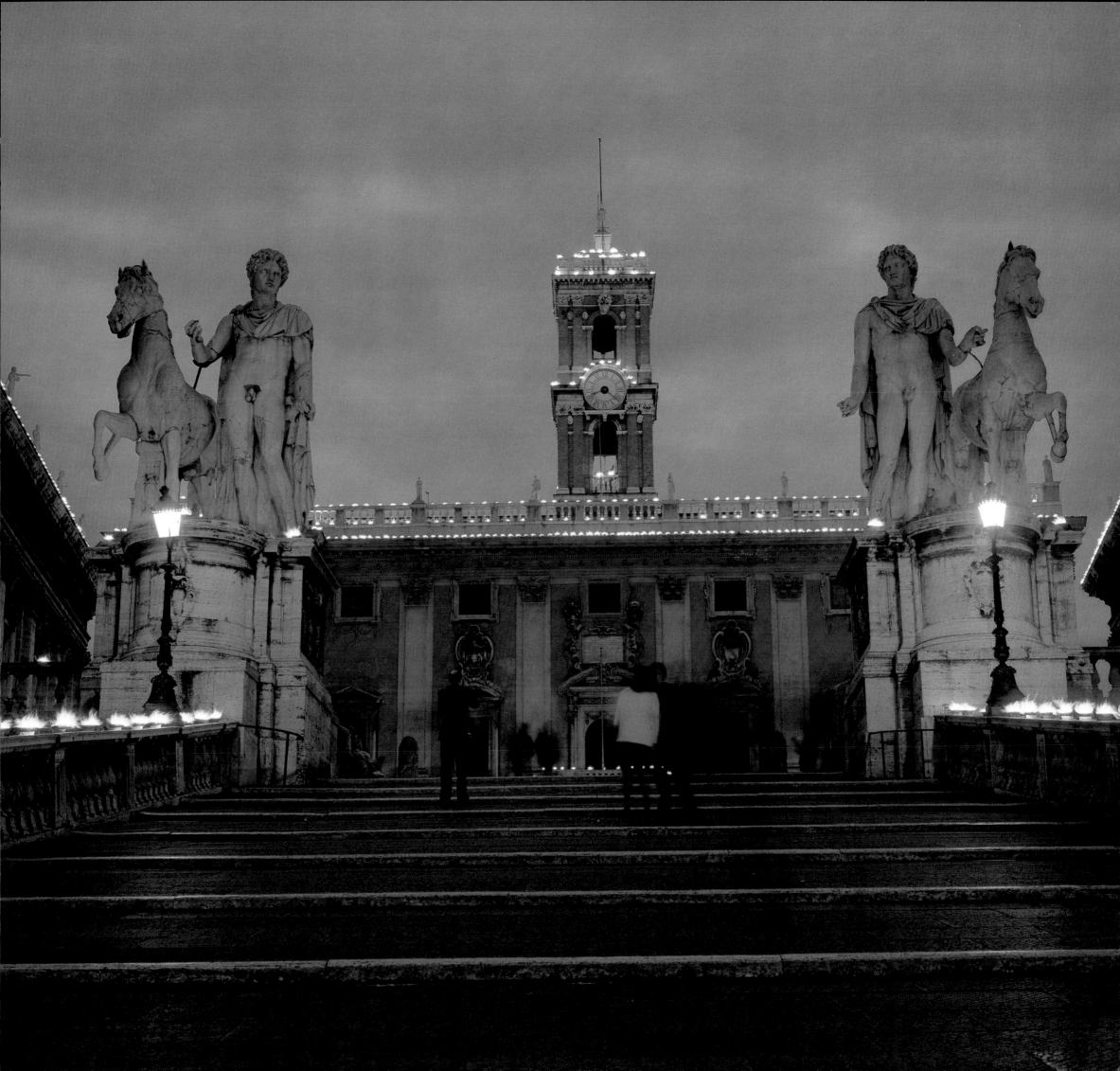

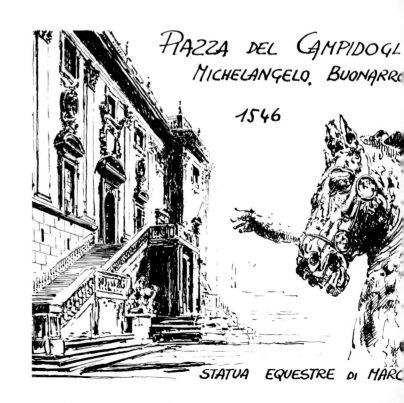

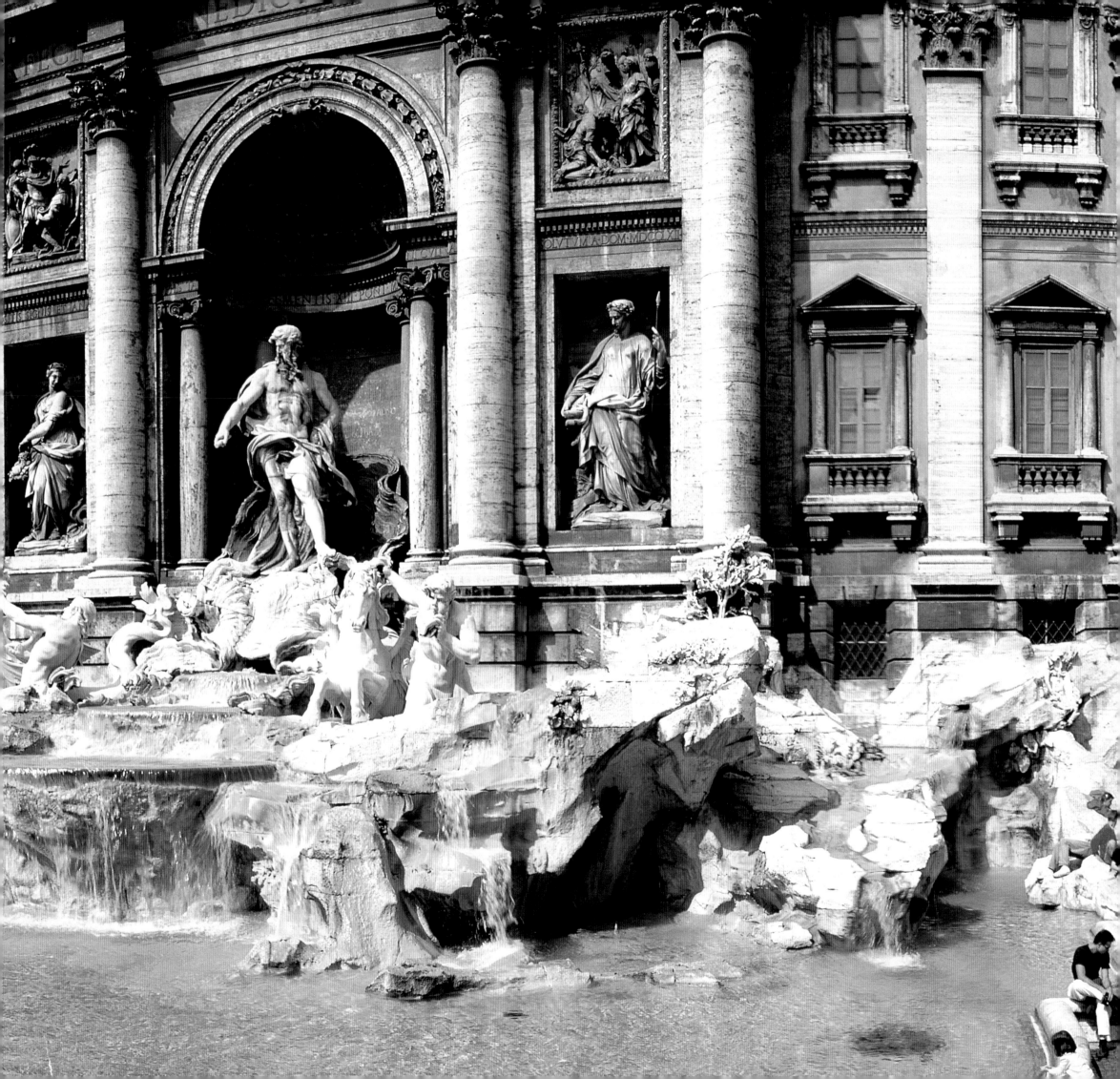

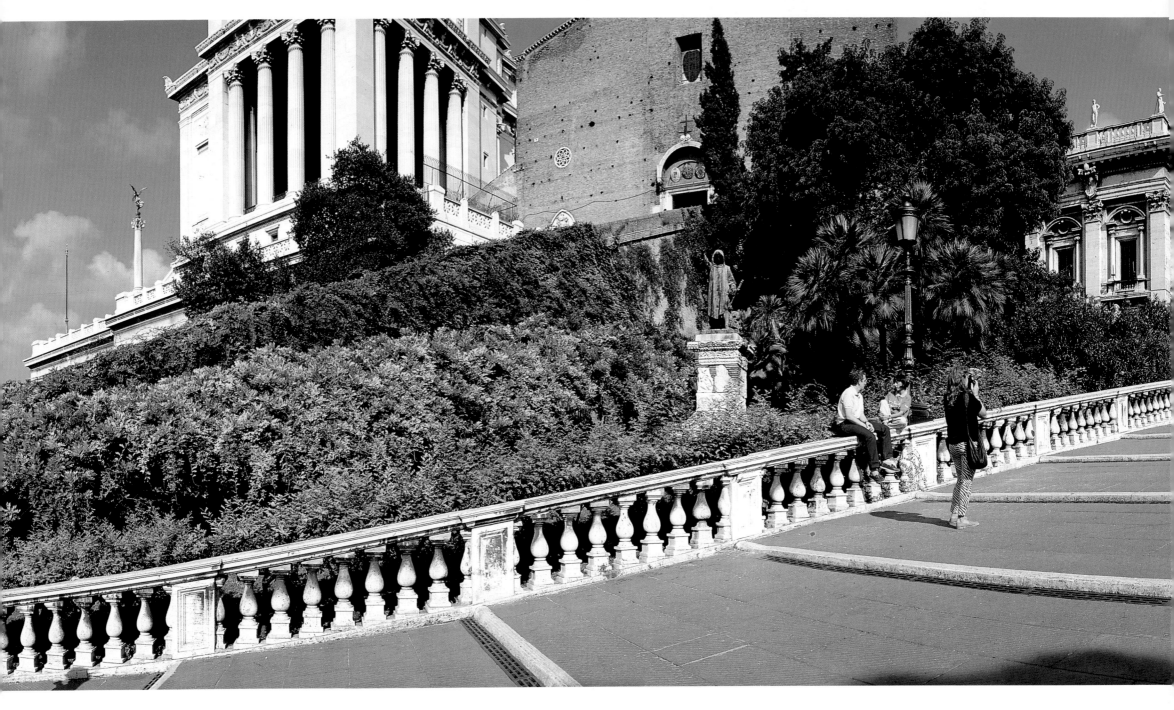

PALAZZO DEI CONSERVATORI

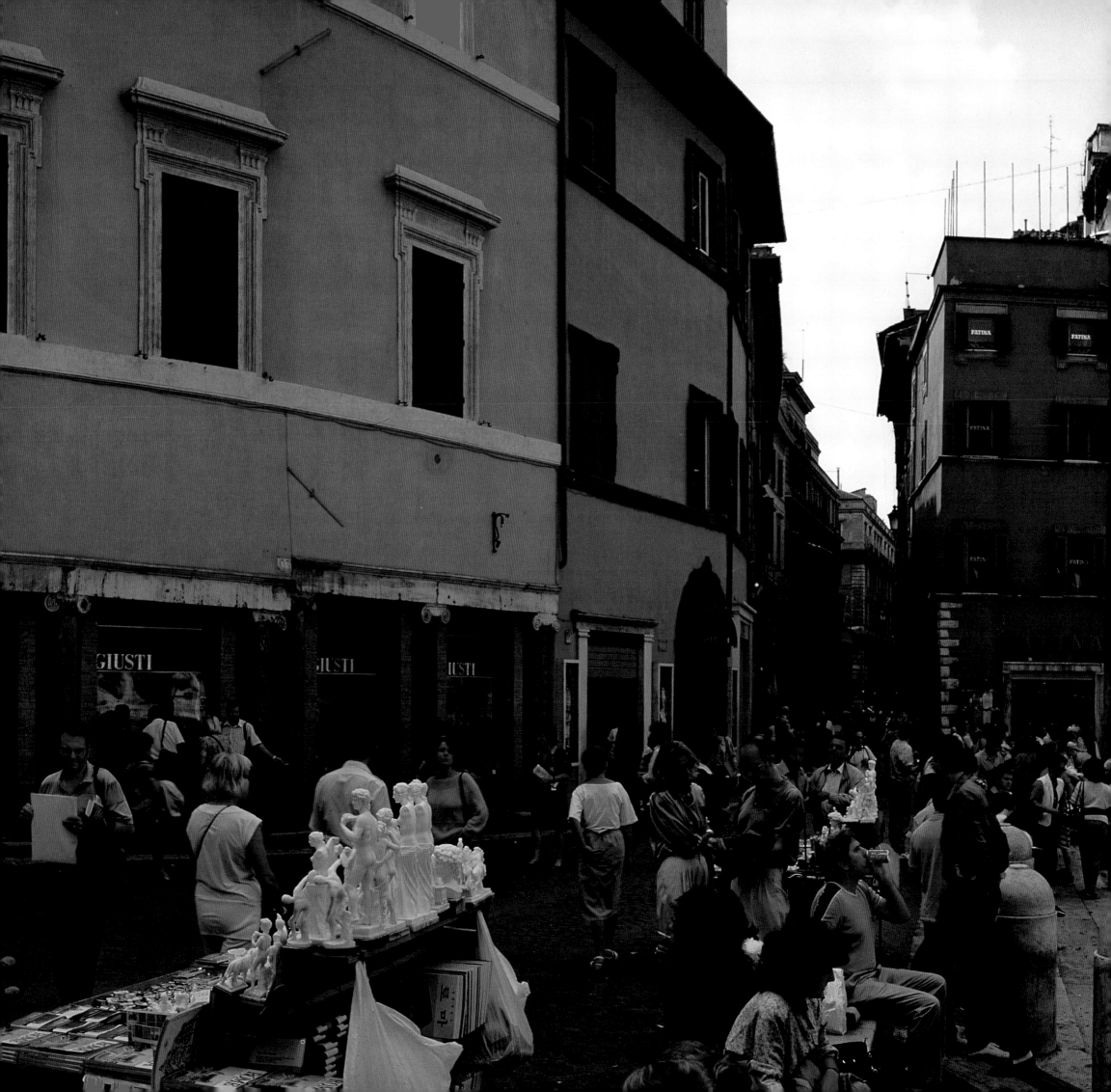

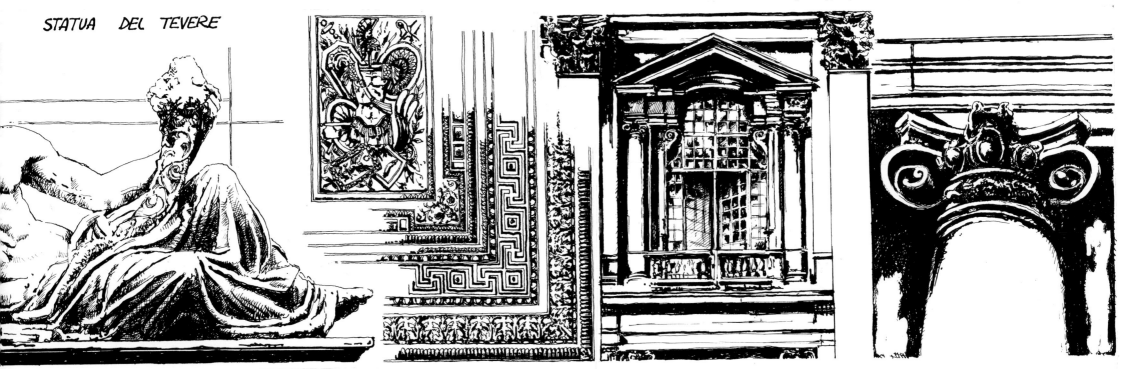

STATVA DEL TEVERE

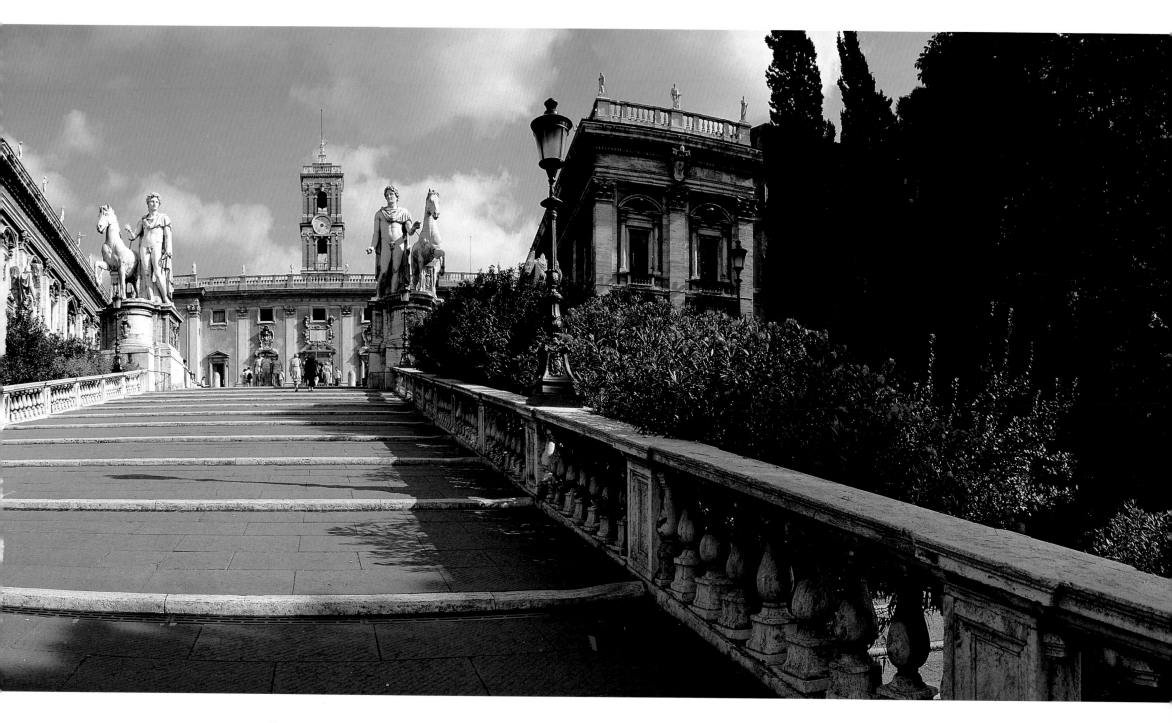

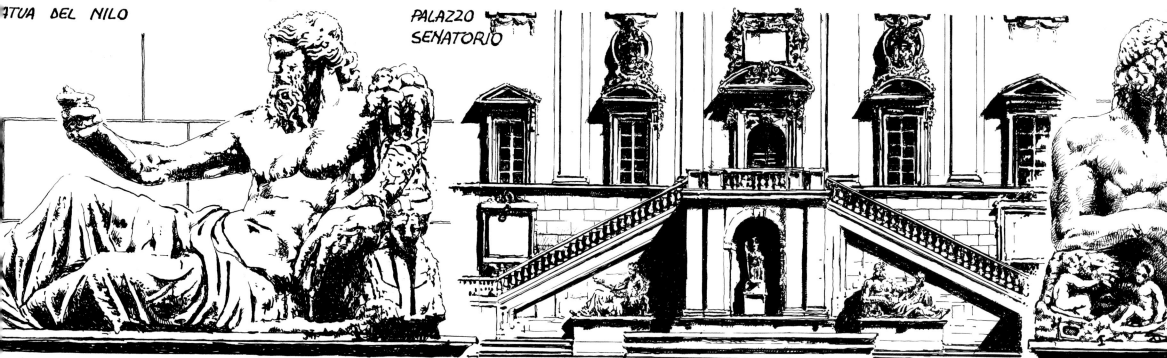

STATUA DEL NILO

PALAZZO SENATORIO

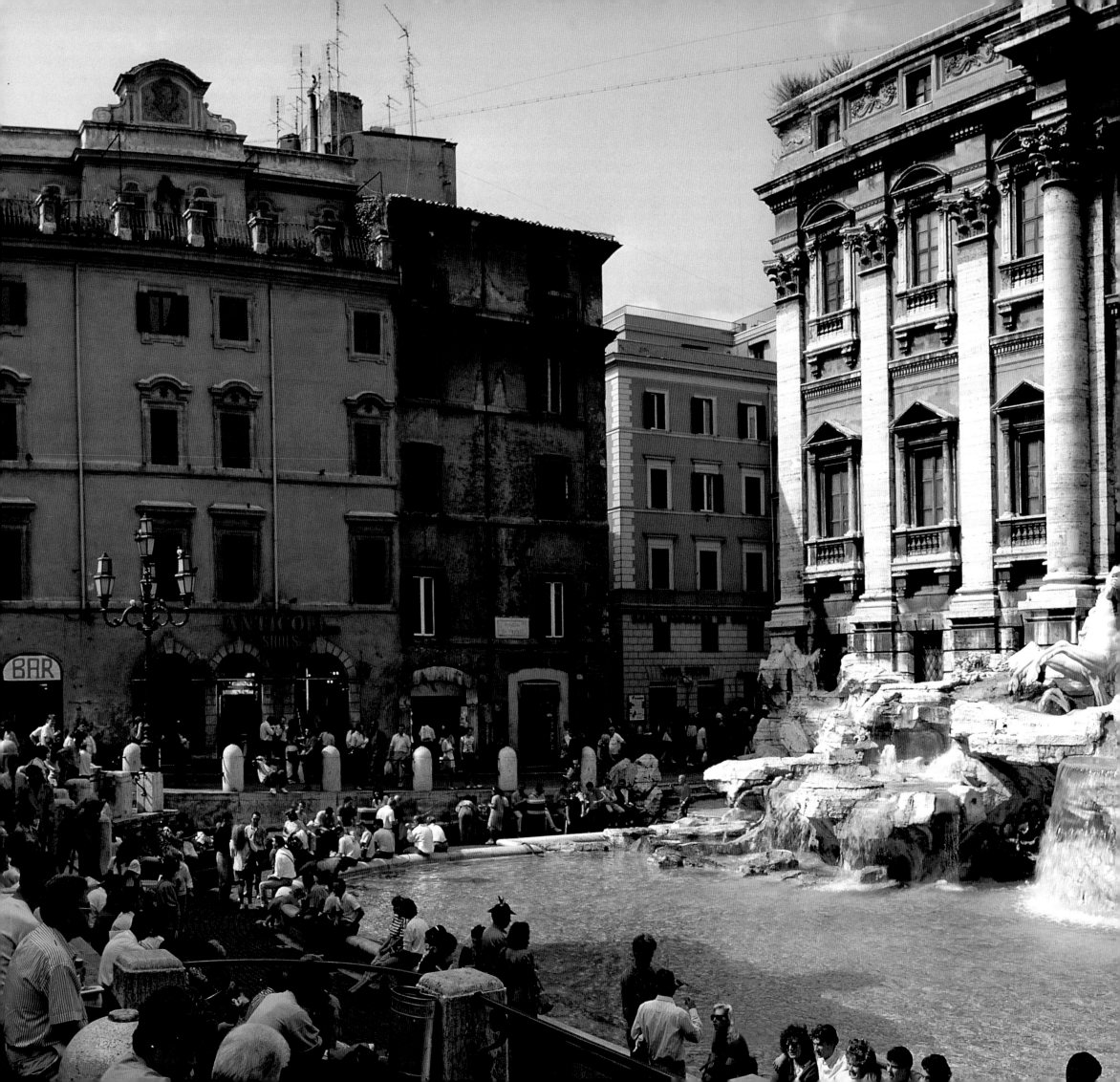

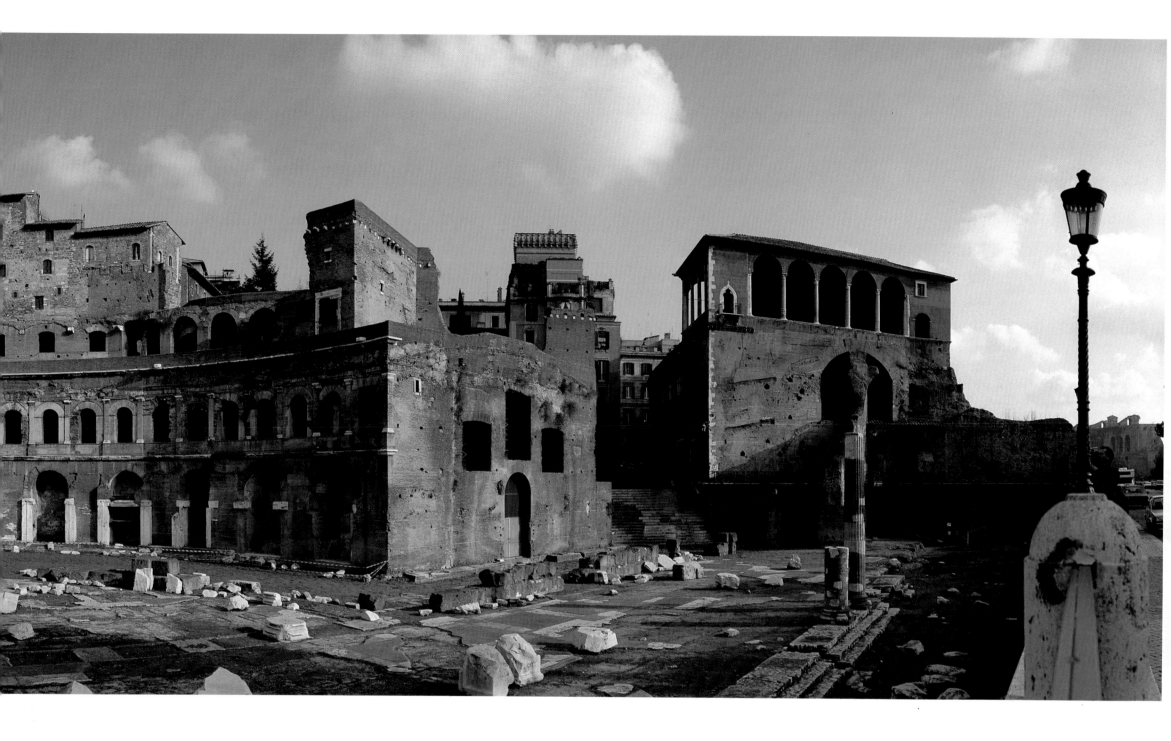

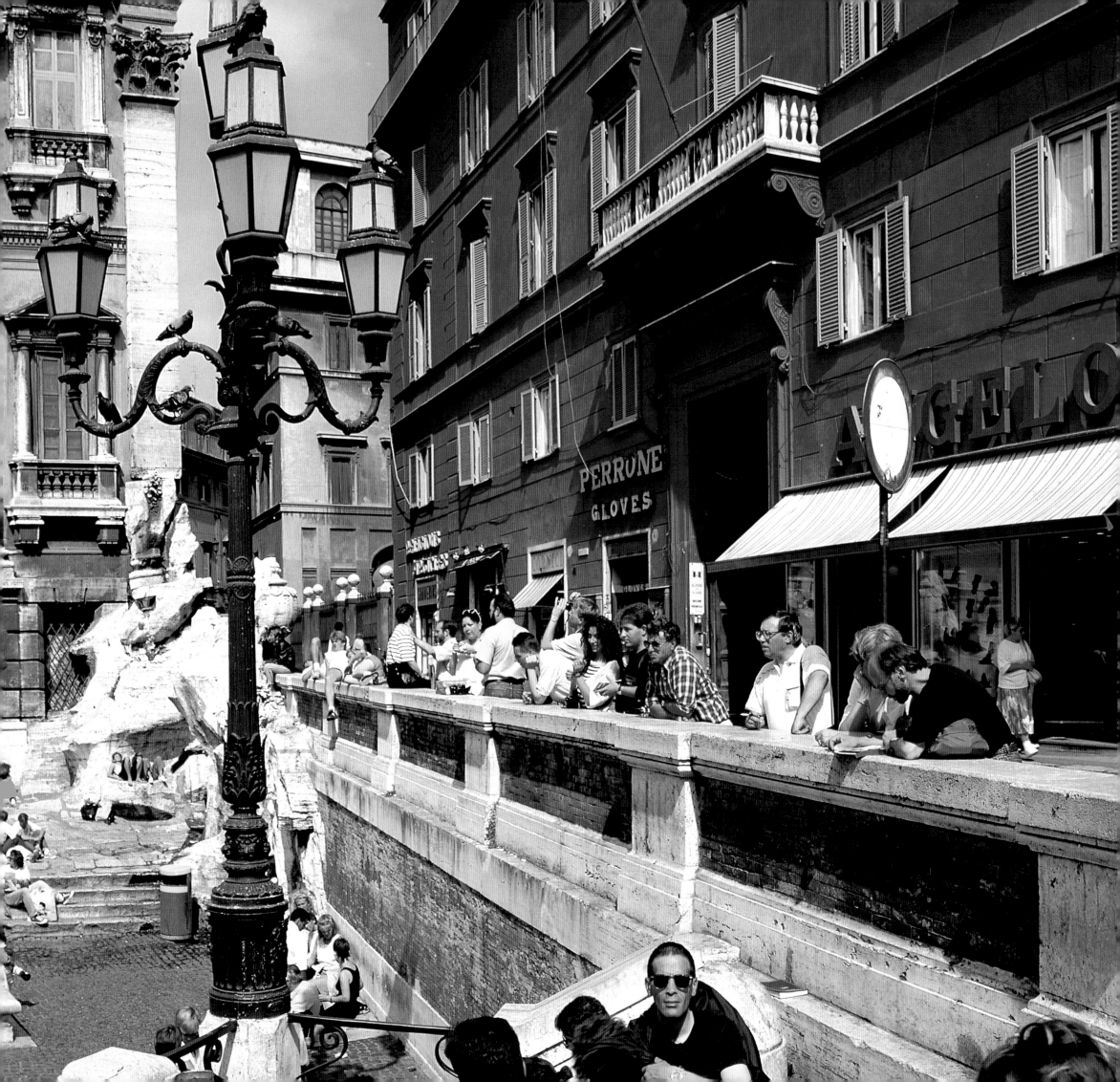

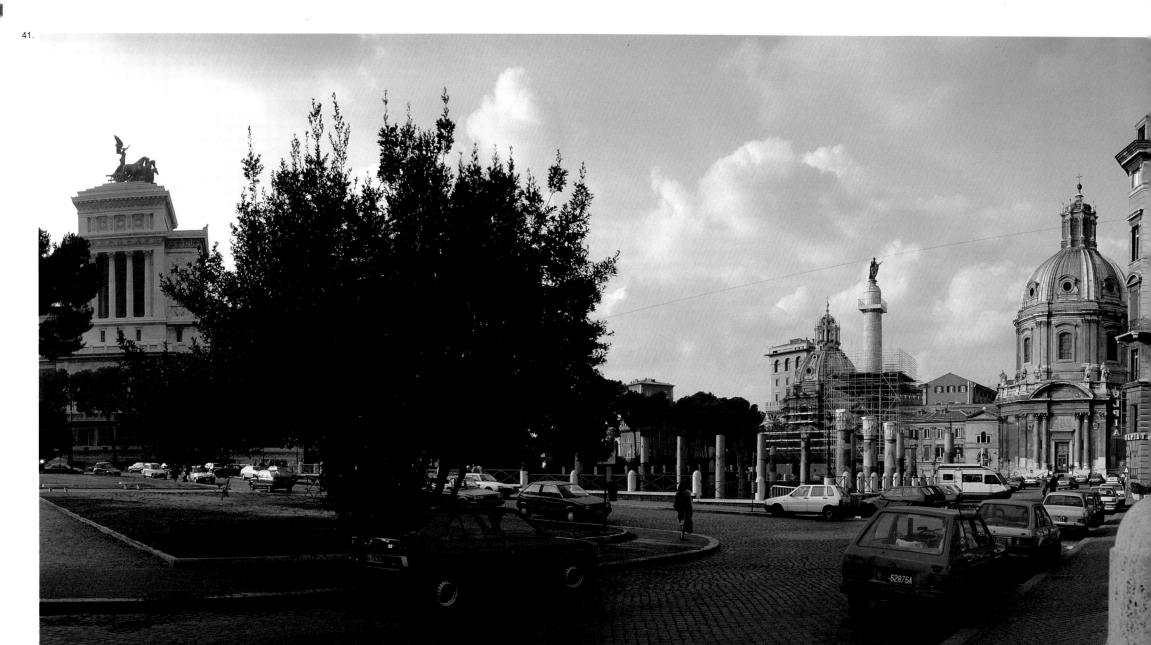

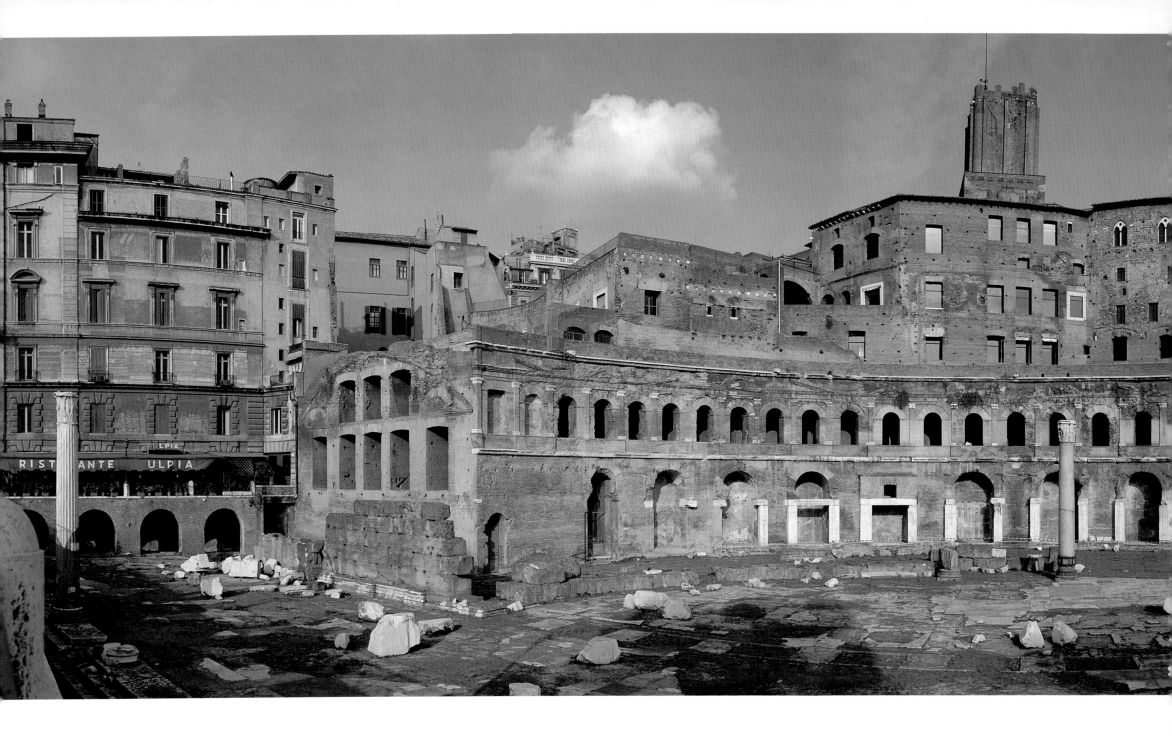

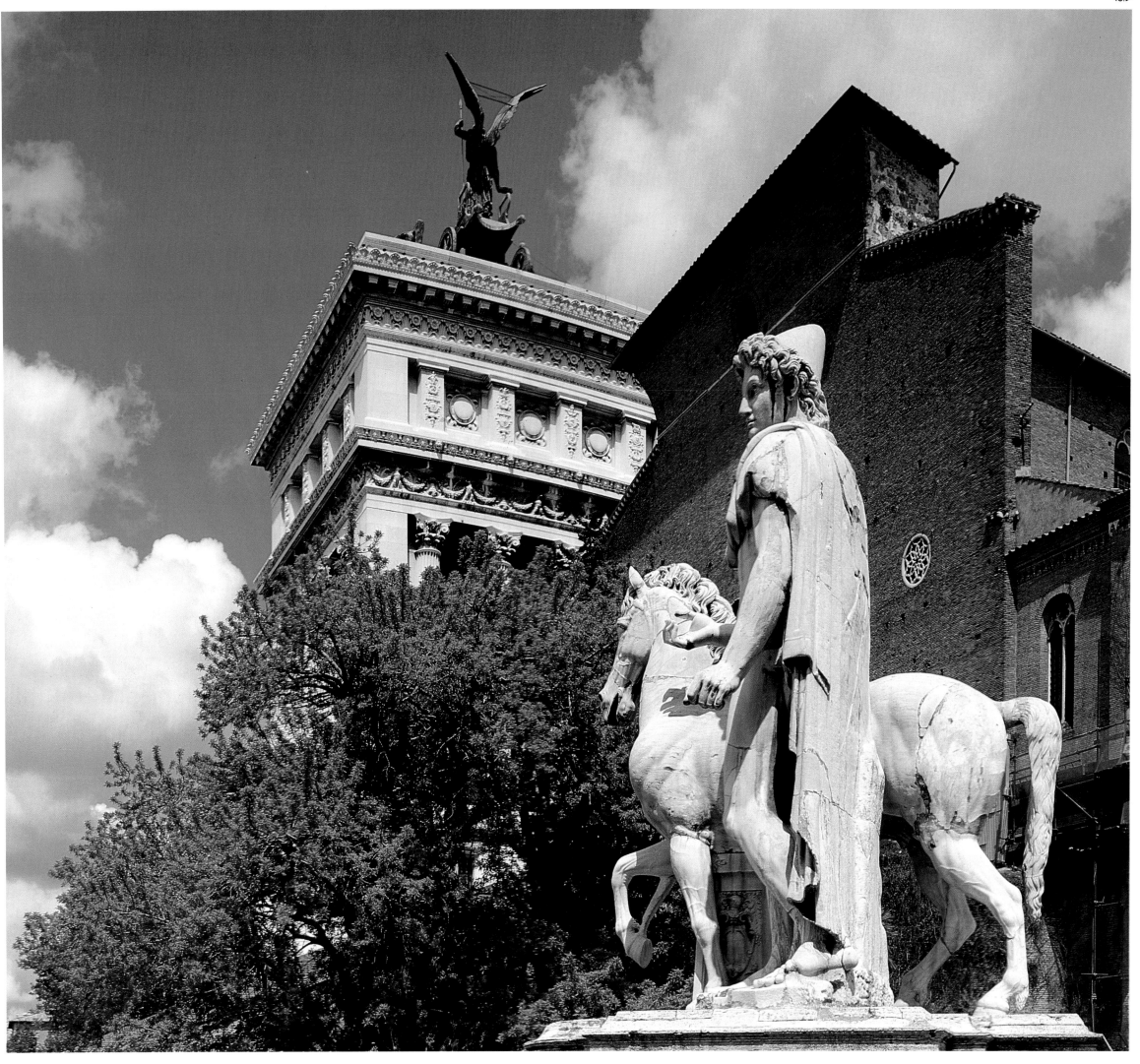

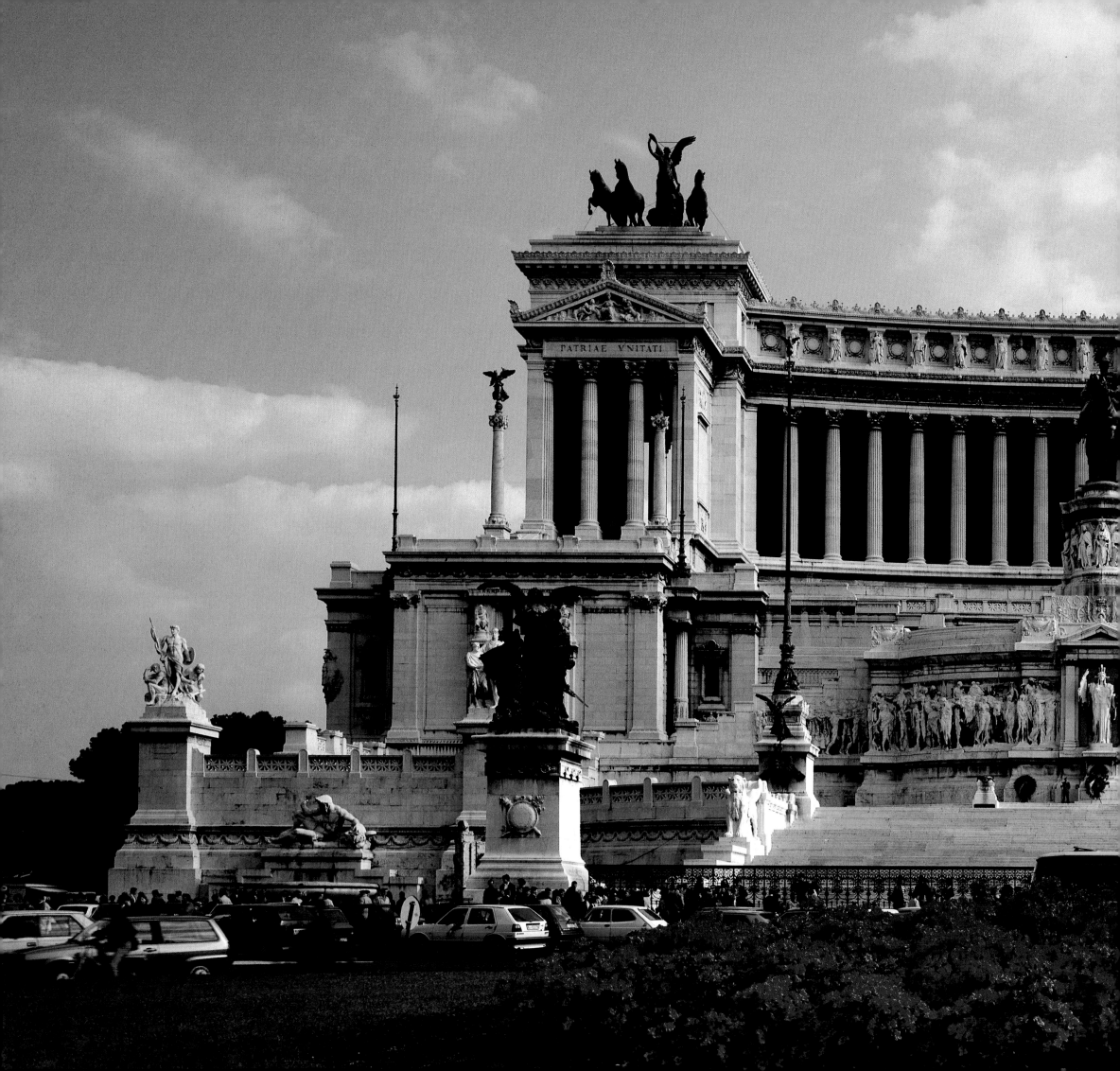

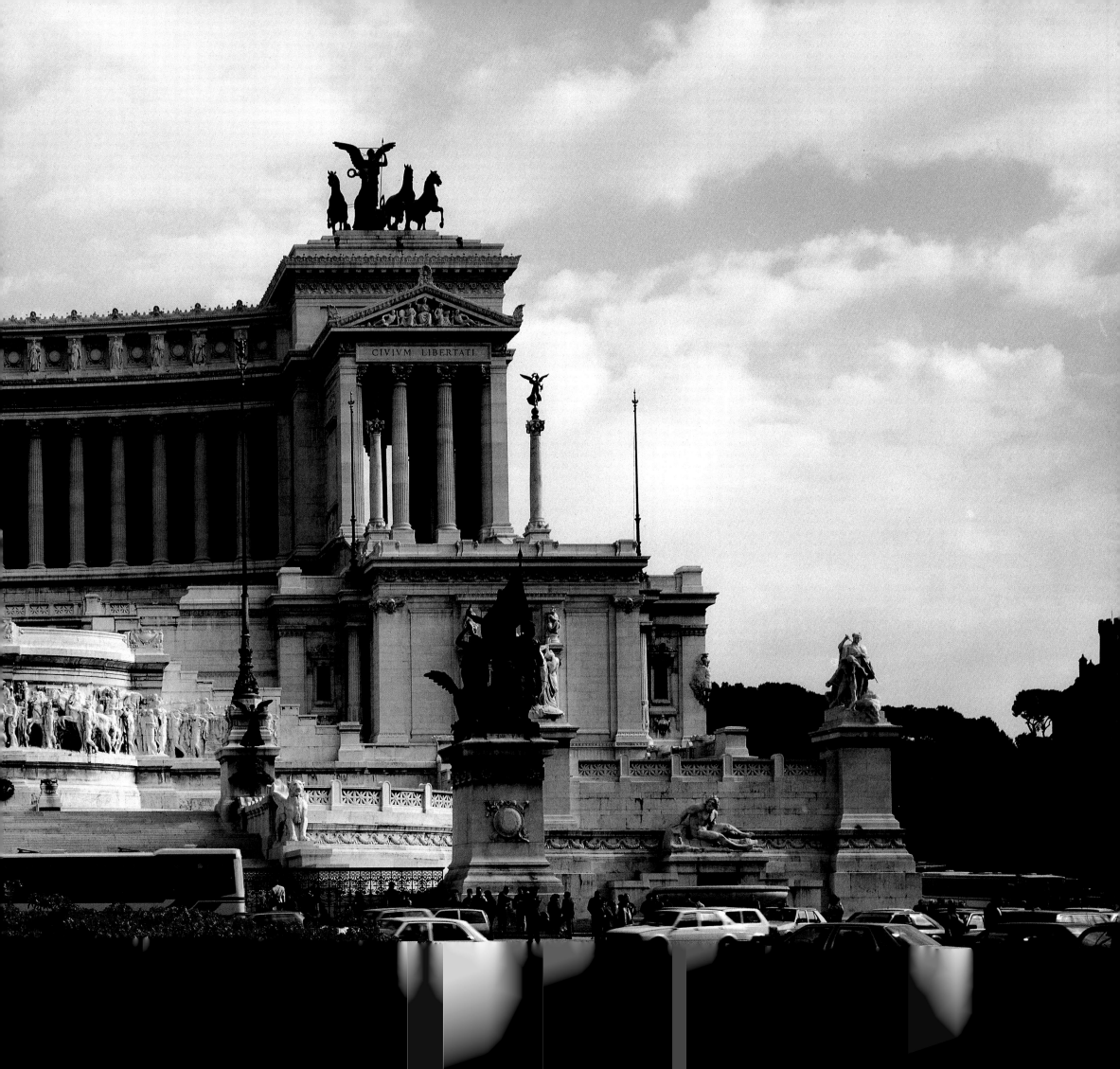

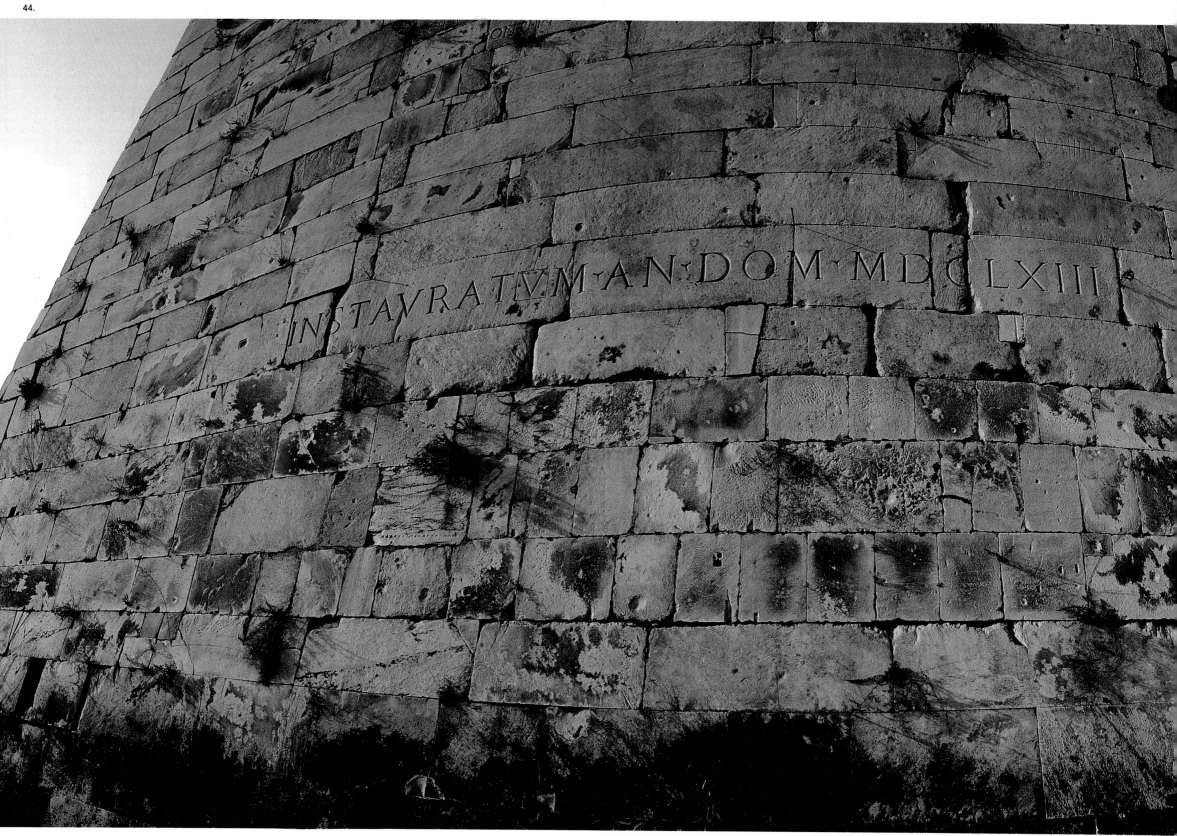

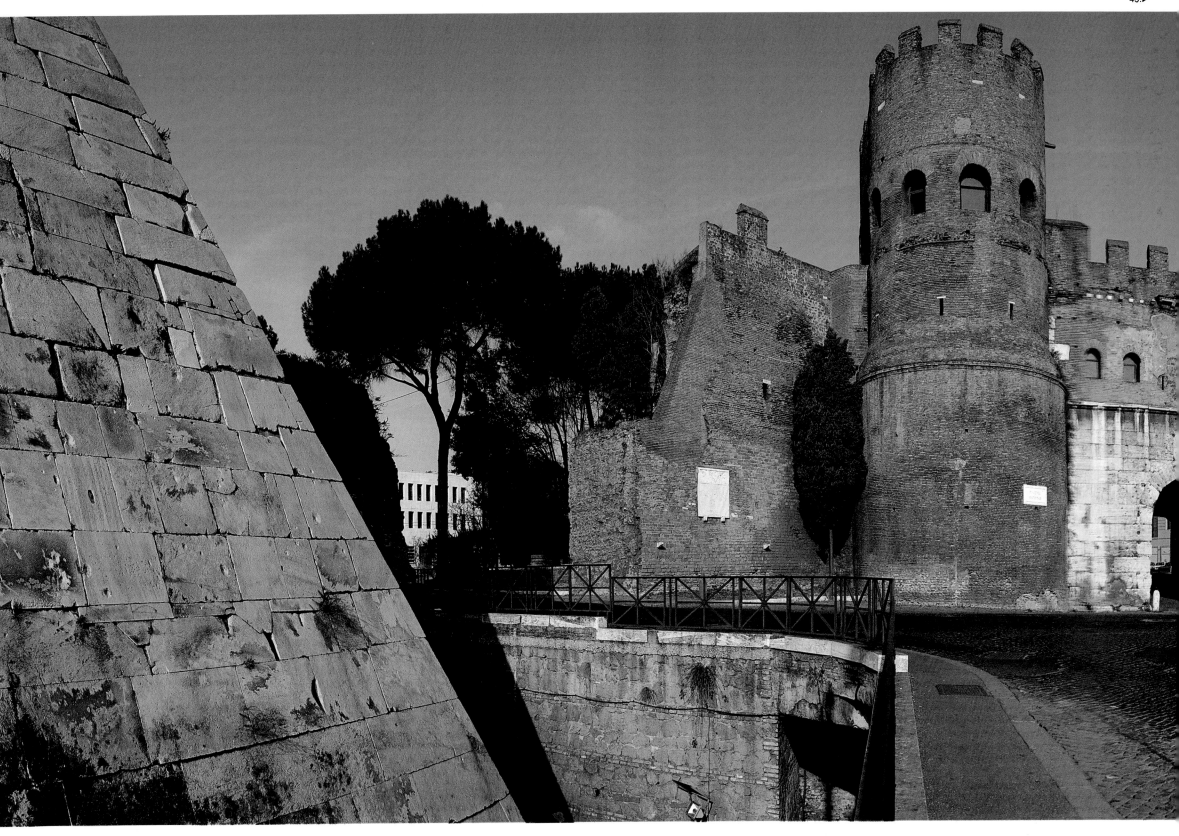

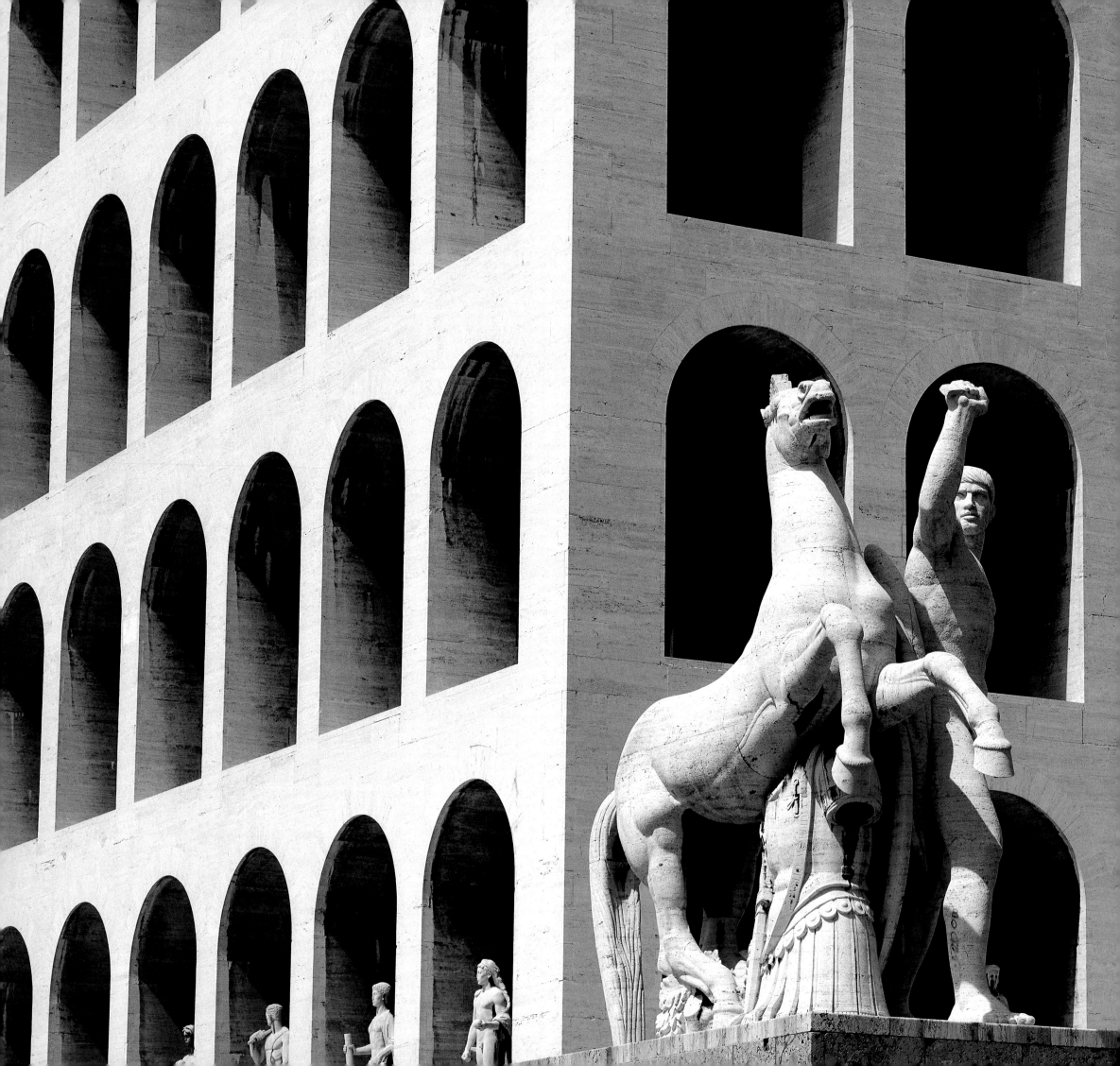

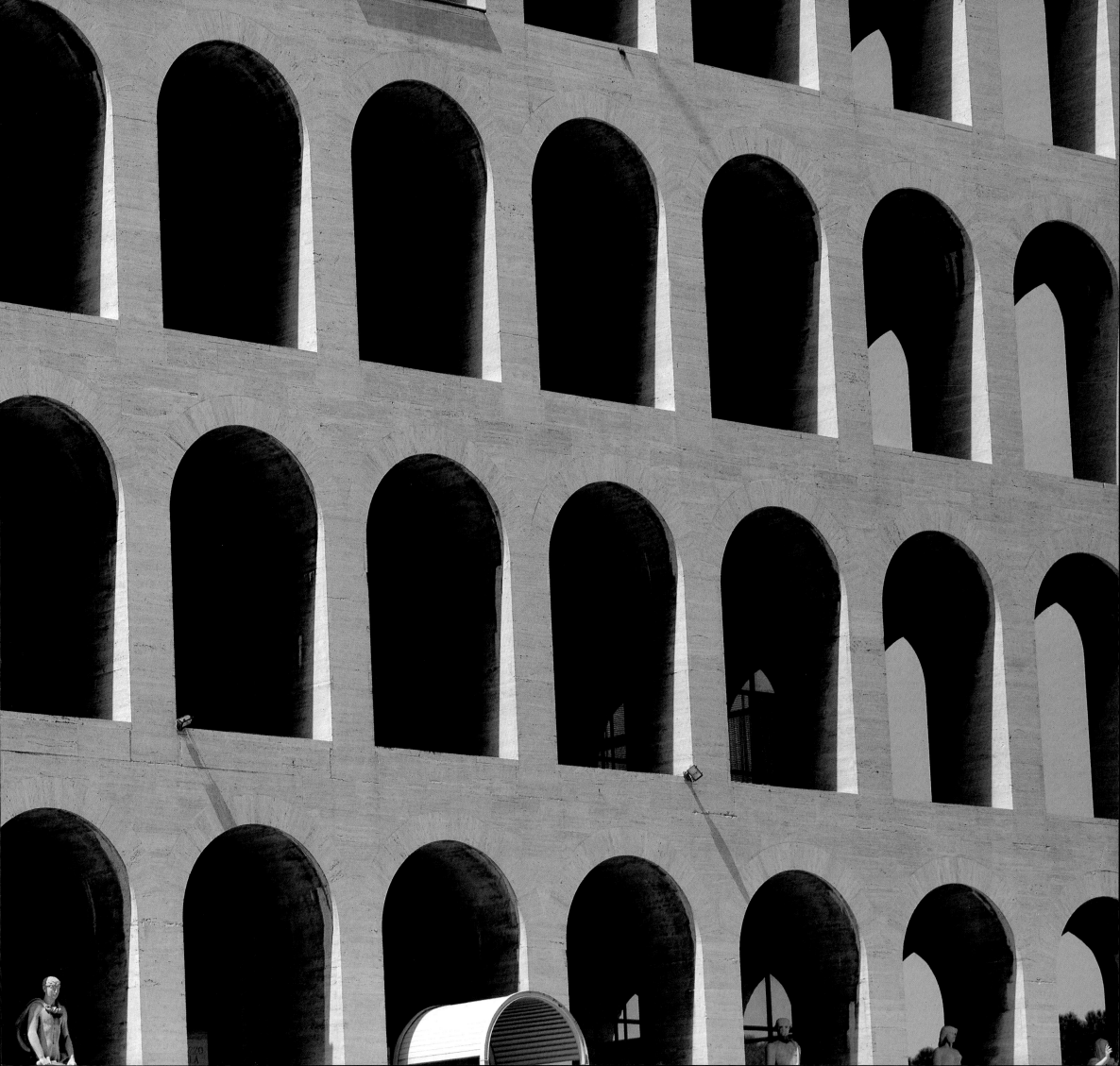

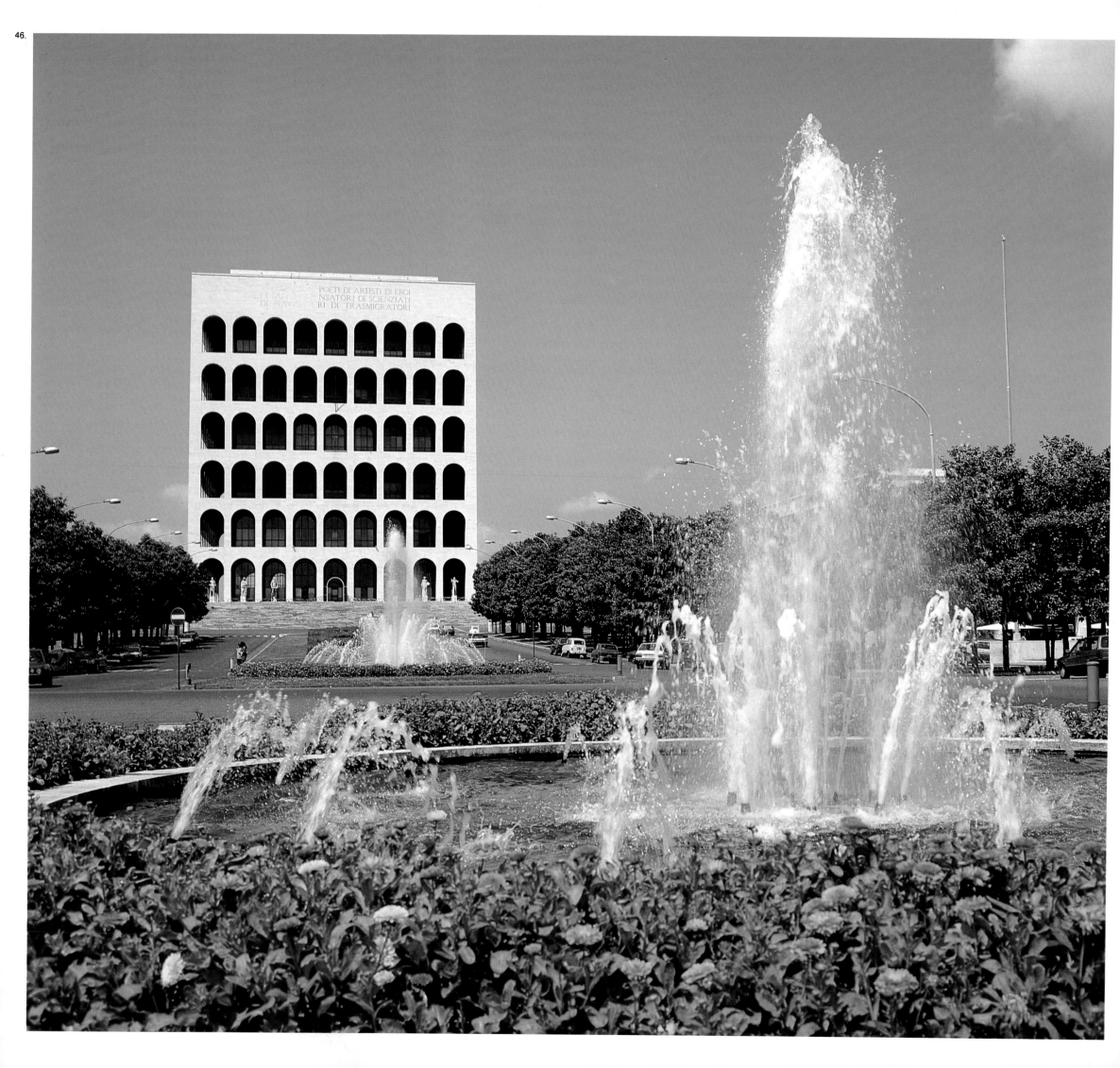

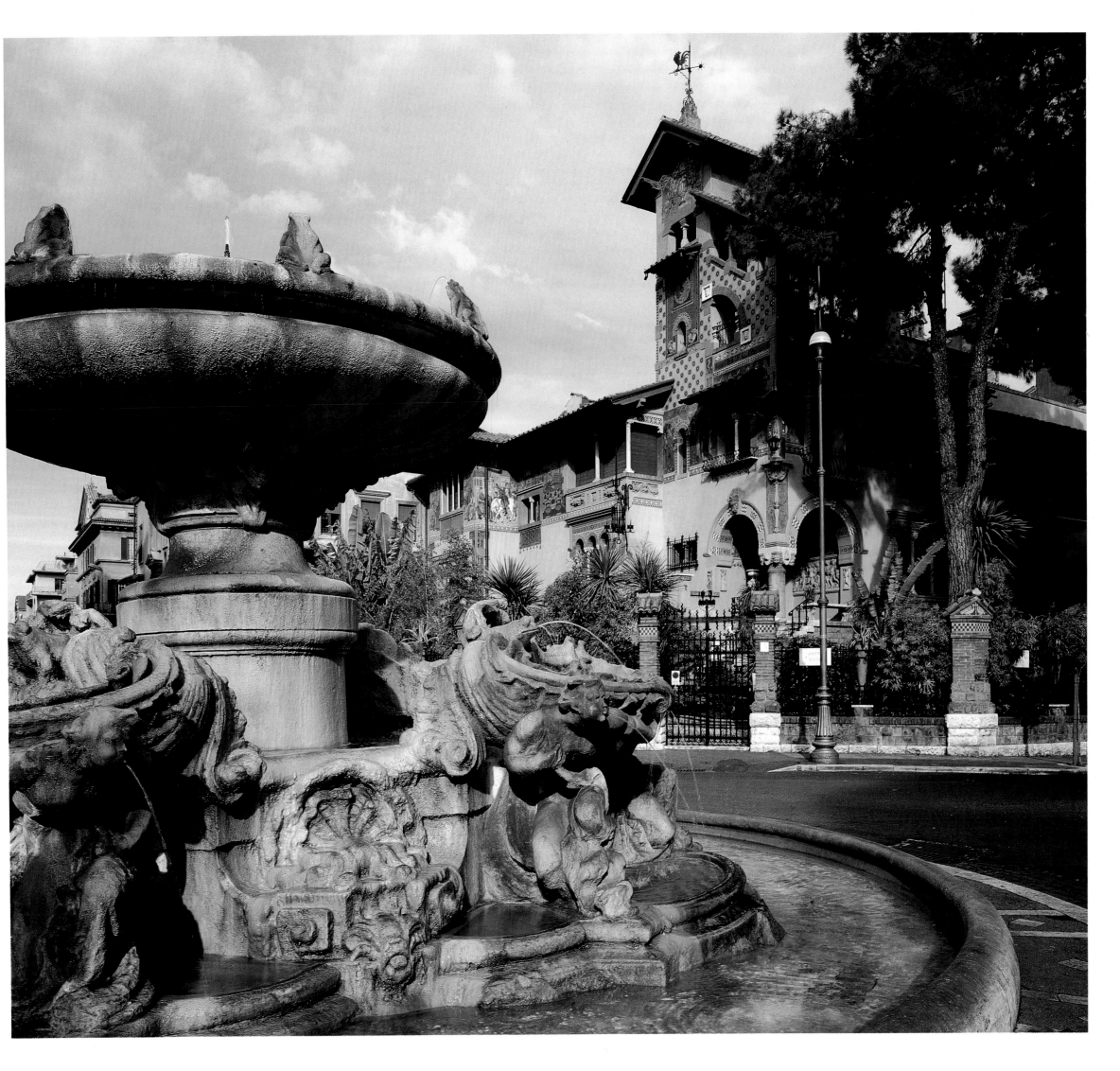

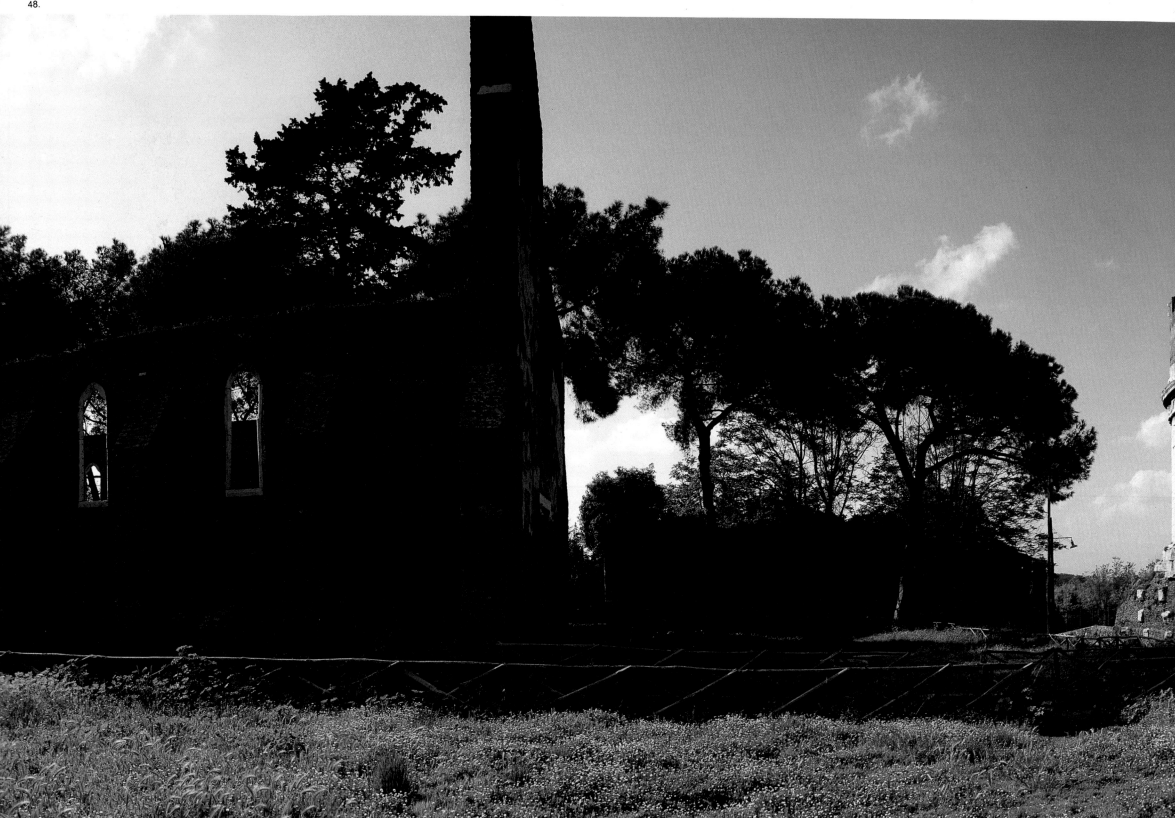

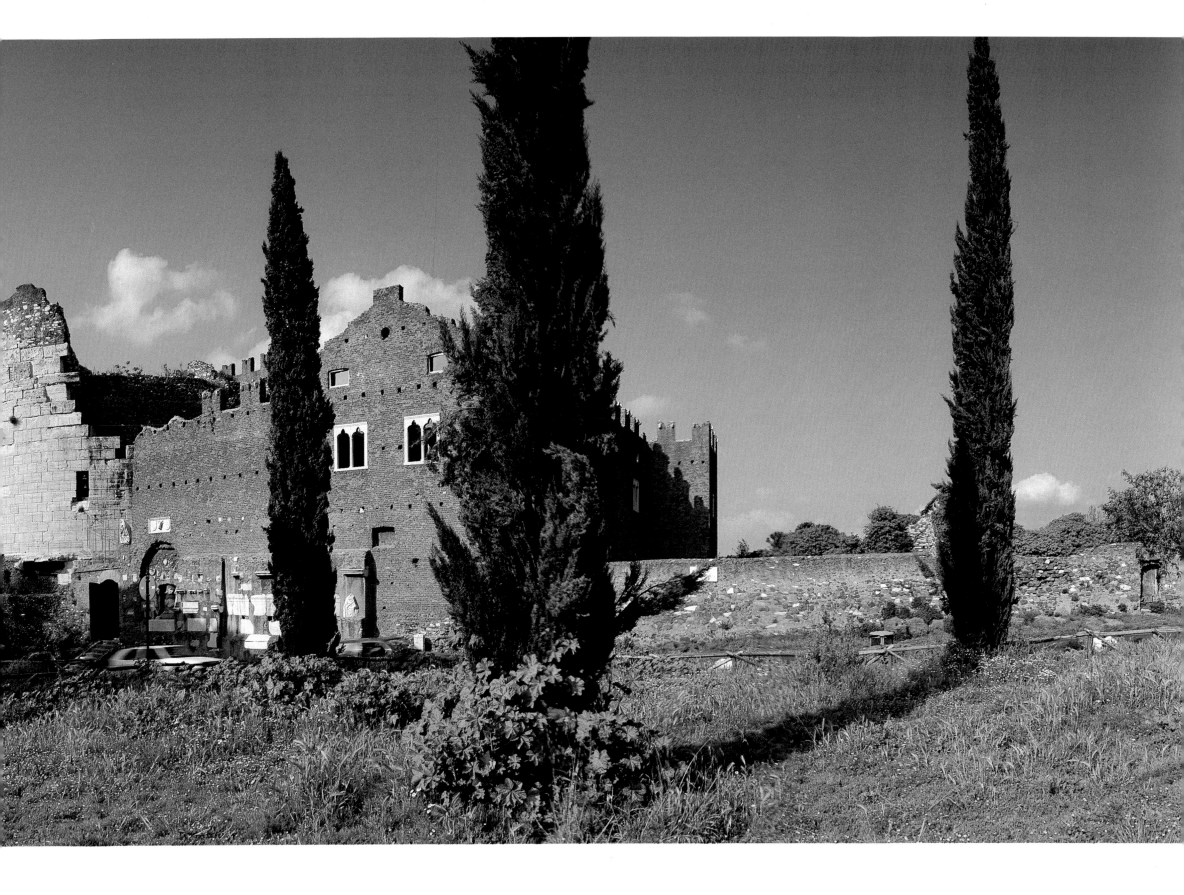

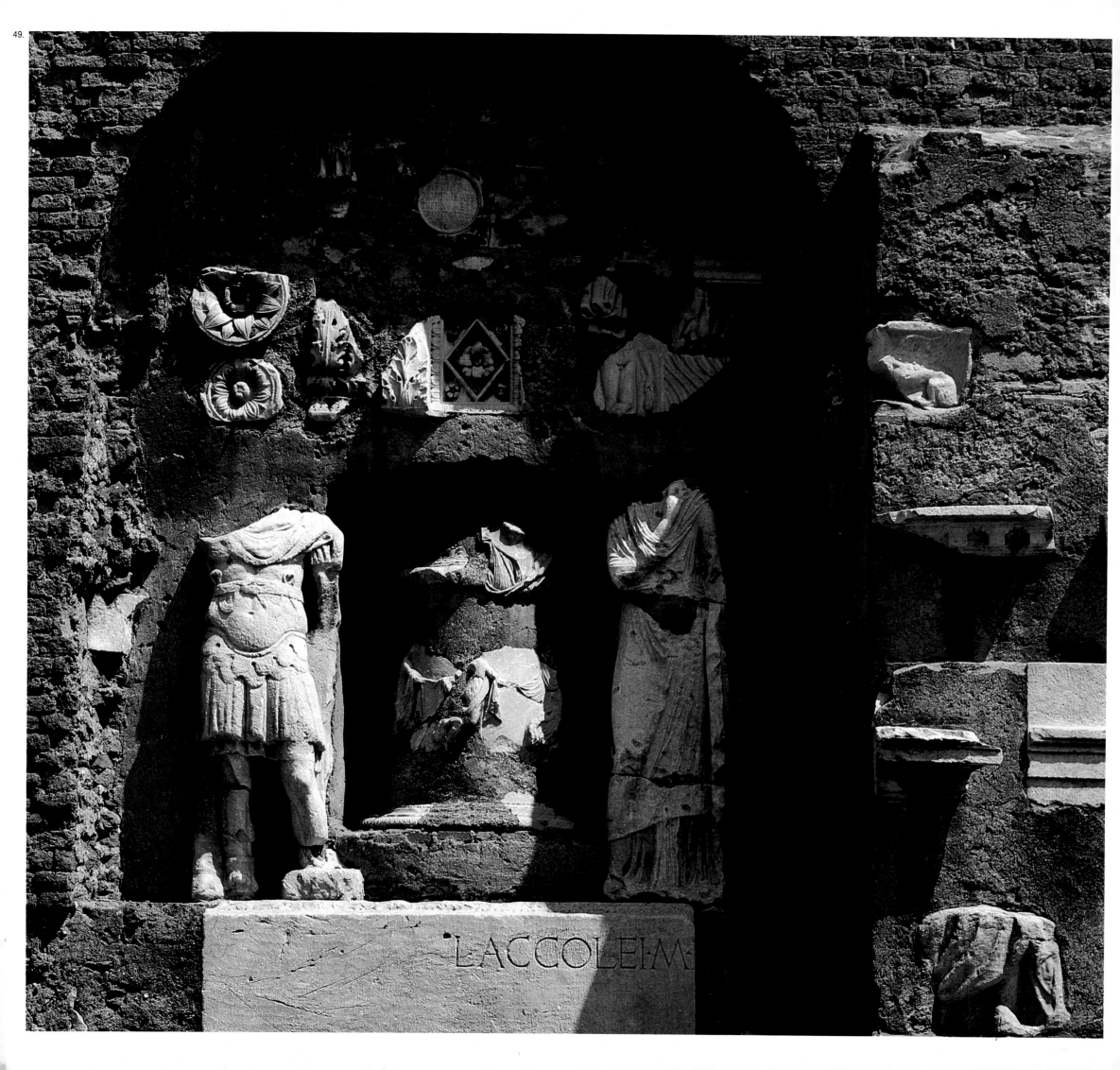

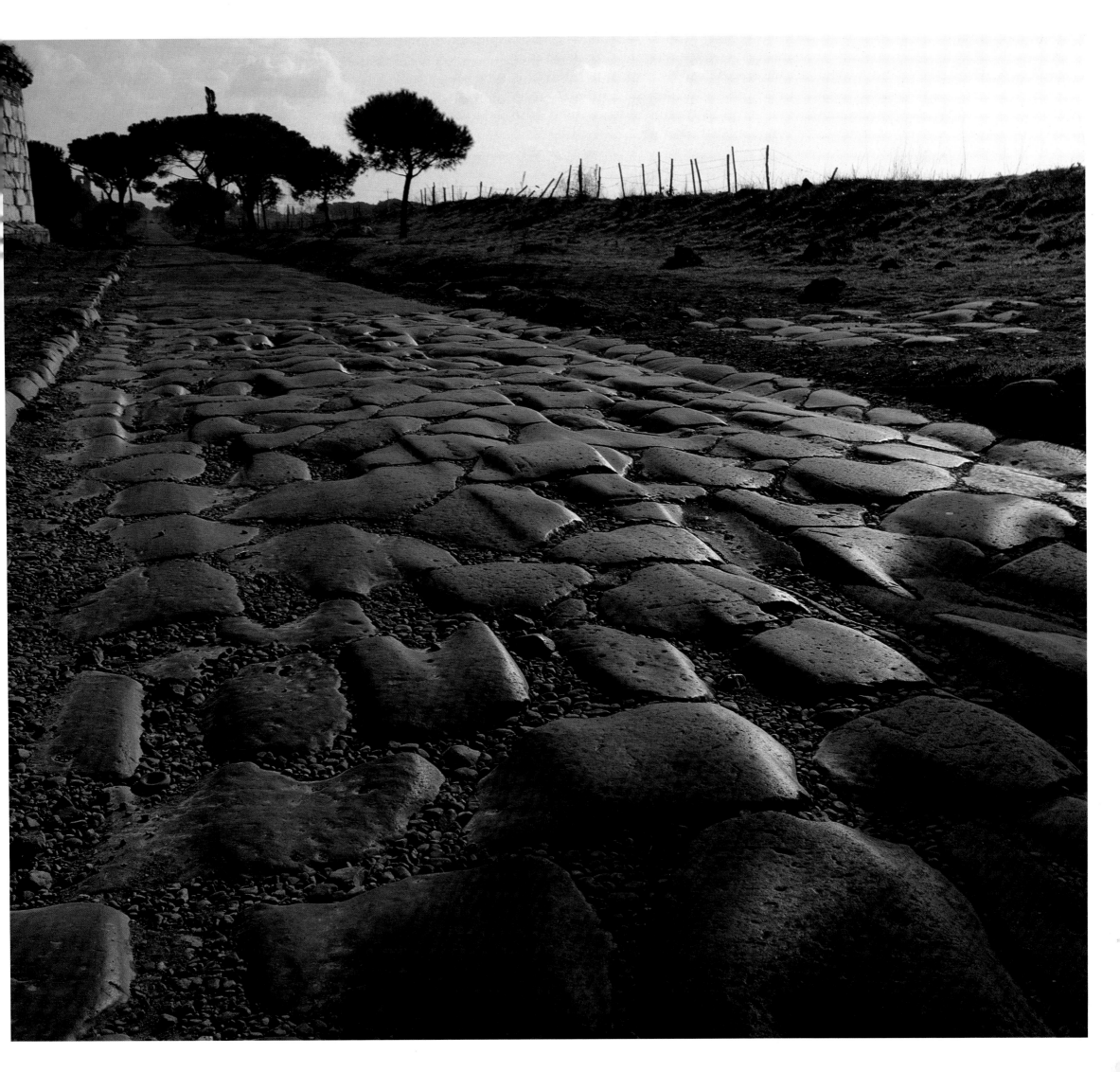

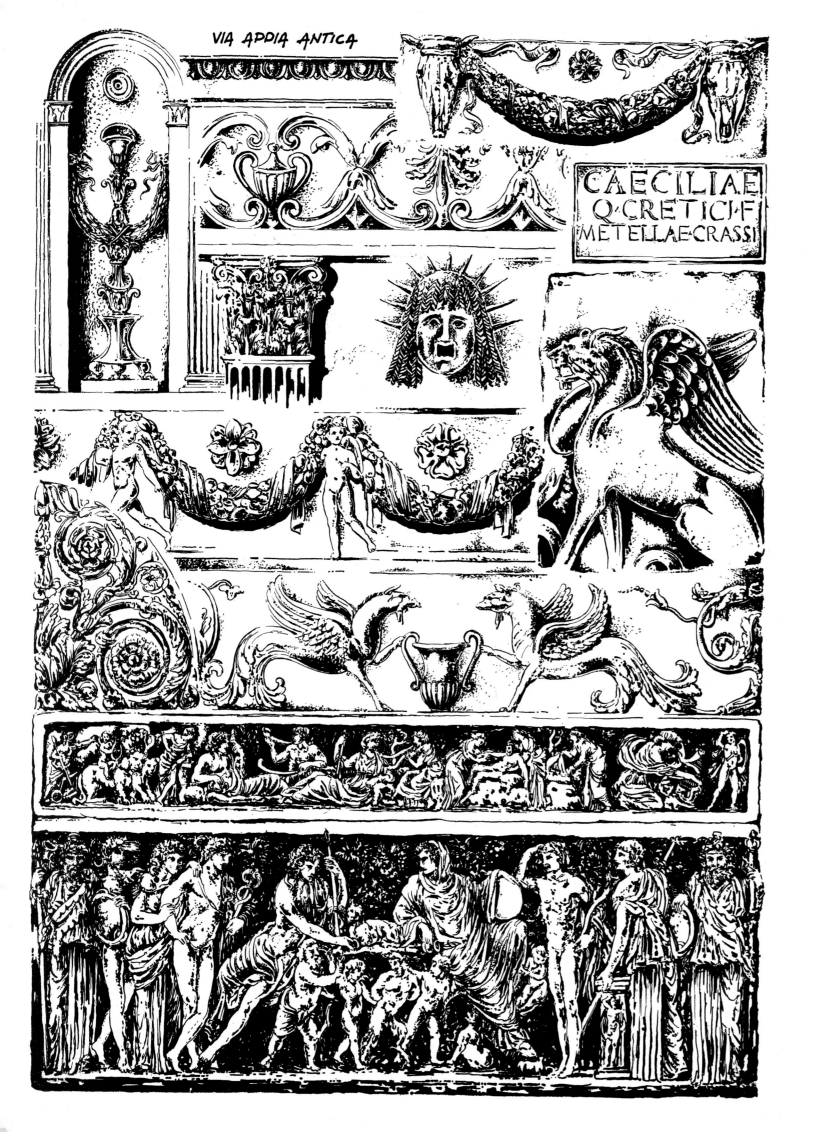

VIA APPIA ANTICA

CAECILIAE
Q·CRETICI·F
METELLAE·CRASSI

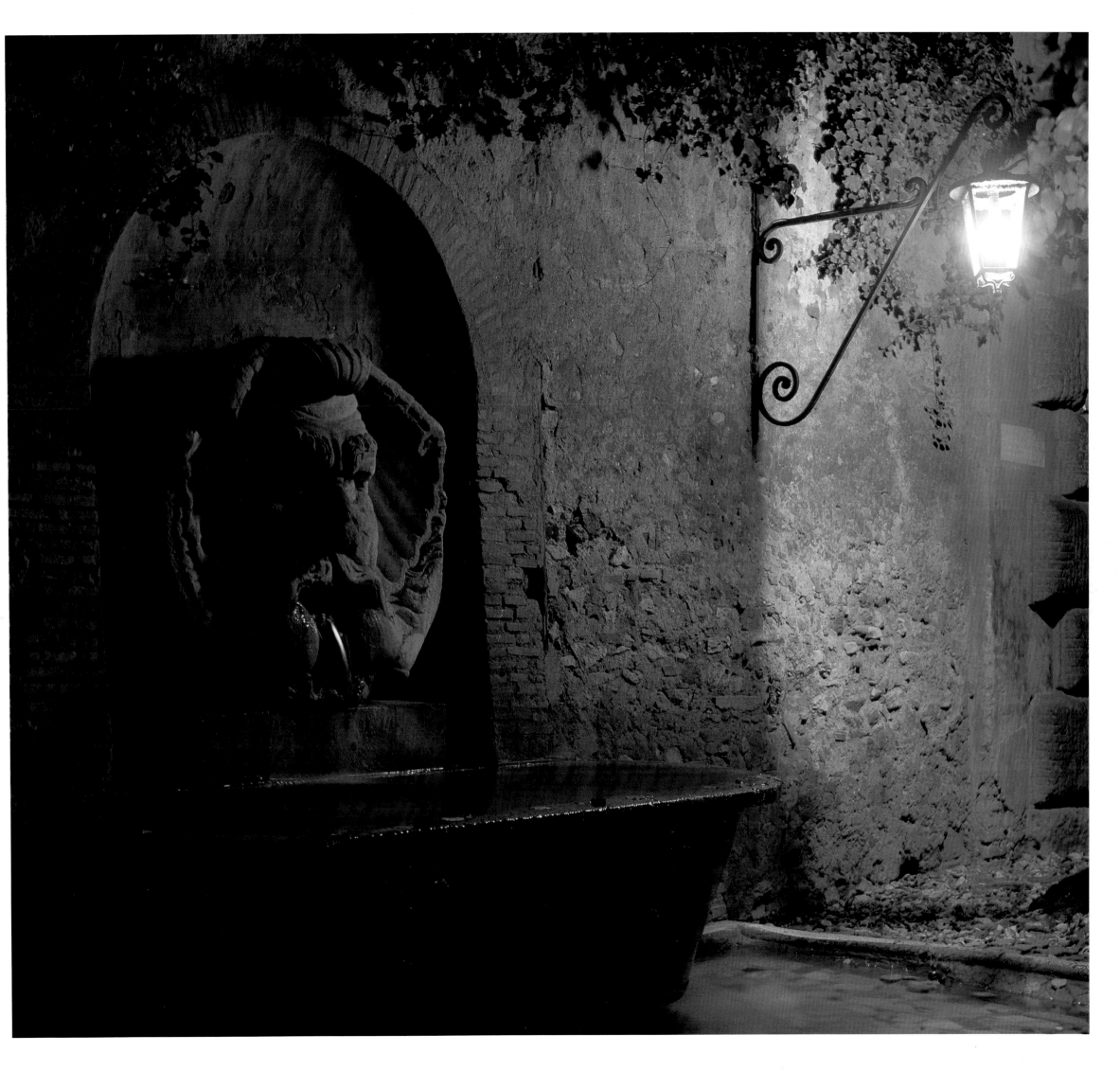

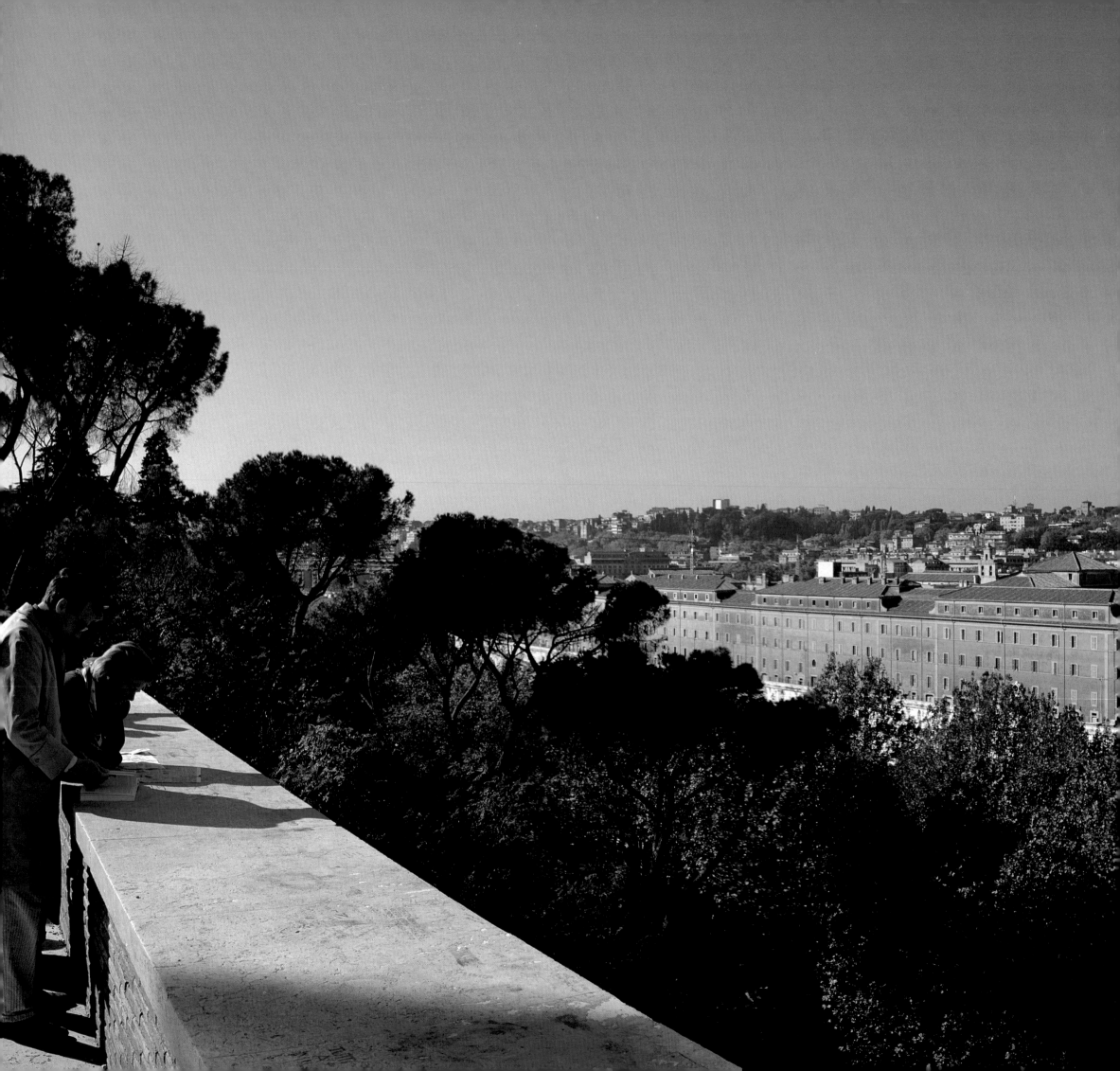

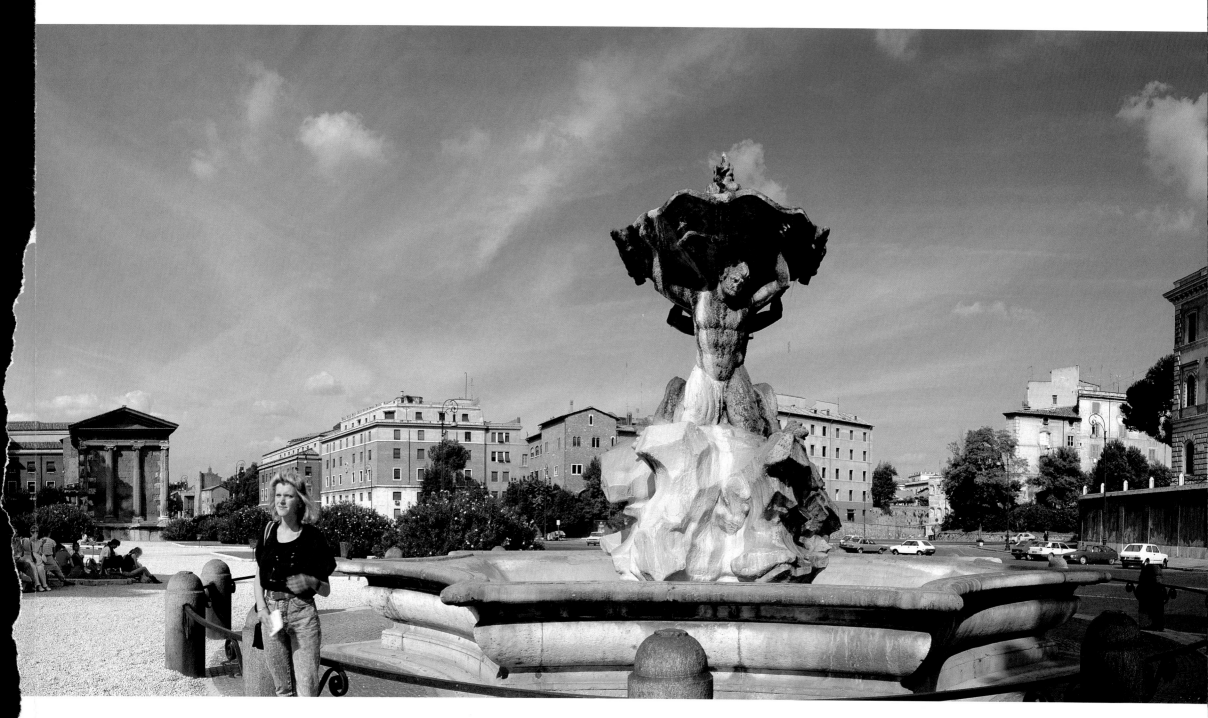

TEMPIO DELLA
FORTUNA VIRILE
— I SEC. A. C.

FONTANA DEI TRITONI
CARLO FRANCESCO BIZZACCHERI
1715

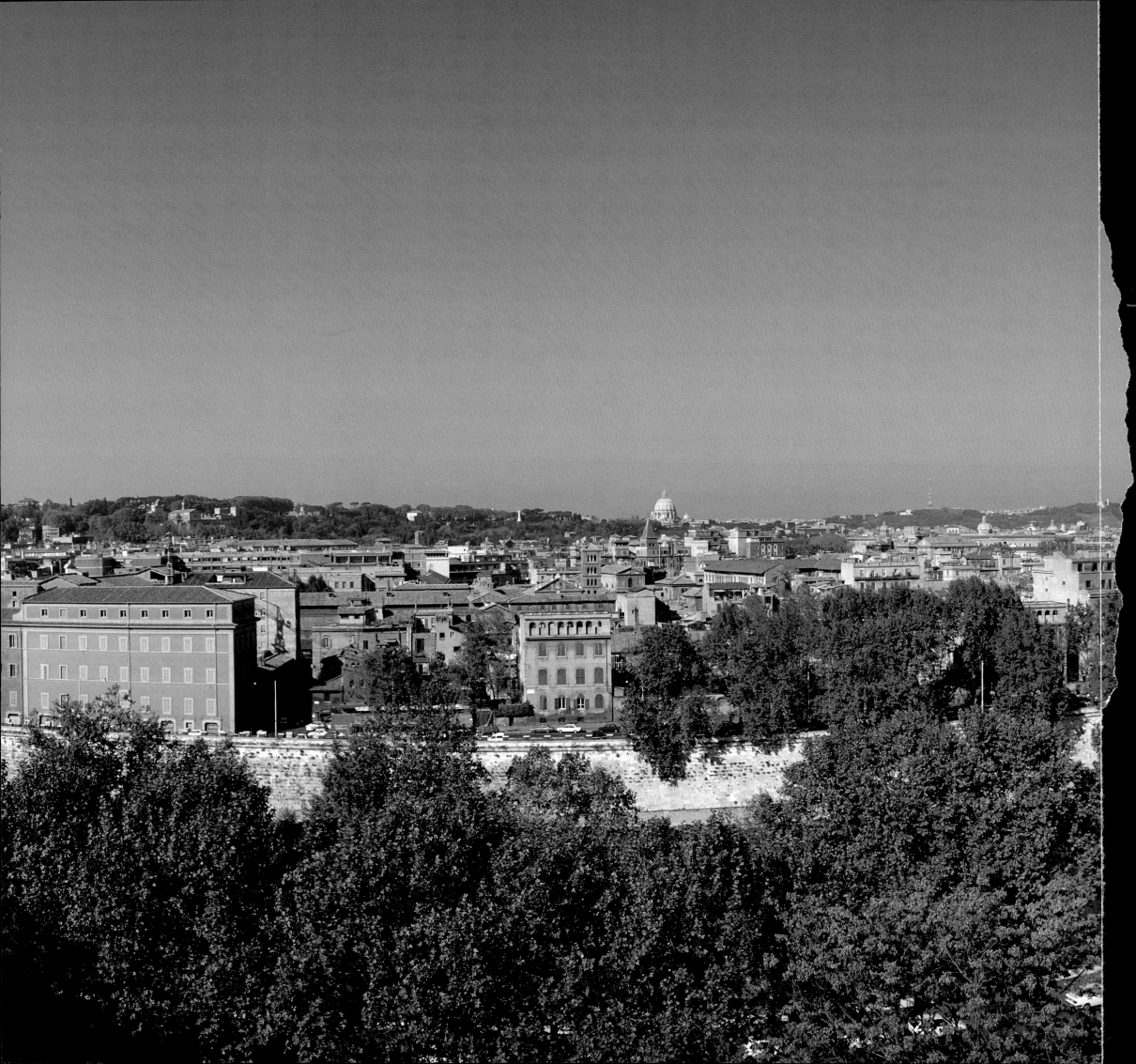

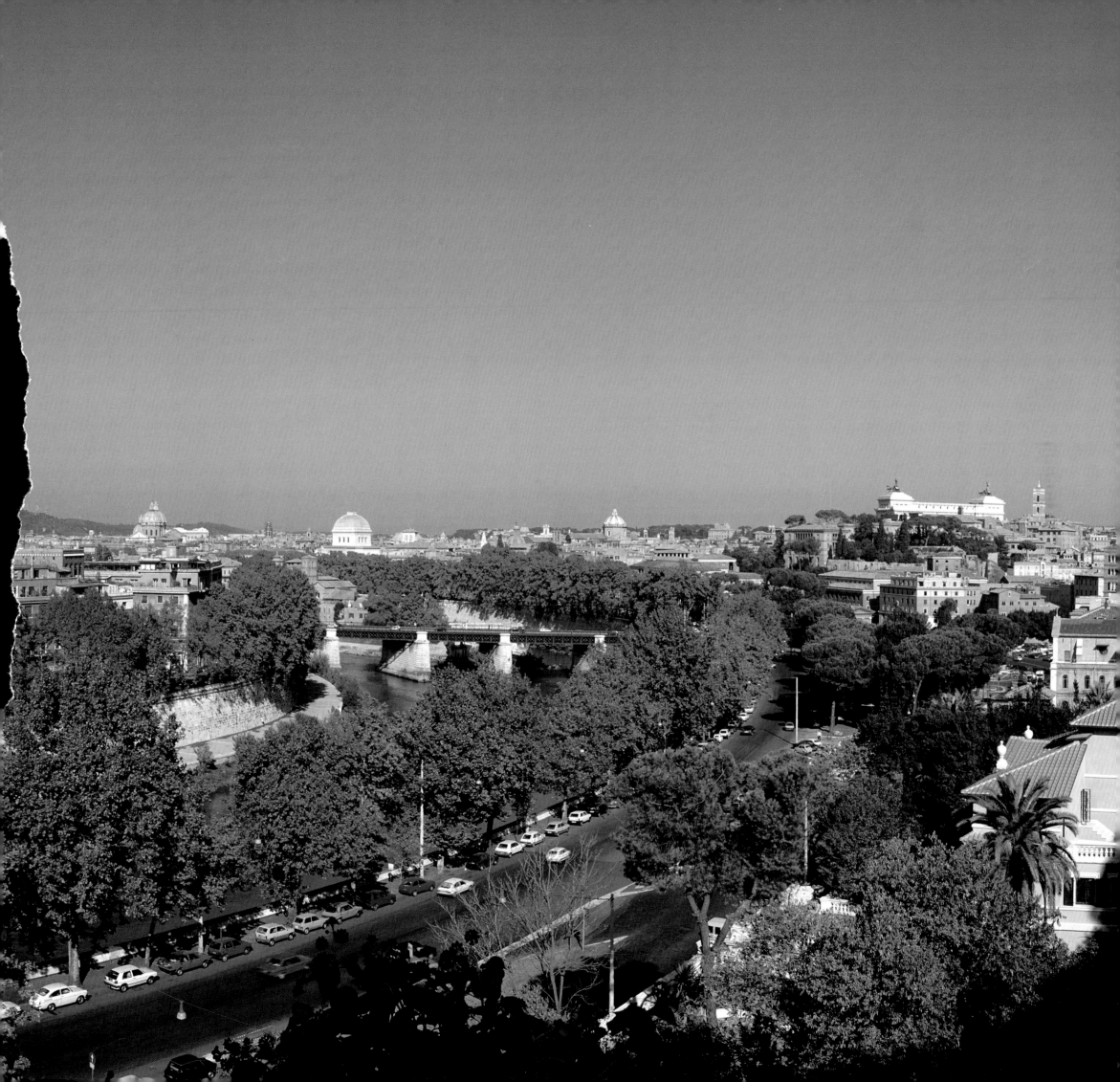

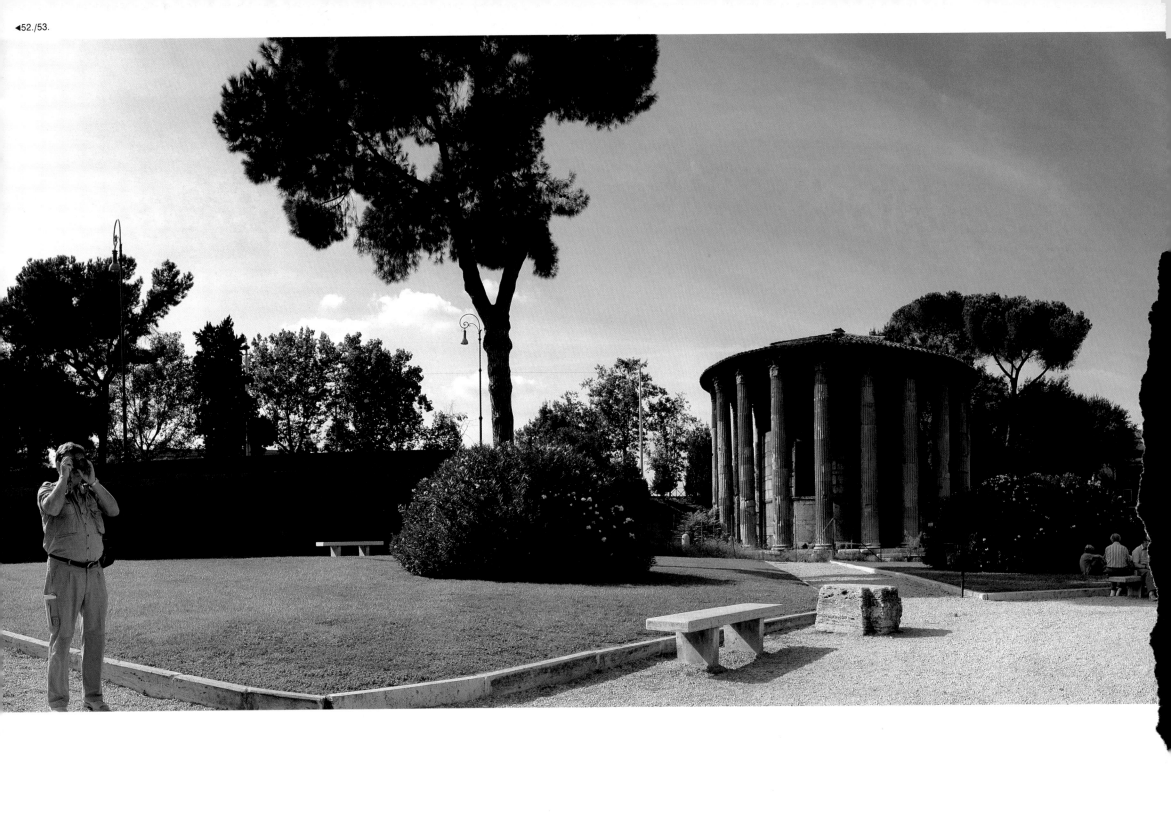

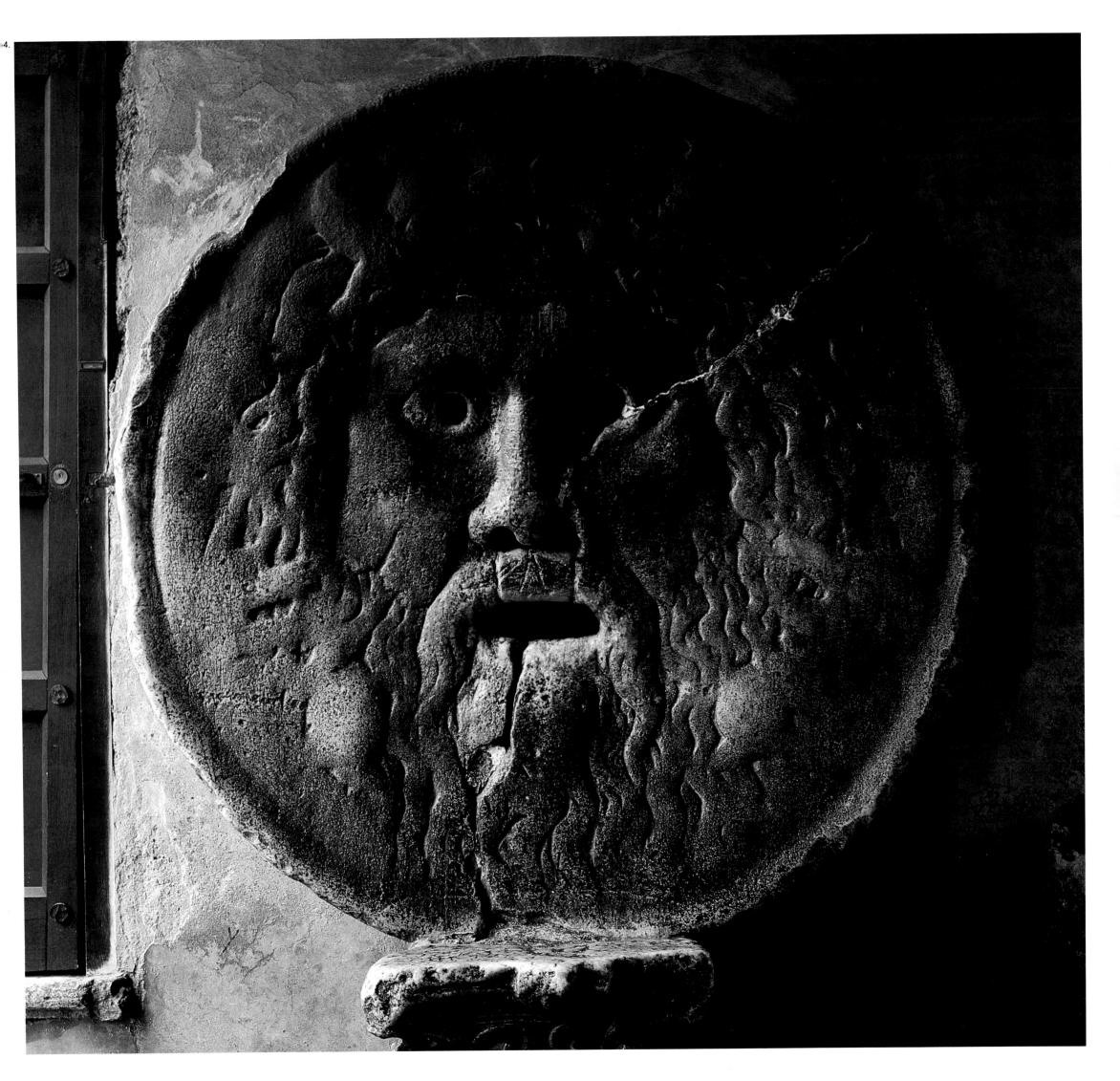

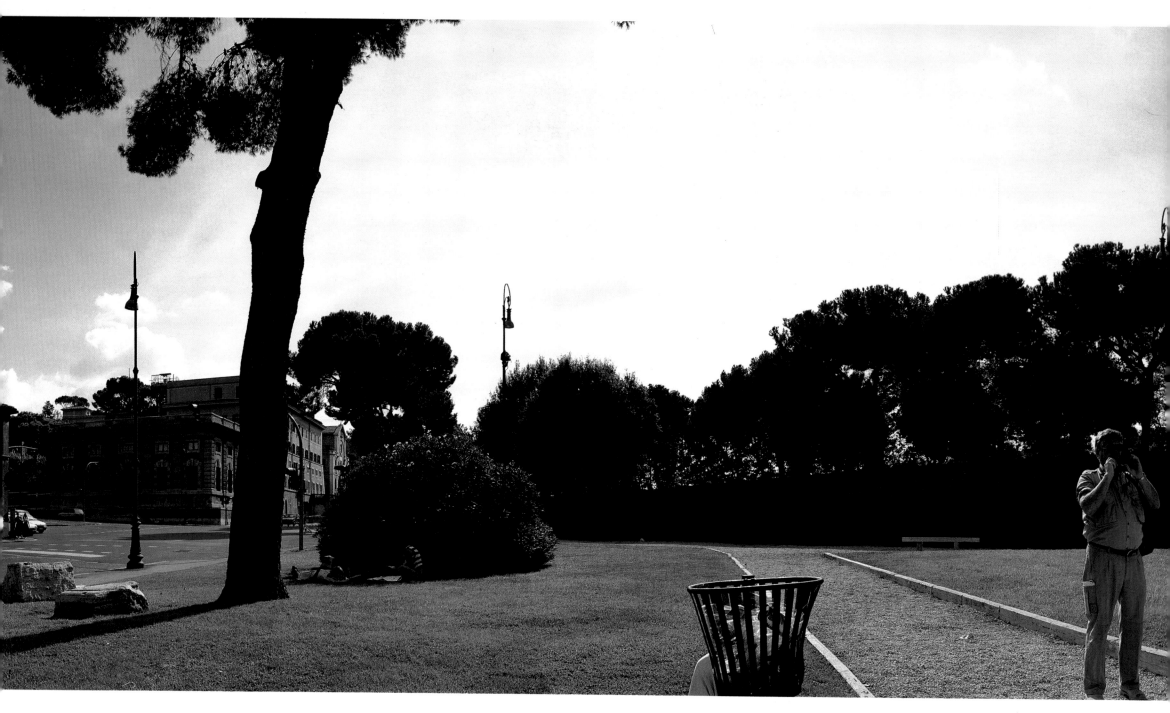

O'ALTARE CATTEDRA PLUTEO

VIRGINIS MARIA

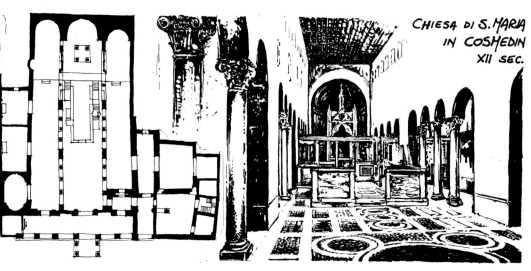

CHIESA DI S. MARIA
IN COSMEDIN
XII SEC.

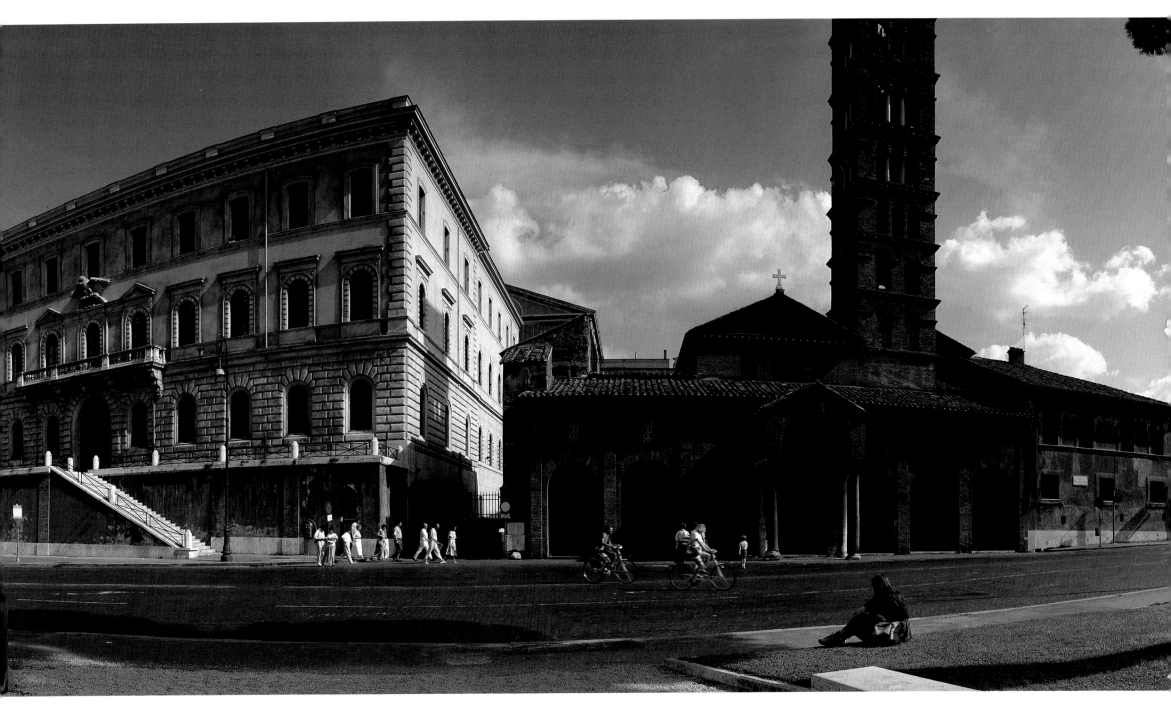

CRESCENZI PORTA DEGLI ARGENTARI PORTICO FRONTE
203 D.C.

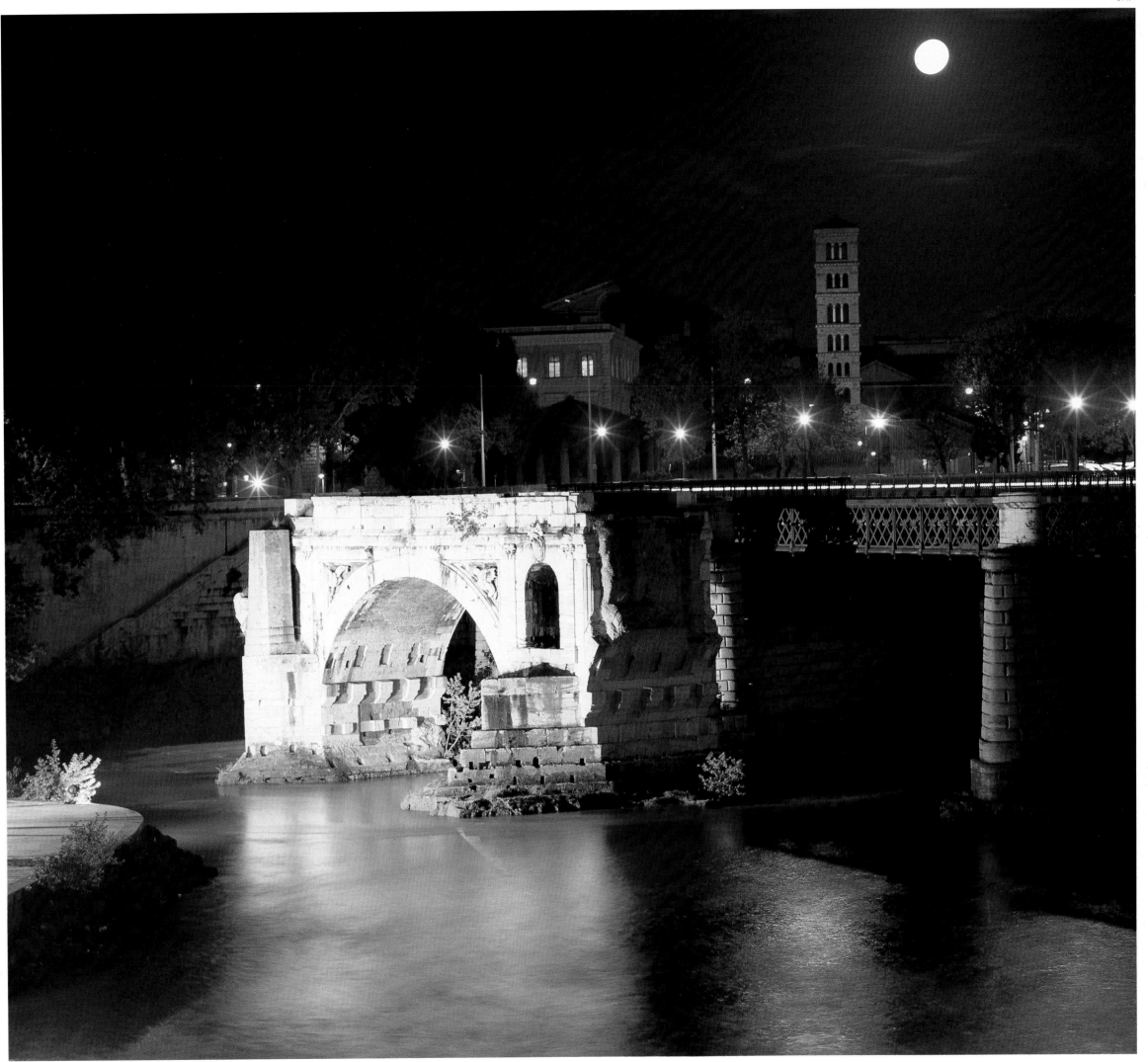

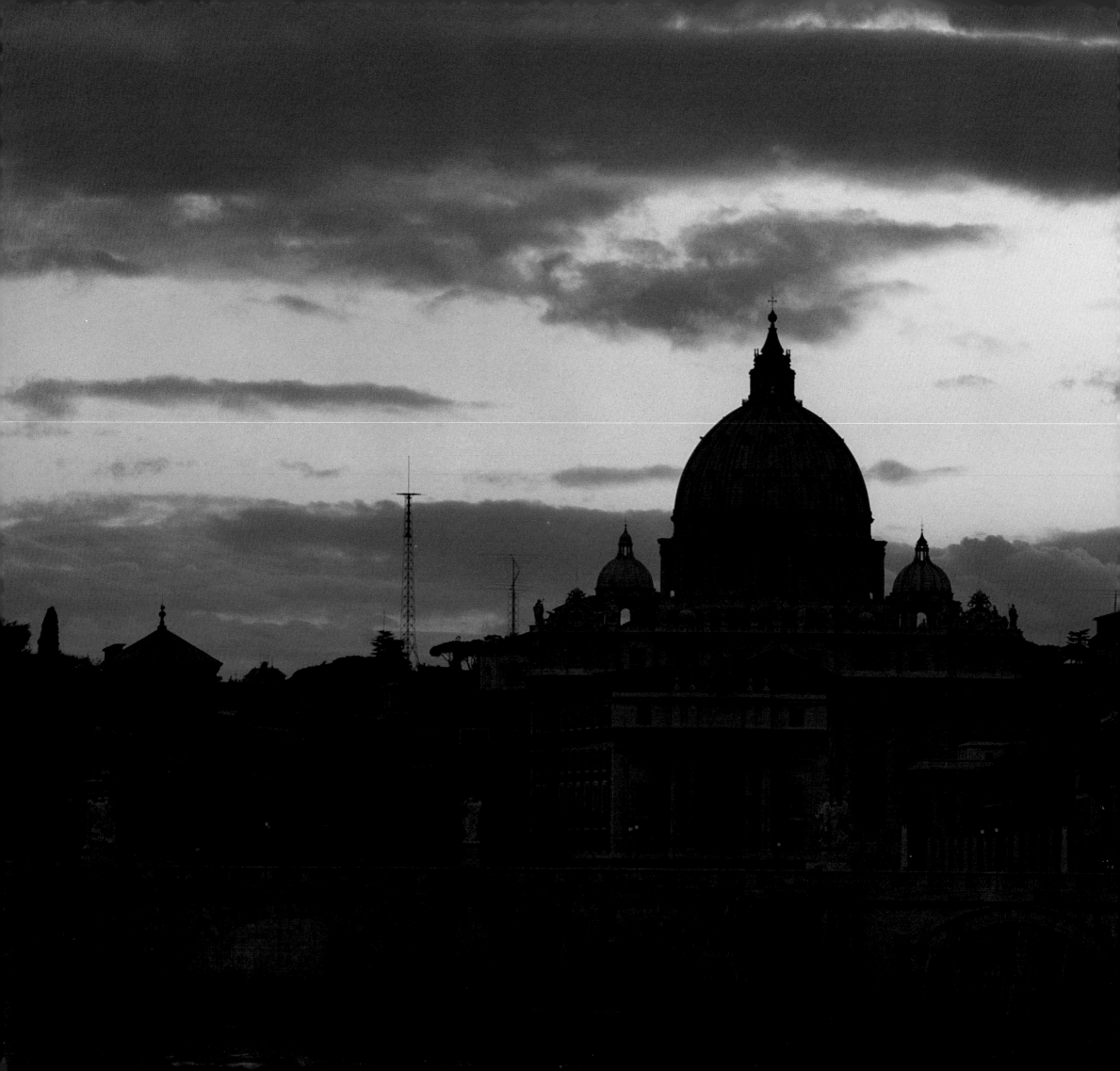

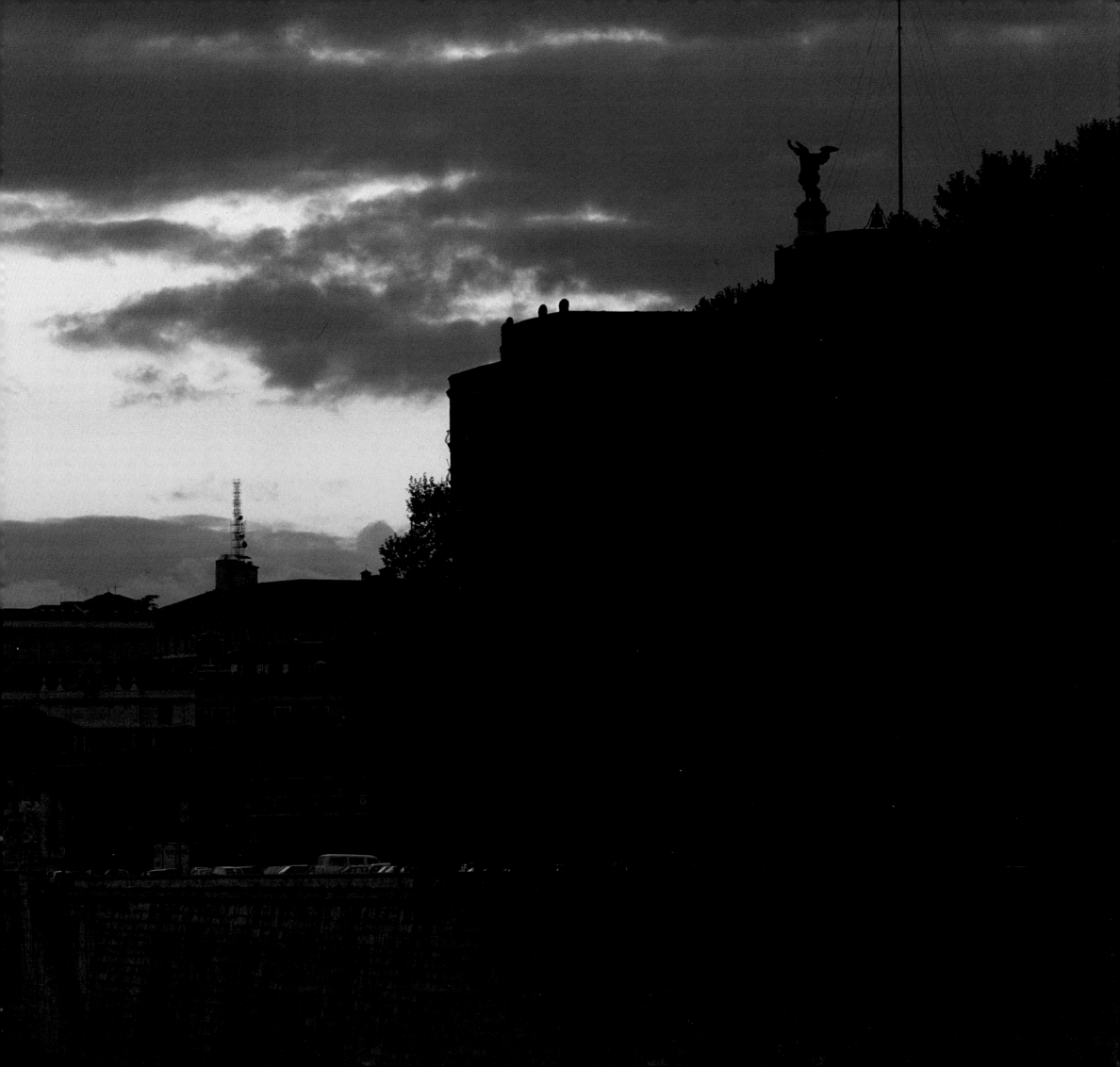

58.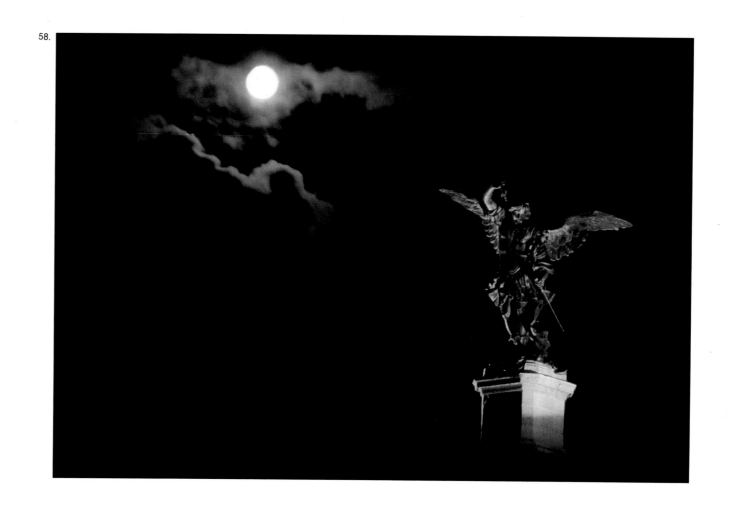

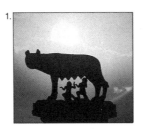

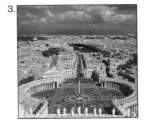

This well-known statue has served as the emblem of the Eternal City since time immemorial and is recognizable throughout the world as the symbol of Rome. Because the figure mounted atop the Capitoline Hill is exposed to the elements, it is a reproduction. The original bronze—the work of an unknown Etruscan artist in the fifth or sixth century B.C.—is on display at the Palazzo dei Conservatori and is probably the same she-wolf statue Cicero reported to have been struck by lightning in 65 B.C. (Traces of this event can be seen on the hind paws of the original.) The twins, however, were added by Antonio del Pollaiolo in the early sixteenth century, when a more complete representation of Rome's legendary origin was sought.

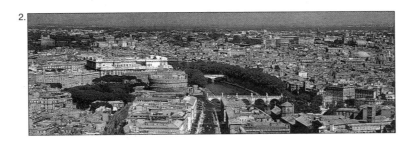

Rome has some thirty centuries of history, all of which is seen in this view that encompasses the ancient ruins that are testimonies to its past grandeur—medieval towers, Baroque churches, Renaissance palaces, and the monuments erected after the Unification. It is a city like no other. Surrounded by the gentle slopes of its neighboring hills, the gardens of the Janiculum, the Pincio, and the Villa Borghese, and traversed by the silvery Tiber, the city combines both history and nature. Rome is a city that is alive, gentle, luminous, sun-kissed, and infinitely beautiful.

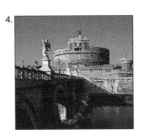

One of the most frequently depicted symbols of Rome is this circular turreted fortress now known as Castel Sant'Angelo, which has appeared in paintings and codices dating from the Middle Ages. Like Trajan's Column, the Colosseum, and the Arch of Constantine, Castel Sant'Angelo has long been identified with the Eternal City. The castle began as Hadrian's Tomb, a mausoleum the emperor ordered built in A.D. 135, when burial in the Ara Pacis had become impossible.

The original structure was an eighty-four-square-meter enclosure adorned with marble and statues surrounding a cylindrical building sixty-four meters in diameter and topped with a quadriga driven by the emperor, a symbol of his power. A spiral tunnel led to the burial chamber. When Aurelian decided to build new city walls in A.D. 275, he used the mausoleum as a bridgehead on the other side of the Tiber. Later, Theodoric used it as a prison, a role it would serve for centuries until its restoration began in 1901. Alexander VI

(Rodrigo Borgia) fortified it with bulwarks (later expanded by other popes) and took advantage of a passageway linking it to the castle at the Vatican, securing a second papal residence that could also be used as a refuge in case of danger. Sixtus VI chose Castel Sant'Angelo to hold the papal treasure. The prisons of the fortress were infamous; countless prisoners died there during the sixteenth and seventeenth centuries.

◀ 0 |45° |90° |135° |180°

5.
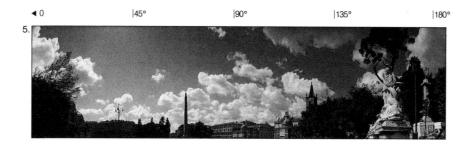

Piazza del Popolo is the gateway to Rome for those arriving from Via Flaminia to the north. In the sixteenth century, Sixtus V moved one of the obelisks of the Circus Maximus here, in recognition of the piazza's importance and to direct the traffic. The lions at the

foot of the obelisk were added by Guiseppe Valadier in the early nineteenth century, when he redesigned the piazza in the neoclassical style. The best view of the piazza is from the terrace of the Pincio Gardens, which also date from the Napoleonic period.

◀ 0 |45° |90°

6.
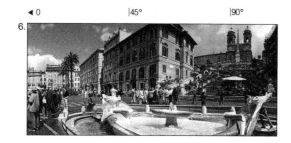
7.

8.
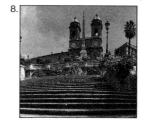

The façade of the sixteenth-century church of Trinità dei Monti, with its two campaniles and the obelisk in front, is not unlike the stage of a great theater, with the Piazza di Spagna its front row. The eye is immediately drawn to the well-known rococo steps which were built by the eighteenth-century architect Francesco de Sanctis. Once the favorite meeting place of artists and models, the Spanish Steps today are visited by tourists from around the world, who enjoy the array of azaleas furnished by the city each spring and

the handicrafts and leather goods laid out by street vendors.
Another feature of the Piazza di Spagna is the Barcaccia Fountain that Urban commissioned from Pietro Bernini and his son Gianlorenzo in 1623 to commemorate the great flood of 1598, when the square could be reached by boat. The fountain, in fact, is in the form of a boat (*barca* in Italian) that is sinking. This was the first of the many Bernini fountains that enliven Rome's piazzas.

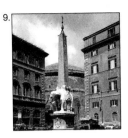

In ancient times there was a temple near the Pantheon dedicated to Minerva Chalcidica, which eventually gave its name to the church of Santa Maria sopra Minerva, the seat of the superior general of the Dominicans. In front of the church in the square is a curious monument of a small marble elephant with an obelisk on its back. The animal looks more like a pig than a pachyderm and is known in Rome as the *pulcin* della Minerva (*pulcin* being a corruption of the Roman word *purcin,* meaning "pig"). The sixth-century Egyptian obelisk comes from nearby Iseo Campense. The monument was erected by Ercole Ferrata in 1667, but is by Bernini.

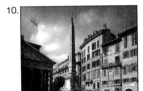

The Pantheon is the only pagan temple to survive intact, thanks to the Byzantine emperor Phocas who presented it to Pope Boniface in A.D. 609, transforming it into a Christian church and saving it from destruction. Built by Agrippa in 27 B.C., it was completely restructured in Hadrian's time. Known to the people of Rome as the rotunda, it is a key feature of the local panorama. Its dishlike dome is still the broadest in the city, bigger even than the cupola of St. Peter's. The Pantheon overlooks Rome's lowest-lying area, which in ancient times was frequently flooded by the Tiber. The street level in those days was even lower than it is today, and there was a stairway leading up to the temple. The large shell behind the Pantheon corresponds to the apse of another temple erected by Agrippa and dedicated to Neptune. This is one of the many ruins that lend color to this area and show how thickly concentrated were its monuments and public buildings in the days of ancient Rome.

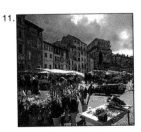

Today as yesterday, Campo dei Fiori is the popular heart and soul of Rome, as we can see in the market whose stalls stand under the baleful gaze of Giordano Bruno. The stern bronze monument erected to the memory of this heretical friar reminds us that this congenial, sunny piazza was once the stage for public executions. It was an usual choice for the site of gallows and scaffolds, since until it was paved in the fifteenth century to allow the construction of a fine cardinals' palazzi, it was nothing but meadow. From then on, it was a business center, full of inns, courtiers, and booksellers. Today it contains boutiques and handicraft shops.

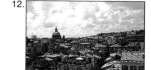

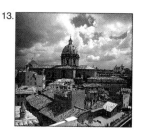

Every Roman dreams of living in a house that looks out over the inner city. The roofs of Rome have a distinct color, gray or pink, according to the weather and time of day. Among the penthouses and terraces, one can still see delightful hanging gardens, which are at their finest in spring and fall. They inspire envy in visitors—especially those from the north—for the mild Roman climate. Another distinctive feature of the skyline is its parade of domes and cupolas of all shapes and sizes that rise in glory into the crystal blue of a sunny day. They are an essential part of the panorama: from the large dome of St. Peter's, to the elegant profile of San Giovanni dei Fiorentini, or the bold touches Borromini conferred on the dome he designed for Sant'Ivo alla Sapienza. It may be the very abundance of these cupolas that renders the Roman sky so fascinating and so spectacular.

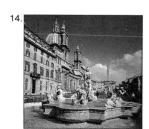

Piazza Navona has for centuries been "the" square for Romans; a meeting place and marketplace, a popular center pulsing with life. Since the fifteenth century, when the market that formerly occupied the Capitol was moved here, the vast open space that was the ruins of Domitian's Stadium started to come to life. It was originally called Piazza in Agone (a tribute to the athletic competitions that had taken place there; *agone* means "struggle") and only later, through linguistic corruption, evolved into "Navona." Piazza Navona soon became the site of popular festivals, races, and tournaments. From 1653 until the mid-nineteenth century, the piazza, which was then concave, would be flooded. Romans would splash and romp in the lake that was formed.

In the middle of Piazza Navona stands the renowned Fountain of the Four Rivers, the subject of some of the stories of the square's Baroque monuments. Some stories have some footing in history: the sculptor Bernini worked here, winning the favor of Urban VIII but losing that of Innocent X later. You will also be told that the attitudes displayed by two of the rivers personified reflect deprecation and fear of the church of Sant'Agnese, opposite, and are the work of Bernini's most determined adversary, Borromini.

The River Plate has one hand outstretched toward the façade of the church, allegedly for fear that it might collapse on the fountain at any moment. The Nile's gesture, an allusion to the fact that its source was still a mystery, is said to be covering its head in horror so as not to see the work of the sculptor's rival from Lombardy. The truth is that the façade was built two years after the fountain, so the result achieved by these postures cannot have been intentional.

The Fountain of the Four Rivers is a brilliant work and one of Bernini's masterpieces. The four rivers (the Plate, the Nile, the Danube, and the Ganges) represent the four parts of the world that had submitted to the dominion of the Church. The dove on top of the obelisk is the symbol of the Pamphili, Innocent X's family. The exotic fauna around the fountain, and the pains Bernini took to correctly represent the plants that sprout here and there among the rocks, bear witness to his love of nature, which is brilliantly blended with the purely sculptural aspect of the statues. The other two fountains at the sides of the piazza were also made from sketches by Bernini. The Fountain of the Moor is so named for the figure in its center: an Ethiopian holding a dolphin.

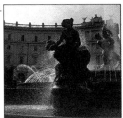

16.

Piazza dell'Esedra lies a short distance from the main railway station, Roma Termini. Its actual name is Piazza della Repubblica, but its nickname comes from its having been constructed on the outer exedra of the Baths of Diocletian. The square is enhanced by two fine, circular palazzi by Gaetano Koch and by the church of Santa Maria degli Angeli, designed by Michelangelo as an adaptation of the ancient baths' ruins.

The piazza's main claim to fame is its Fountain of the Naiads, commissioned by Pius IX, who wanted to reinstate the Marcian aqueduct (144 B.C.) that had once carried water into Rome from the upper valley of the Aniene. The sculptures, by Mario Rutelli, were added later. They represent the nymph of the lakes, with a swan; the nymph of the rivers, resting on a river monster; the nymph of the oceans, taming a wild horse; and the nymph of the underground waters, lying on a dragon. The centerpiece is a sea lizard clasping a dolphin, from whose mouth rises a tall jet of water.

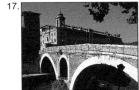

17.

The Ponte Fabricio, built by the consul Lucius Fabricius in 62 B.C., is the oldest bridge to have survived from ancient Rome. Also called the Bridge of the Four Heads, it joins the Tiberine Island with the left bank of the Tiber. There are two possible explanations for its nickname. The Ponte Cestio connecting the island to the right bank may have been considered a continuation of the first, thought of as having one head on each bank and another on each side of the island.

This rather prosaic explanation, however, must surely bow out in favor of the much more colorful story that lies behind two four-faced herms that were installed at the entrance of the bridge when it was repaired. It seems that the four architects to whom Sixtus V had entrusted the repairs were extremely quarrelsome, and their endless altercations scandalized all of Rome. The pontiff waited until the work was completed and then ordered the architects' heads to be chopped off, a sentence executed on the bridge itself. Nevertheless, the pontiff wished to show that he recognized the quality of the work, hence the two pillars with their "four heads."

18.

Trastevere is the district that stretches along the right bank of the Tiber. "Trastevere" means "across the Tiber" and it was not officially regarded as part of the city until the administrative reforms introduced by Augustus. The area was seen as hostile territory in the days of the Republic. It was here, in fact, that the Etruscans established themselves after they had been driven out of Rome and sought to restore their king, Tarquinius Superbus, to the throne. Later, fine villas and gardens were erected on the hillside. Many foreigners took up residence here, and the first Jewish colony was established under the Republic. And Trastevere retains its appeal. There are such jewels as the church of Santa Maria in Trastevere, among the finest in Rome. This basilica was begun long before the days of Constantine; some believe it was founded during the papacy of Calixtus I (A.D. 217–22). Its present appearance includes numerous alterations: The portico dates to the seventeenth century; the campanile and mosaics, to the twelfth; and its façade matches the rest of the piazza, with its fine octagonal fountain and the elegant Palazzo San Callisto (two medieval works that were completely rebuilt in the seventeenth century).

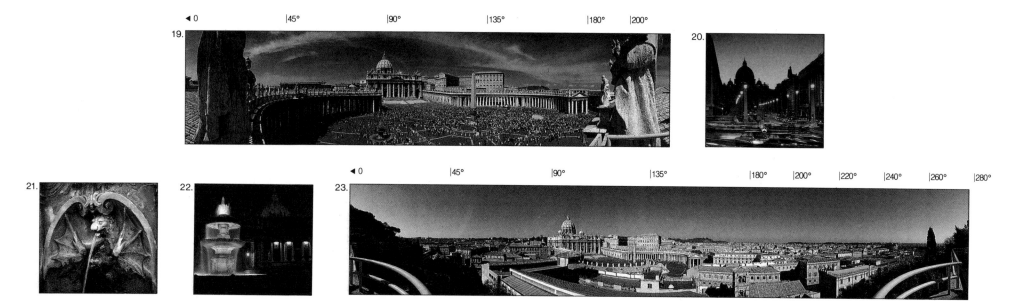

◄ 0 | |45° | |90° | |135° | |180° | |200° | |220° | |240° | |260° | |280°

From whichever angle, St. Peter's Square looks familiar. With its cupola by Michelangelo, its façade by Maderno, and its colonnade by Bernini, it encompasses two centuries of architectural achievement. When Alexander VI entrusted Bernini with the layout of the piazza in 1656, the façade had already been in place for more than forty years, and some hundred and fifty had passed since the laying of the first stone of the new basilica. Bernini demolished the old buildings that clustered around what had been the forecourt of the original Constantinian basilica established in the fourth century over the tomb of St. Peter. Bernini intended to use his sprawling colonnade to create an elliptical space, the traverse axis of which would be marked by the two fountains and the famous obelisk placed there by Sixtus V in 1586. His original design called for a third colonnade that would have enclosed the piazza. Bernini later decided to move this third arm back to create a small introductory square that would provide a view of the cupola and the whole array of columns. Neither proposal was ever put into effect, however.

Throughout his project, Bernini kept in mind the view that would greet someone who stepped out of the narrow alleys of the town and into this vast open space. Unfortunately, the installation of Via della Conciliazione in 1950 eliminated all the streets in the quarter surrounding the square and destroyed this wonderful effect forever.

The fountains themselves are a continuing source of delight, however. Bernini skillfully used them near the foci of his ellipse, accentuating the shape of the piazza. The one on the right dates to the time of Innocent VIII. It is fed by the Paolino aqueduct. Indeed, a

seventeenth-century visitor called it the most beautiful fountain in Europe and wrote that "it surges forth with such majestic abundance that it seems to throw a river into the air." Demolished in 1614 by Maderno and rebuilt on a larger scale, it was eventually joined by its twin in 1667. To ensure it would put on an equally fine display, this second fountain was not inaugurated for another ten years, when the work of feeding new springs into the same aqueduct was completed.

Via della Conciliazione also boasts such interesting fountains as those, each adorned by a dragon, alongside the fifteenth-century Palazzo dei Penitenzieri, one of the few ancient buildings left intact when the new street was opened up.

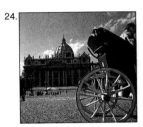

24.

A splash of color is cast on St. Peter's Square by a traditional *botticella,* an open hackney cab for two. Introduced on a wide scale in the eighteenth century, it has proved the ideal vehicle for those who want to enjoy the beauty of Rome at a leisurely pace for three hundred years. It is helped by the mild Roman climate, with its sun and light winds that make you want to get out and see the sights accompanied by the sound of the horse's trotting hooves, or perhaps take a drive up to the Janiculum or the Pincio, a pleasure many Romans themselves have by now forgotten, amid the frenetic rush of their city and its increasingly chaotic traffic.

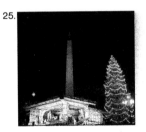

25.

For several years, St. Peter's Square has had a Nativity scene set up under the obelisk of Sixtus V. This is a traditional crèche: a shed, an ox and an ass, a Madonna with a blue mantle, a bearded St. Joseph; the sort of Nativity scene to be found in thousands of homes. Here, however, it is not the wall of a home, but Bernini's colonnade and the façade of the basilica that form the backdrop, with Michelangelo's dome as stand-in for the star of Bethlehem. There are all kinds of crèches in Rome, from the "historic" type found in the Aracoeli and that carved in marble at the end of the thirteenth century by Arnolfo di Cambio for the church of Santa Maria Maggiore to the more richly decorated and sumptuously endowed crèches of the churches of Sant'Ignazio, San Rocco, and Santa Croce in Gerusalemme. At St. Peter's, however, the most striking feature is the simplicity of the representation and the fact that the crèche is out in the open, at the mercy of the elements—a setting that heightens the contrast between this picture, the symbol of poverty and fragility, and the grandeur of the piazza.

26.

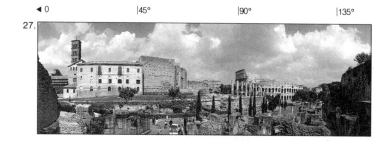

The area now partly occupied by the church of Saints Martina and Luca, set between the slopes of the Capitol and the Arch of Septimius Severus, is one of the most important sites of ancient Rome's development as a democracy. It was in this place, then known as the Comitium, that the people gathered and assemblies were held in the days of the Republic. From podiums called *Rostra,* because they were decorated with the prow of captured enemy warships, the speakers would harangue the crowds. The Arch of Septimius Severus was erected on the edge of this area in A.D. 203 by the Senate to commemorate the victories of the emperor and his sons Geta and Caracalla over the Parthians.

The monument is accessible by steps. Its sculptures are heavy, almost overdone, giving the arch the same mellowness of color that shows the increasing influence of the Near East. The façade and the cupola of the church of Saints Martina and Luca are also fully conceived to highlight the interchange of light and color. Reconstruction of this building took Pietro da Cortona almost forty years, from 1632 until his death, in 1669. The result lends both energy and variety to this corner of the Forum.

◄ 0 |45° |90° |135°

27.

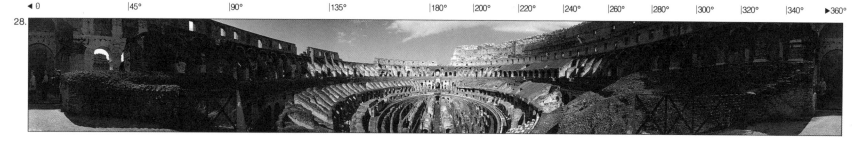

◄ 0 |45° |90° |135° |180° |200° |220° |240° |260° |280° |300° |320° |340° ►360°

28.

29.

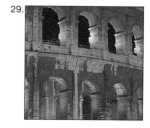

Until the nineteenth century, the archaeology of the major remains of the ancient Roman world—the Colosseum, the Temple of Venus and Rome, and the Arch of Constantine—were cut off from the rest of the city and surrounded by vegetable gardens and vineyards, separated from the homes on the edge of the city by a spur of Palatine Hill. This was cleared away during the demolition that opened up Via dei Fori Imperiali during the Fascist period. Now, of course, the area is only too taken up by the city proper, with the endless traffic sweeping around the outer rings of the ancient amphitheater.

This area was originally a marsh. Nero began the work of reclamation to provide a site for the construction of his imperial palace, the Domus Aurea, in front of which he erected an enormous statue in his own honor. That monument probably led to the name Colosseum being attached to what is actually the Flavian Amphitheater. Begun under Vespasian in A.D. 72 and finished under Titus eight years later, the Colosseum is elliptical in shape and could hold up to 50,000 spectators. It was used for gladiatorial shows and wild animal hunts. There is probably little truth to the story that Christians were martyred

here during these events. In any case, the bloody spectacles continued until the sixth century. During the Middle Ages, the Colosseum became a sort of quarry, its marble taken for the construction of new buildings. By the sixteenth century, this sacking became standard practice. Many of Rome's famous Renaissance buildings, including the Palazzo Venezia and the Palazzo della Cancelleria, owe their splendor to travertine blocks looted from the ruin. This recycling continued until the middle of the eighteenth century, when Benedict XIV consecrated the Colosseum to the cult of the martyrs. From then on, the Church concerned itself with the structure's restoration, preserving it in the majestic incompleteness in which it stands today.

The Arch of Janus and the medieval church of San Giorgio al Velabro are situated in an area of tremendous historical significance. It was here that the shepherd Faustulus was supposed to have found the twins being suckled by the she-wolf. Legends aside, the name Velabro, which means "marsh," indicates that in ancient times this spot, still one of the lowest parts of Rome, was flooded by the Tiber as far as the Palatine. The Arch of Janus shows that the commercial activity of the Forum Boarium, cattle market, extended this far. This four-fronted honorary arch was erected in Constantine's time. The *jani* were covered passageways similar to today's arcades and were shelter to those using the market. A relatively late work, the arch is partly made of fragments of other monuments. San Giorgio al Velabro is one of the many churches that the Greek colony in Rome built between the Tiber and the Palatine in the Middle Ages. The basilican floor plan dates to the seventh century; the outer porch was added later, perhaps in the ninth century; and the campanile was erected in the twelfth century. The interior has some fine seventh- and eighth-century frescoes and a mosaic in the bowl of the apse that critics attribute to Pietro Cavallini, the most outstanding of Rome's thirteenth-century mosaicists and painters, in whose art one can see the influence of Cimabue and Giotto.

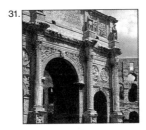 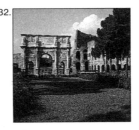

The Arch of Constantine is another of the monuments that is most resonant with the ancient city. Since the Renaissance it has been the symbol of antiquity itself, standing as it does a stone's throw from the Colosseum. It is the largest triumphal arch to have survived, erected in A.D. 315 to celebrate the emperor's defeat of Maxentius three years prior. Its sculptures have been sketched for centuries by the scores of artists and students who have come to Rome to learn the secrets of the arts of the ancients. What can be seen here is a true anthology of sculptures, nearly all of them from earlier periods. By Constantine's reign, Rome no longer had the skilled workmen capable of decorating a monument this size, and it was necessary to adapt and recycle fragments of existing sculptures.

Alongside Rome's largest triumphal arch stand the ruins of what must have been the ancient city's grandest temple, the Temple of Venus and Rome, dedicated by Hadrian in A.D. 135. It had been constructed to his own design. It was a double temple made up of two identical buildings with their apses back to back. The part dedicated to the divine personification of Rome faced the Capitol, that to Venus, mother of Aeneas and progenitrix of the Gens Julia, essential in the foundation of Rome and the Empire, looked out on the Colosseum. The bronze tiles that originally covered the temple were removed by Honorius I in the seventh century to place on the roof of St. Peter's Basilica. All that remains of this complex is the south side and two apses.

33.
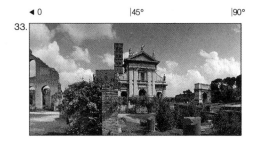

34.
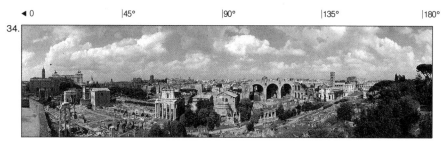

This view greets the eye in the ancient Fora, sweeping from the slopes of the Capitol to the Arch of Titus. Here is the former city whose ruins bear witness to its former glories. It is hard to believe that this area was a swamp just a few thousand years ago. The Fora originally lay in a marshy valley at the feet of the Viminal, Quirinal, Palatine, Capitoline, and Esquiline hills and was crossed by a stream that was later channeled into the Cloaca Maxima in order to drain the area. Thus reclaimed, it became an important meeting place and market and later became the site of basilicas and arcades where public affairs were conducted. When Rome became a republic, the market was transferred to the Velabro area, and the Forum became the city's administrative, political, and religious center. At the foundation of the Empire, the ancient Forum soon proved to be too small and was added to by a succession of Imperial Fora. The original center continued to be embellished with sumptuous buildings and superb monuments like the Basilica of Maxentius, which was begun in A.D. 306 and completed by Constantine several years later. It was both the largest and the most richly decorated of the Roman basilicas, with three aisles (of which only the northern is still standing). Also worth nothing is the Arch of Titus (A.D. 81), which has a single barrel vault. During the early years of the nineteenth century, Valadier did away with the changes made during the Middle Ages and restored the arch to its original form. Another interesting example of how the Middle Ages and subsequent eras dealt with Rome's imperial buildings is the church of Santa Maria Nova, usually called Santa Francesca Romana, which incorporates the remains of the western portico of the Temple of Venus and Rome.

35.

It was the practice in ancient Rome to throw traitors and other major criminals to their death from the Tarpeian Rock on the Capitol, named for the girl who was the first to be executed this way after she admitted the Sabines into the city. Archaeologists have established that this rock was located where the monument to Victor Emmanuel II now stands, as shown in photo 43. But it is next to impossible to convince any real Roman that the lump of tufa stone crossed by Via di Monte Tarpeio was not the site of Tarpei's demise.

This belief is encouraged by the fact that it was near this so-called Tarpeian Rock that the city built its gallows during the Middle Ages. In 1385, a condemned criminal, Giordanello Alberini, made provision in this will for a picture of the Madonna to be painted *ante furcas et locum justitae* ("in front of the gallows, in a just place"). Indeed, a miracle was reported to have occurred there in 1470 when it is said that an innocent young man was borne up by the Virgin as he hung on the rope. The Confraternity of Santa Maria delle Grazie began a collection for the construction of a church dedicated to Santa Maria della Consolazione on the slope of Monte Tarpeio.

As time passed, other chapels sprang up nearby and the church itself grew to such an extent that in 1583 it was necessary to build another. This was designed by Giacomo della Porta and included part of the original structure. The work was eventually completed by Martino Longhi the elder. The white façade, silhouetted by the green slopes of the Capitol, is dotted with pictorial and scenographic effects. Longhi himself only got as far as its architrave; the upper tier wasn't finished until the nineteenth century.

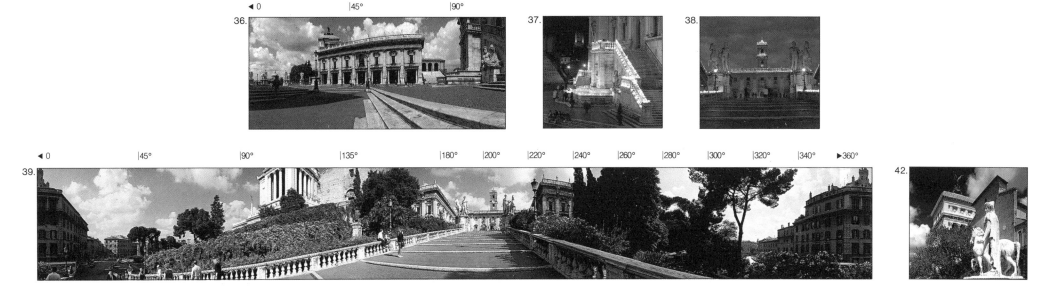

The Capitol was the center of religious and political power in ancient Rome and remains the repository of the city's artistic heritage. It has fulfilled its religious, political, and cultural functions consistently and it remains the heart of Rome.

The Capitol itself is a hill with two summits. The one to the north, where the church of the Aracoeli now stands, was once known as the Arx (the fortified citadel where the populace gathered for protection in emergencies). The one to the south was occupied by the Capitoline Temple of Jupiter. The Piazza del Campidoglio, in the fold between these points, was called the Tabularium (literally where the "tables of the law" were deposited) and was surrounded by arcades decorated with the likenesses of divinities that also housed the spoils of war brought back to Rome from foreign campaigns. When Rome's golden age came to an end and the city's population declined as a result of the economic malaise of the early Middle Ages, the Capitol survived, still teeming with life, as the marketplace, the home of the guilds and corporations, and the venue for the public functions that continued to be exercised. Despite the general air of decadence, the Capitol remained the symbolic center where emperors were crowned.

In the sixteenth century, Paul III entrusted Michelangelo with the task of restructuring the piazza. The new layout completely changed its orientation. The old Capitol had faced the Fora; the new is linked to the modern city. Michelangelo rebuilt the façade of the thirteenth-century Palazzo Senatorio, which stands on the ancient Tabularium, and added its twin stairway. He also supplied the drawings for the museum building and the Palazzo dei Conservatori, which replaced the medieval Palazzo delle Corporazioni. To broaden the square, he considered the idea of gradually widening the steps approaching it and of setting the two lateral palaces at an angle to the Senate. Another of his goals was to design the surface of the piazza with a motif composed of rectangles within ovals and to install on either side of the stairway the statues of Castor and Pollux dating from late imperial times that had been discovered when the foundations were being laid for the synagogue. Michelangelo, however, died before the work was completed. The architects who continued his work were not entirely faithful to the plans of their great predecessor. The nearby church of Santa Maria in Aracoeli stands where Sibyl is supposed to have revealed to Augustus the imminent descent of the Son of God with the words *Ecce ara primogeniti dei*. Built in the early centuries of Christianity's official recognition (as early as A.D. 574 according to some sources), it was the scene of Rome's most intense civil upheavals during the Middle Ages. On more than one occasion, in fact, the church was transformed into a forum where people could gather to discuss the *res publica*. Its most important function was as the religious center that the Capitol once had been. In this city full of churches, Santa Maria in Aracoeli occupies a special place in the heart of the Romans, as the home of the Santo Bambino, an image of the Holy Child carved in wood from the Garden of Gethsemane that is an object of much popular devotion.

40.

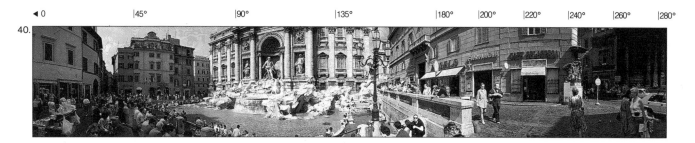

The Trevi Fountain is situated on the spot of the first century Acqua Vergine aqueduct, which is named for a young girl believed to have shown a water source to some thirsty soldiers. While the fountain was renowned in antiquity, it was neglected during the Middle Ages and did not regain its prominence until the fifteenth century, when Nicholas V brought the aqueduct back into operation. Leon Battista Alberti designed a fountain with a huge rectangular basin and three large spouts for Nicholas. Because of the three spouts or that the fountain stood at the meeting place of three roads, the names Treio or Trevio—medieval corruptions of the word *trivium*—began to appear on contemporary documents.

Numerous alterations were made over time. Bernini's plan, giving the fountain a monu-mental form, was approved by Urban VII but shelved after the pontiff's death. It became a source of inspiration for Nicola Salvi, however, after he won the competition to style the fountain in 1732. The result is a marriage of architecture and sculpture, with the severe façade of the Palazzo dei Duchi di Poli lurking behind the sculptures, which are dominated by a powerful Neptune amid a pair of winged horses and two Tritons. It is the water itself that animates the whole composition.

A Roman custom dating to the Middle Ages promises the visitor that he is sure to return to Rome if he drinks from this fountain and then turns his back and tosses a coin over his shoulder, into the water. This ritual, or parts of it, has endured.

41.

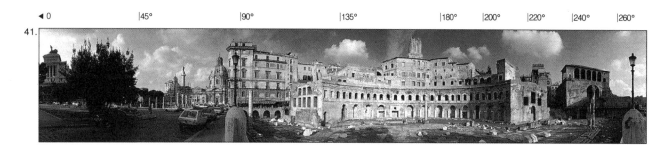

The complex of monuments that makes up Trajan's Market, the Torre delle Milizie, and the loggia of the Knights of Rhodes (or Malta) provides a résumé of three of the faces Rome has worn over the centuries. Even through its ruins, the exedra of Trajan's Forum bears witness to the grandeur of imperial Rome and the ingenuity of its architects. Indeed, it was the desire to create space for this grand project that led Apollodorus of Damascus to level a layer of the Quirinal that occupied the area and to place at the sides of his Fora two exedrae. Alongside this sumptuous system of open spaces stands the rugged Torre delle Milizie, the symbol of medieval Rome, whose overriding concern was with its own defense. Often called Nero's Tower by the locals, recollecting the site from which the emperor watched the fire that destroyed the city in A.D. 64. This is an anachronism: the tower was actually built in the thirteenth century. It quickly became the most powerful of the fortresses on the surrounding hills, despite being shorn of one story by the earthquake of 1349 and being slightly crooked because its foundation rests on the remains of other, more ancient structures. The fifteenth-century loggia of the House of the Knights of Rhodes, on the other hand, is a fine example of an innovative concept of space and of a city that flourished at the advent of the Renaissance.

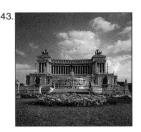

43.

When Rome became the capital of a unified Italy in 1870, it was endowed with signs of its new status. A monument to Victor Emmanuel II, the great nation builder, it was part of a more far-reaching town-planning project, namely, to transform Piazzetta Venezia—which, surrounded by Renaissance and Baroque palazzi, had been a mere widening at the end of Via del Corso—into one of the city's focal points and a leading crossroads. The monument, usually referred to as the Vittoriano, was designed to make a great impression along the axis of Via del Corso. To achieve this effect, great changes were made to the piazza's original look. Space was created by knocking down a set of buildings crossed by several medieval streets and a palazzo-cum-tower erected in the time of Urban III. Later, even the Palazzetto Venezia was demolished and rebuilt, in a somewhat reduced version, farther back, where it stands now. Sacconi, the architect called upon in 1885 to oversee its construction, died twenty years later with his work still unfinished.

Even in 1911, when it was inaugurated on the fiftieth anniversary of the Kingdom of Italy, the Vittoriano lacked finishing touches. The structure consists of two levels, the first of which now contains the Tomb of the Unknown Soldier, who was killed in the First World War. The equestrian statue of Victor Emmanuel stands on the second level in the middle of the monument. Above that is a thick forest of columns belonging to the portico and the propylaea, themselves topped by two groups representing the quadrigae of Unity and Liberty. The choice of glaring white marble proved an unhappy one, since it clashes with the brownish hues of the surrounding buildings. Despite it all, the monument has become an integral part of the landscape, and it is difficult to imagine a panorama of the city without the Vittoriano somewhere in the background.

◄0 |45° |90° |135°

44.

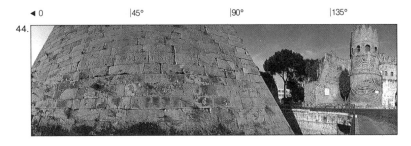

Rome is indeed an eclectic city. Among its modern buildings, ancient ruins, medieval towers, and Baroque churches, there is even a pyramid, a small one, to be sure, but a pyramid nonetheless. Thirty-seven meters high, with a thirty-meter base, it was erected in 11 B.C. by the praetor Gaius Cestius Epulo, who was sufficiently taken with the tombs of the pharaohs to want a small-scale model for himself. It is made of bricks clad with blocks of Carrara marble. The interior has a burial chamber with decorative paintings and a vaulted ceiling. Visitors have always been taken with this unusual monument. The *Mirabilia urbis Romae,* a twelfth-century vade mecum for pilgrims to Rome and a mine of information about local traditions during the Middle Ages, claims that this is the burial

place of Romulus and Remus, and was so constructed to keep dogs from walking on it. Aside from generating legends, however, the pyramid has also been put to other uses. Since the structure was located at what later became a strategic point in the city's defense, Aurelian made it a bastion in the ring of walls he built around Rome. The Porta San Paolo nearby was also erected in Aurelian's time. Its name stems from the fact that the street that begins here, Via Ostiense, leads to the Basilica of St. Paul. The gateway in its present form, with its two circular crenellated towers, is the result of alterations made more than a century later, during the joint reign of Flavius Honorius and Arcadius.

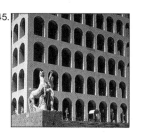
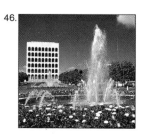

The idea in the minds of those who designed Rome's exhibition quarter (EUR) was to create a modern version of the Eternal City. This ambitious project (spearheaded by Mussolini) called for dignified streets and monuments that would evoke the grandeur of historic Rome. One such building is the Palazzo della Civiltà del Lavoro, regarded by some as a contemporary interpretation of the Colosseum and often referred to as the Square Colosseum. Fascist argot led to its being called the Palazzo della Civiltà Italica, the Hall of Italian Civilization. For the irreverent people of Rome, nicknames such as the Hall with the Holes and the Gruyère were often preferred. The architects who won the competition for its construction in 1939 built it entirely of stone and marble. This choice of traditionally "Italian" materials was applied to all the other EUR buildings, the idea being to preserve the cultural cohesiveness of the quarter by banning the use of iron and reinforced concrete. The palazzo itself was conceived on the grand scale—indeed, the entire Pantheon would fit neatly inside it—and decorated with many enormous statues by Publio Morbiducci and Alberto Felici. The following inscription is carved on each of its four faces as an eternal reminder of the original project: A PEOPLE OF POETS, ARTISTS, HEROES, SAINTS, THINKERS, SCIENTISTS, NAVIGATORS, AND MIGRANTS.

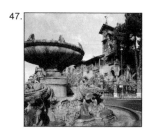

On the slopes of the green Monte Parioli between Via Arno and Via Po, with its villas and expensive residences, lies a very unusual group of buildings. This is the Coppedè Quarter, named for the extravagant architect Gino Coppedè. At the beginning of the twentieth century, he decided to build houses imitating a host of architectural styles. This experiment in eclecticism yielded copies of medieval houses, Oriental buildings, Renaissance palazzi, and Egyptian edifices: a mix disconcerting in a city such as Rome, which is full of original versions of most of these styles. Nonetheless, the Coppedè Quarter is another example of Rome's stylishness and originality.

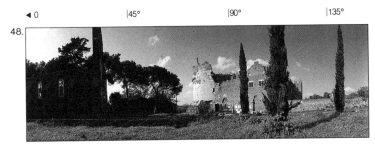

Leaving the city behind and passing along the Appian Way, the visitor becomes a pilgrim to the past. The history that comes to mind is not solely that of the ancient city of the Romans, which the road was built to serve in 312 B.C. There are echoes of the pastoral scenes captured by Nicholas Poussin and Claude Lorrain, for example, and engraved by Giambattista Piranesi, as well as the gloomy representations of the Romanticists, with lurking bandits and threatening thunderclouds. From Statius, who called it the *regina viarum,* to Goethe, who cast it as the leading actor in the melancholy view of a great lost world, the Appian Way has always captured the imagination of artists and poets. It is isolated, immersed in the greenery of the Roman countryside and spared for some of its length from the clutches of developers, at least for the moment. In this singular procession of churches, burial grounds, catacombs, and stately villas both ancient and modern, there remains the fascination and mystery of the sacred site in the natural setting. Here, indeed, the pious tradition of *"Domine, quo vadis?"* still persists. It is immortalized in the little church of the same name built on the spot where Christ is said to have appeared to St. Peter (who had fled from the Mamertine Prison) and exhorted him to retrace his steps and face martyrdom. Yet by far the best known, most painted, and best loved monument on the Appian Way is undoubtedly the Tomb of Caecilia Metella, a tower-shaped, cylindrical sepulchre made of blocks of granite and decorated with a frieze of ox heads hung with wreaths. During the Middle Ages, its strategic position on one of the main roads to the city made it the scene of bloody struggles between the leading Roman families. It served as a protective castle until 1435, when it was completely abandoned. Later it became a bivouac for troops marching toward the city, as well as a hideout for criminals. It eventually became so notorious that its total demolition was voted by the Senate in 1589 during the papacy of Sixtus V. Fortunately, the resolution was overruled through the intervention of a senator who reminded his colleagues of the history of the place. Virtually all that remains of the castle itself is the original tomb, and our imagination must be content with the few ruins to be found along the roadside.

The pouting yet congenial mask on the outer wall of Savello Park in Piazza Pietro d'Illiria was moved here at the beginning of the twentieth century from a fountain that once stood in Campo Vaccino, as the Forum was once called. This fountain was designed by Giacomo della Porta and installed between the Marforio Statue, the Arch of Septimius Severus, and the ruins of the Temple of Castor and Pollux in 1593. The styling of the mask was entrusted by della Porta to a well-known stonemason, with instructions to produce a "genteel work in white marble." It spouted water across a wide tub made of red porphyry that was described in a contemporary chronicle as "a great granite bowl that now serves as a fountain and stands in the middle of the Forum Romanum; it is used to water the animals brought to market there." The name Campo Vaccino was thus derived from the old Forum's use as a cattle market (*vacca* means "cow"). This old basin was eventually promoted to a higher status in 1818, when it was chosen to adorn Piazza Quirinale.

52.

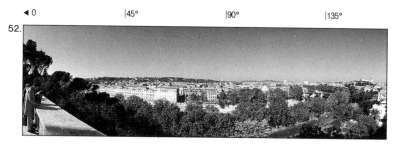

In the heights of Rome are some special places from which to admire the city. One such place, located at the end of the Aventine, is the parapet of Savello Park, known for its garden of orange trees, whose perfume fills the grounds. In the twelfth century, the castle of the Savello family stood nearby, and its walls still enclose part of the grounds. The Dominicans of Santa Sabina softened the warlike slope of the hill by making it the convent's vegetable garden and a place for study and contemplation. The park has remained a delightful green space, one of the quietest and most secluded in Rome. It offers one of the finest views of the city. From here, one can see the houses, towers, and Romanesque campaniles of Trastevere and, on the other bank, the ancient temples and the silver thread of the Tiber winding around its island; the Forum Boarium. Michelangelo's great dome of St. Peter's dominates the sea of cupolas that stud the Roman skyline. On the right, the domes of San Carlo ai Catinari, Sant'Andrea della Valle, and Sant'Agnese in Agone can be seen, although they almost overlap one another. The cypresses of Villa Sciarra, and the profile of Monte Mario and the Janiculum, with the monument to Garibaldi and the lighthouse, can be seen in the background. Somewhat closer are the Torre del Campidoglio, the Torre delle Milizie, and the quadrigae of the Vittoriano.

53.

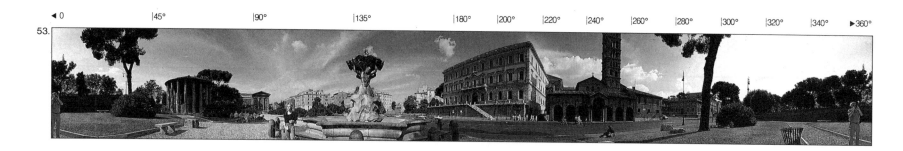

54.

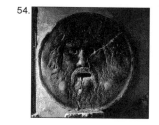

55.

Piazza della Bocca della Verità, set, along with the medieval church of Santa Maria in Cosmedin, among ancient temples, is a unique sight. In antiquity, this was a great trading area, situated as it was near the most frequently used wharves. The number of temples suggests that some thought was given to providing those arriving by river an attractive picture of the city. During the Middle Ages, a Greek colony was established here and on the strip of land between the Tiber and the Palatine, and the numerous churches that sprang up there bore the names of Eastern saints. The most representative church is Santa Maria in Cosmedin. First erected in the seventh century on the ruins of a tufa temple identified as the Ara Maxima of Hercules, it looks much the same as it did in the twelfth century. The two temples in front escaped destruction because they continued to be used as churches until the nineteenth century. The circular temple, commonly called the Temple of Vesta due to its resemblance to the one in the Forum that was consecrated to the goddess, was built in the second century B.C. and was in all probability dedicated to Hercules Olivarius, the protector of oil merchants. The other is referred to as the Tempio della Fortuna Virile. It was built during the Republic as the Temple of Portunus, the god of doors. The name of the piazza itself derives from the large stone mask known as the Mouth of Truth, which probably began life as the cover of a well or a branch of the Cloaca Maxima and was brought to the church's portico in 1632. Its fame rests on the claim that if a liar puts a hand in the mouth, it will be chopped off.

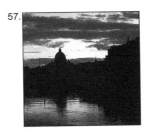

56.

The island in the Tiber has been the stuff of legend for centuries. The oldest holds that the island was formed from the sludge that clung to the heaps of the Tarquins' grain that the Romans dumped into the river after driving them out of the city. Among other things, it was the site of the Temple of Aesculapius, the god of medicine and healing. In 292 B.C., after a ship that had been sent to Epidaurus to ask the Oracle how to end the pestilence then ravaging the people of Rome had returned, a snake that was sacred to Aesculapius and that had been presented to the ambassadors as a gift, slipped into the Tiber, alighting on the banks of the island. The temple became a place where the sick went to be treated, primarily with the waters of the river itself, which seem to have had healing properties. The island is still the site of one of the city's most important hospitals, the San Giovanni Calibita, or *Fatebenefratelli* (literally "do good, brothers") Hospital. The spot where the temple stood is now occupied by the church of San Bartolomeo all'Isola, which was founded before 1000 and completely rebuilt by Martino Longhi the younger in the seventeenth century, after being destroyed by a flood. The floodwaters of the Tiber have repeatedly damaged the first stone bridge erected by the Romans in 179 B.C. to replace the Pons Sublicius, the famous wooden footbridge defended by Horatius Cocles when "even the ranks of Tuscany / Could scarce forbear to cheer." Known as the Broken Bridge, its remains still stand in the middle of the river.

57.

Rome never repeats itself. When the sky is sparklingly clear, evening suddenly descends, heralded only by the distant fire of the dying sun behind the great dome of St. Peter's. Then the Tiber becomes a lure for lovers, calling them to its banks. As always, the river tells the city's story. Between the dusk and the lighting of the lamps is an intermezzo during which Rome changes yet again, becoming a full-scale relief model of itself. And that is when it establishes the rules of the game all visitors fall prey to among its eternal charms. Finally, at nightfall, the angel is lit.

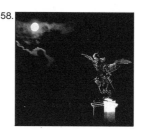

58.

The angel sheathing his sword on top of the Castel Sant'Angelo is an image dear to Romans. The statue commemorates the end of a pestilence in the sixth century A.D. The story goes that Gregory the Great, on returning from a procession calling for divine intervention against the scourge, raised his eyes toward the fortress and saw an angel slowly returning his sword to its sheath. The epidemic suddenly came to an end, and a statue was erected to commemorate the event. The one we see today is made of bronze and was installed in the middle of the eighteenth century.

The work of Flemish artist Peter van Varschaeffelt, it is very different from its predecessor, a marble statue by Renaissance sculptor Raffaello da Montelupo that now stands in one of the courtyards of the castle. There were four earlier versions: The first, made of wood, simply eroded; the second, made of marble, collapsed; the third had bronze wings and was destroyed by a thunderbolt; and the fourth was melted down to make arms during the sack of Rome in 1527. And so, in one form or another, an angel has been there for centuries to cast a benevolent, protective eye over the Eternal City.